THE ART OF GOD

The Heavens & The Earth

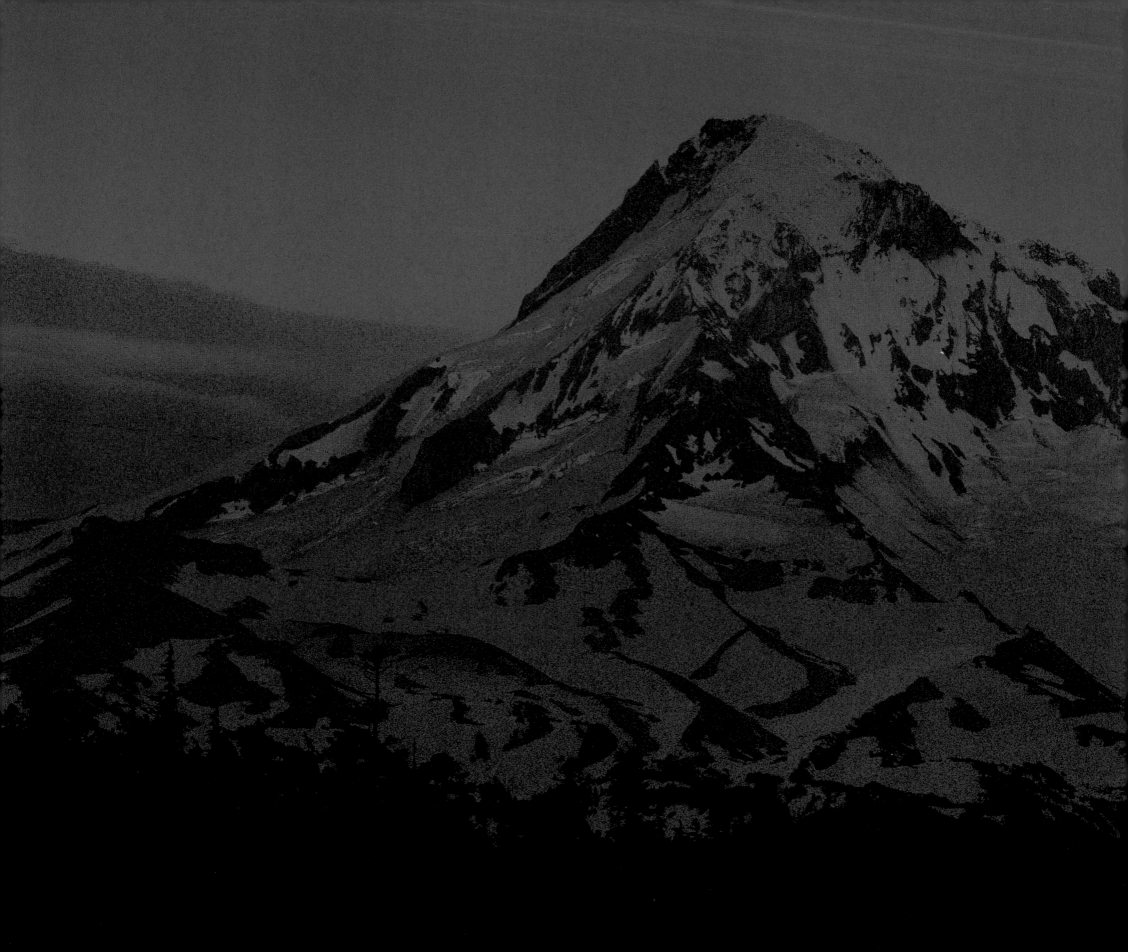

1. Mount Hood, Oregon Cascades

THE ART OF GOD

The Heavens & The Earth

RIC ERGENBRIGHT

Tyndale House Publishers Incorporated, Wheaton, Illinois

Visit Tyndale's exciting Web site at www.tyndale.com

Library of Congress Cataloging-in-Publication Data
Ergenbright, Ric, date
 The art of God / Ric Ergenbright.
 p. cm.
 ISBN 0-8423-1898-4 (hc : alk. paper)
 1. Creation. 2. Nature--Religious aspects--Christianity.
 3. Creation Pictorial works. 4. Nature--Religious aspects -
 -Christianity Pictorial works. I. Title.
 BS651.E74 1999
 242--dc21 99-24843

Printed in Singapore
05 04 03 02 01 00 99
7 6 5 4 3 2 1

This book is dedicated to my wife, Jill, and our daughters, Erin, Dana, and Megan; to my sisters, Jan and Dinah, and their families; to the memory of my parents, Eric and Mary; and, above all, to the glory of my Lord and God, Jesus Christ.

TO THE READER

No human work can adequately describe or illustrate the work of God, and this book is certainly not an attempt to do so. It is instead a meager adjunct to the topic it addresses—the supreme artistry of God in creation. As such, its purpose is not to define the art of God or to limit it by the narrow subject matter and personal vision of my photography, but to encourage you to experience it firsthand and to see God's majesty through what He has made. Consider this, then, as an abbreviated catalog, spotlighting a few selected pieces from the greatest art exhibit in the world. Indeed, the world *is* the exhibit, and everything in it is the art of God.

May this book inspire you to look at the splendor of God's creation through new eyes and praise Him for the great things He has done.

ACKNOWLEDGMENTS

I wish to express special thanks to Tim Botts for his invaluable suggestions regarding design; to Lee Hough of Chariot Victor Publishing for believing in the project enough to let it go; to Ron Beers and the production department of Tyndale House for their constant encouragement and support; to my daughter, Dana, for her critical editing and uplifting talks of faith; to the members of Grace Community Orthodox Presbyterian Church in Bend, Oregon, for their prayers and love in Christ; and to Pastor Daniel Dillard for his uncompromising devotion to the accurate teaching and earnest application of God's Word. All of you have played a vital role in the development and completion of this book, and I have been truly blessed by your generous contributions.

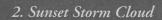

2. Sunset Storm Cloud

*Holy, holy, holy is
the* L<small>ORD</small> *Almighty;
the whole earth is
full of his glory.*

<small>ISAIAH</small> 6:3, <small>NIV</small>

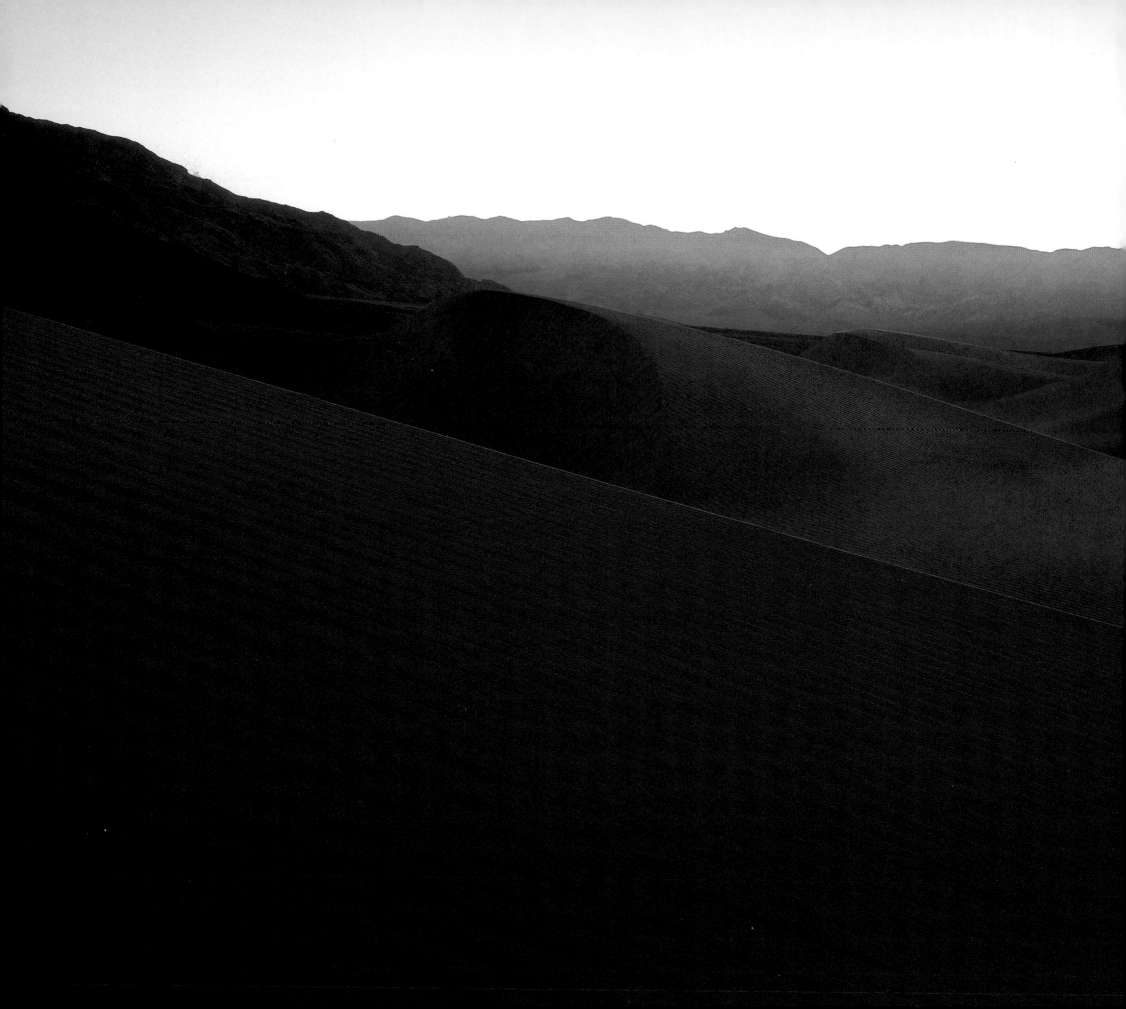

CONTENTS

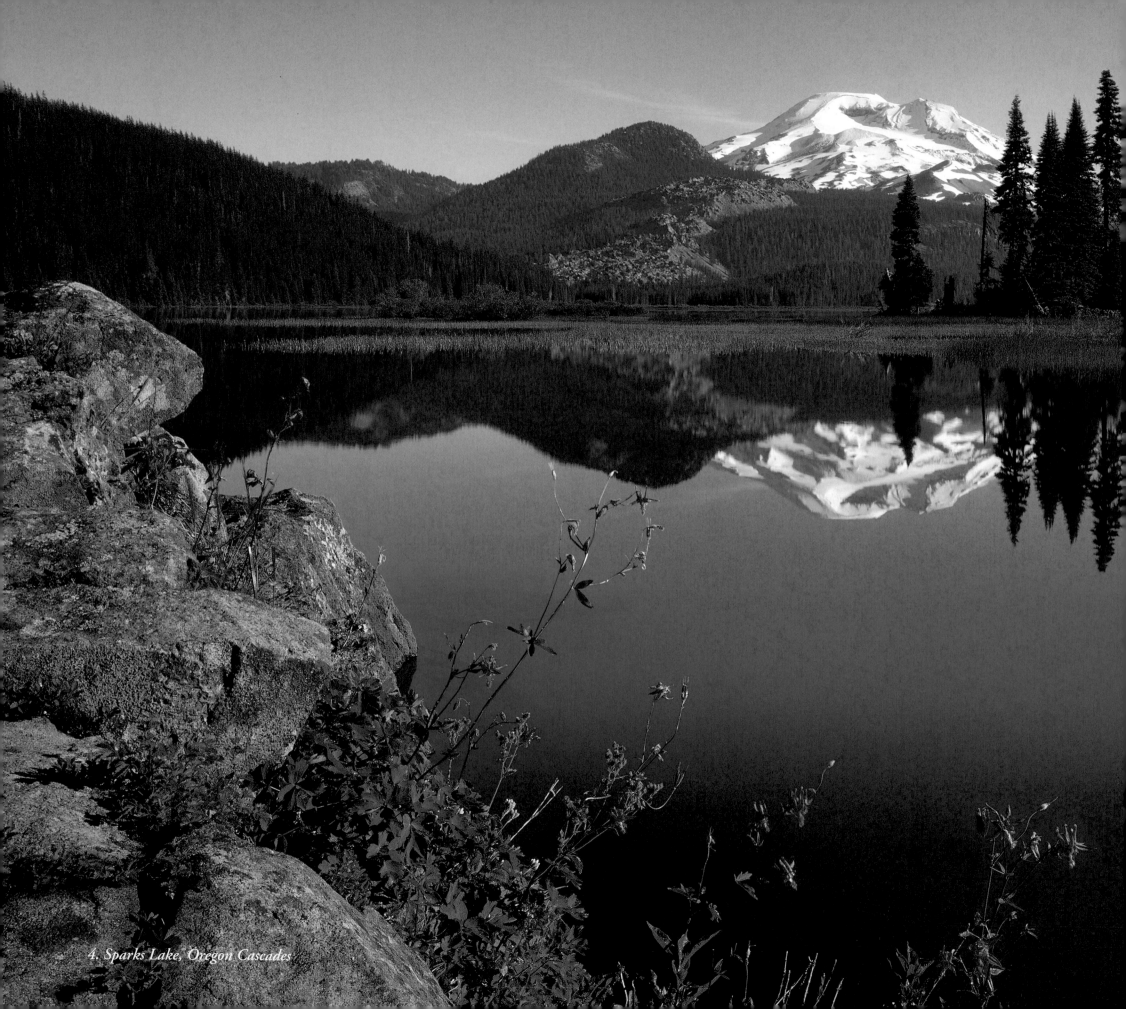

4. Sparks Lake, Oregon Cascades

Holy Scripture and the great hymns of the church are filled with verses praising God for His loving creation of man and earth. For the hands that formed the world and molded Adam from its dust also gave us a reverence for its beauty and a desire to praise Him who made it.

Thus linked by a common origin, we feel a kinship with nature that increases our awareness and understanding of God. As a masterpiece opens a window into the mind of the artist who made it, so the universe reveals much about its Creator. Indeed, so clearly is God displayed in nature that if all Scripture were lost, we could still know something of His character by carefully studying the works of His hands. From its tiniest details to its most majestic vistas, the whole earth points us to the sovereign God of the Bible.

Yet the splendor of the earth is only part of God's creation, and to view it by itself is to see it dimly. For mirroring the perfect world of God is the perfect Word of God, which reveals the perfect love of God in Christ, who is the true foundation of all things. Hence, by the brilliant light of His Word, God has graciously illuminated His creation so that all may see and know and enjoy Him in it.

As a landscape photographer I am blessed to work in "nature's gallery," where the art of God is on permanent display. There I have enjoyed many worshipful hours contemplating the splendor and purpose of His creation and the words of Isaiah 6:3: "Holy, holy, holy is the LORD Almighty; the whole earth is full of His glory" (NIV).

The Art of God was born in the spirit of that worship—to share my joy in experiencing the world He has made, to encourage us to see and glorify Him in it, and to faithfully obey His mandate to care for it.

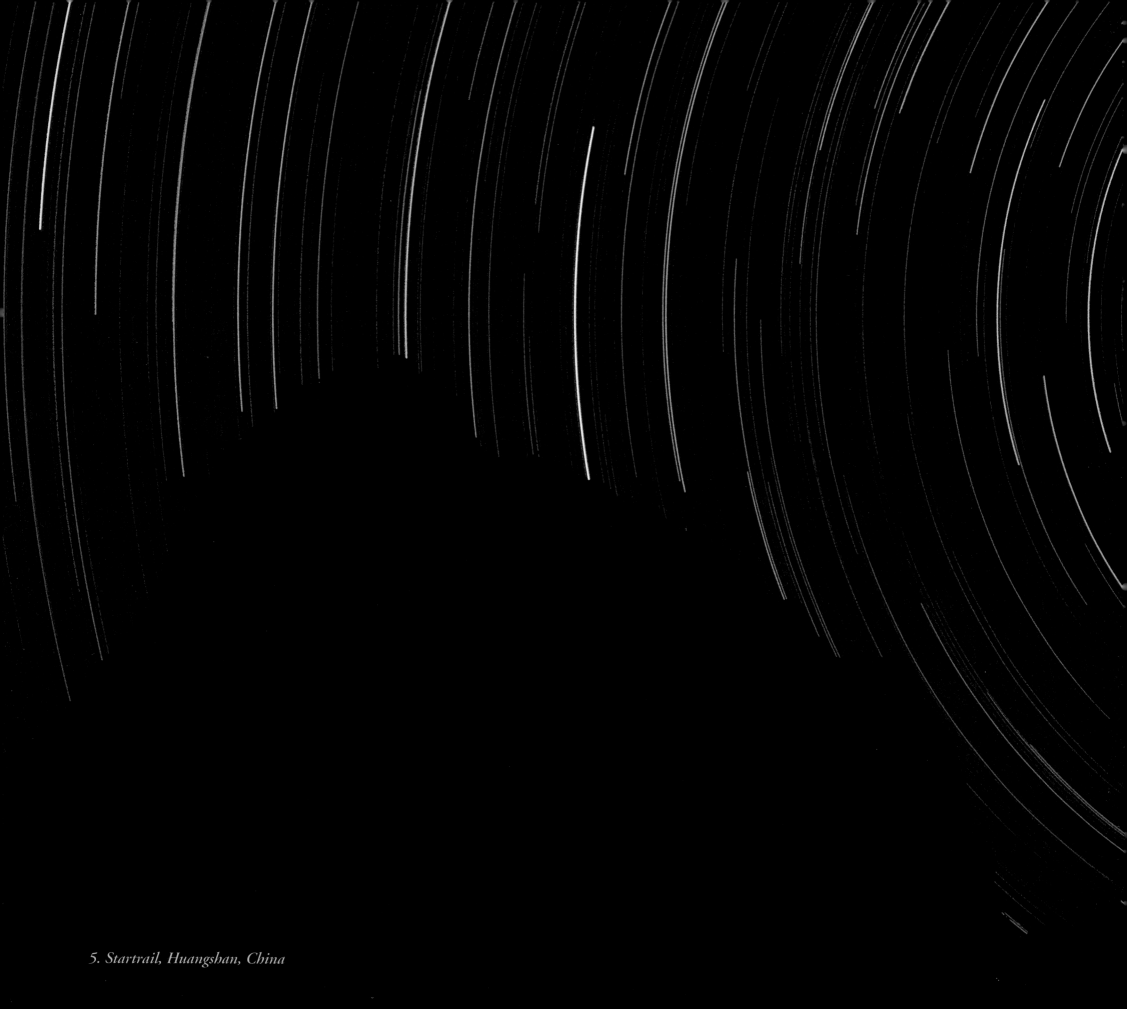

5. Startrail, Huangshan, China

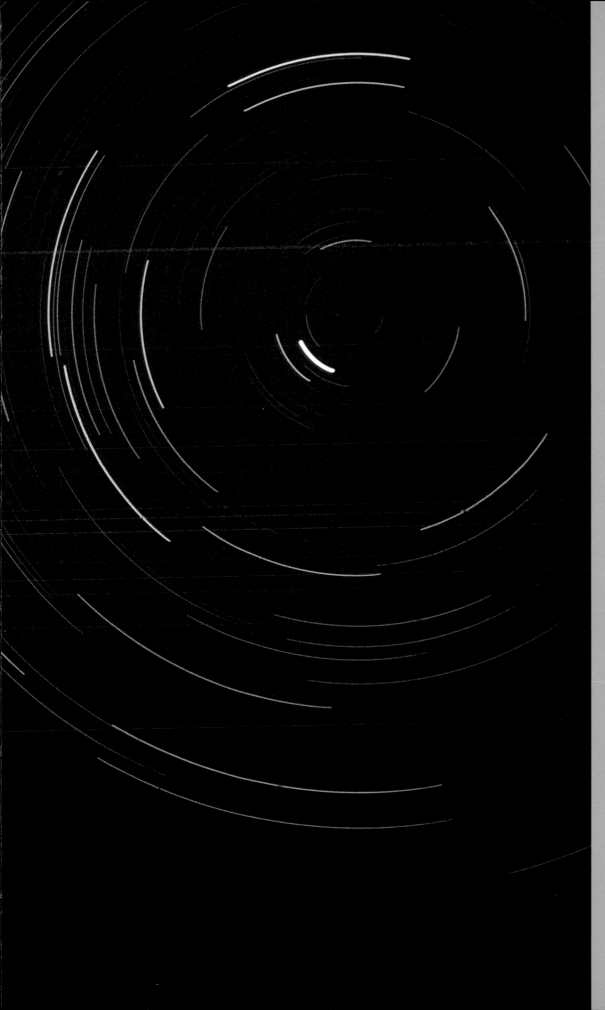

INTRODUCTION

When I consider Your heavens, the work of Your fingers, the moon and the stars, which You have ordained, what is man that You are mindful of him, and the son of man that You visit him? PSALM 8:3-4

13

The seed for this book was sown in my childhood on long summer nights out under the stars. I didn't know it then, of course, or realize that the seed was being watered by those wonderful lazy evenings with my friends. Then there was only the moment, and no better way to spend it than lying on a soft bed of grass, covered by a blanket of warm night air, gazing at the heavens and pondering the eternal riddles of life.

How far is infinity? How long is eternity? How many grains of sand are there on all the beaches in the world? If light from the nearest star takes a thousand years to reach the earth, how do we know that the star is still there?

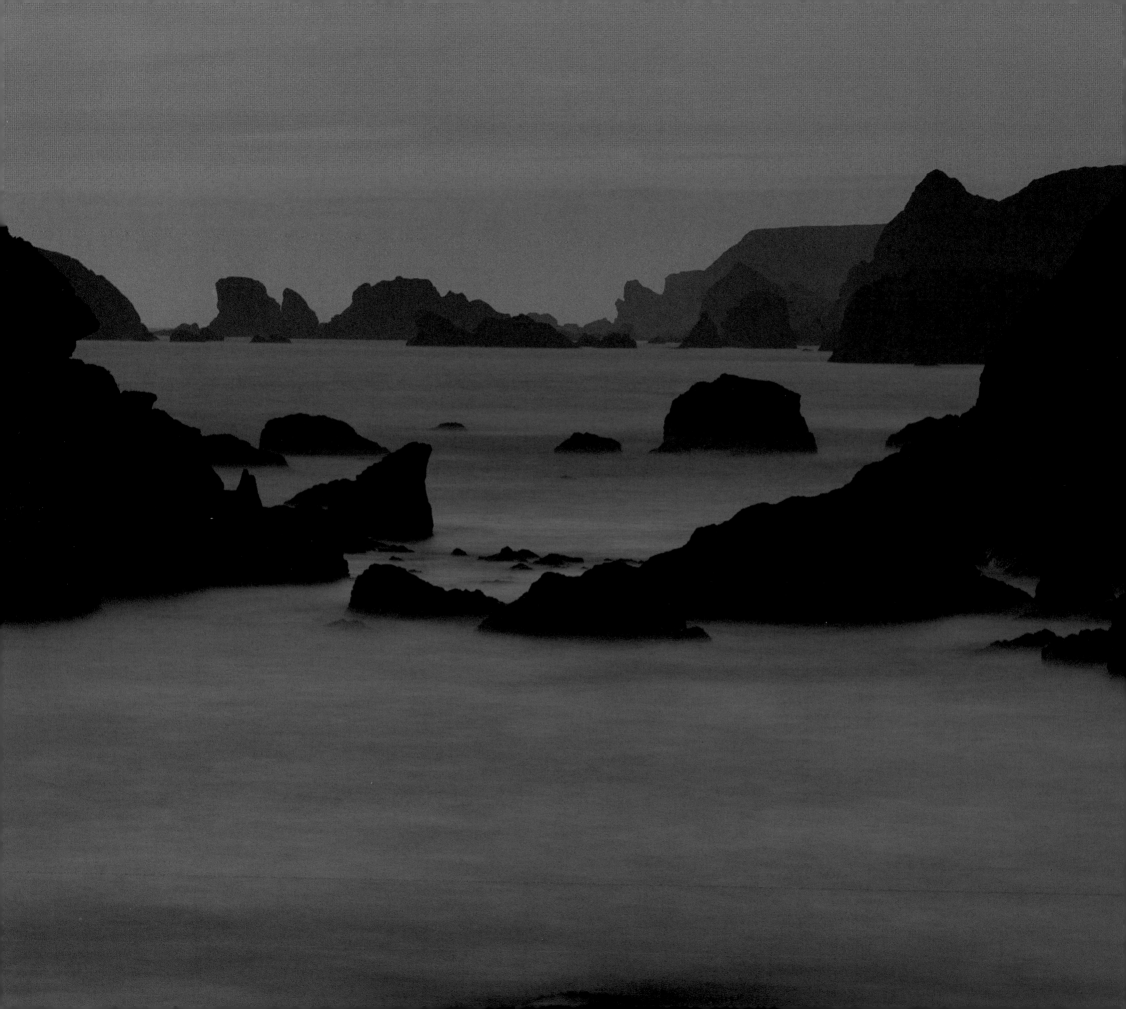

Over and over we would pose and ponder the questions, then discard them in frustration until the very next night, when we would ask them all over again. Our minds raced but never got to the finish line; like all who had pondered the riddles before, we had no answers, only questions.

But based on everything that we saw and considered—from the perfect detail of a tiny flower to the vast sweep of the heavens above—one thing seemed clear: we were but a very small piece of a very big puzzle, and the Maker of that puzzle was an all-powerful and unfathomable God.

Childhood summers soon faded into adolescent memories, and the big questions of life were replaced by smaller questions of self-interest. My gaze turned inward and my view of God grew dim as faith born of natural observation was exchanged for scientific dogma learned by rote. Seeking to please my teachers and avoid the ridicule of peers, I dutifully parroted Darwin's mantra and denied God the glory of His creation. New discoveries would often rip embarrassing holes in the fabric of macroevolutionary theory, but my pride kept me from seeing the philosophical nakedness they revealed. I simply trusted that science would patch the holes and validate my belief. But it didn't. The holes kept getting bigger, requiring narrower blinders and greater faith to avoid seeing the obvious.

Then, in the mid-eighties, some major changes in my life reopened my eyes to God:

my father died, the focus of my work shifted from travel to nature, and I began reading the Bible. Gently but steadily the blinders were pulled back, until I could no longer deny the truth before me: the perfection of everything in the heavens and on earth could only have come from the mind of an all-knowing, all-powerful, all-loving Designer, and never from an eternity of time plus chance.

This discovery was not my doing; it was by the grace of God alone. For as my boyhood observations made clear, the evidence had been in front of me all along. But in my rebellion I was simply unwilling and unable to see it until God opened my eyes (Ephesians 2:4-5).

Freed from spiritual blindness, I clearly saw the true state of my knowledge: what I thought I knew I didn't, and what I didn't know was infinitely greater than I had thought. Lacking in my knowledge of nature were its cause and reason for being; apart from that understanding, all of my learning was but a collection of useless facts. Like a clock outside of the realm of time, it was ultimately meaningless.

The information I lacked was not hard to find; it had been in front of me most of my life. However my pseudo-intellectual pride had not allowed me to seriously consider it. For the understanding I sought was not to be found in scientific journals or the writings of men; rather, it was in the Bible, the Word of the living God. And when I began to earnestly study it—not just looking at an occasional verse or two—my eyes were opened to a work of art so astonishingly complex and beautiful that it rivaled anything I had ever seen or photographed in nature. Indeed, I soon learned that the physical world and the written Word of God were so perfectly and intricately linked that it was impossible to truly know one apart from the other; they were two halves of the same creation.

This is the art of God that is the subject of this book—His perfect creation and blending of the natural world and His written Word into one seamless reality that reveals Him as the giver and meaning of life. To clearly see and fully appreciate the riches of His creation, however, we must dig deeply into Scripture and study its use of symbolism and typology. For by using the

15

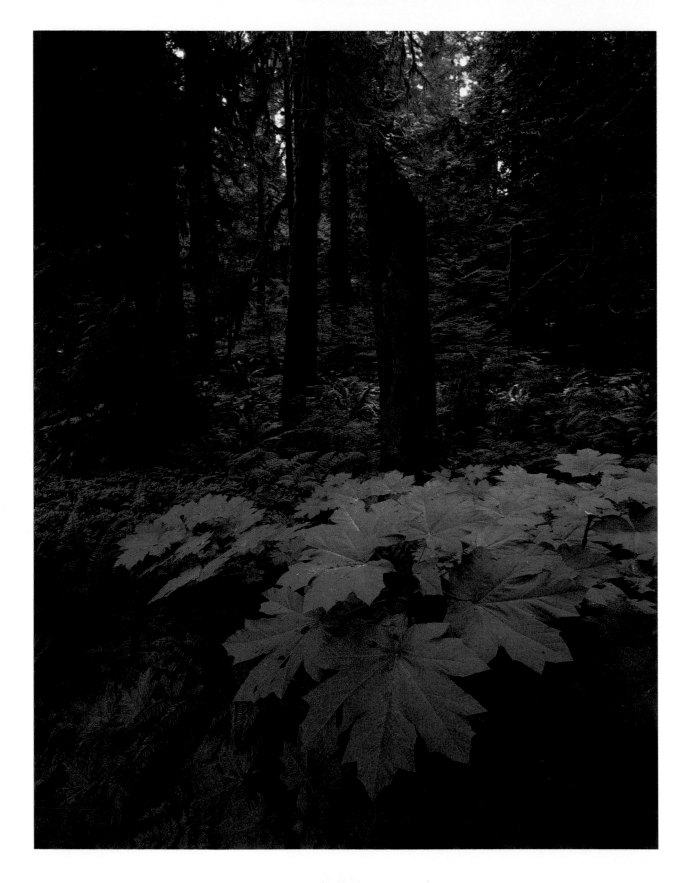

16

I will lift up my eyes to the mountains; from where shall my help come? My help comes from the LORD, who made heaven and earth.

PSALM 121:1-2, NASB

visible and temporal things of the earth to describe the invisible and eternal truths of His Kingdom, God has graciously enabled us to know Him better, and to see and understand our world and ourselves through new eyes.

To see and experience the beauty of nature is a wonderful thing. But to see and experience the beauty of God *through* nature is infinitely more wonderful. The former is His good and gracious gift to all people, but the latter is reserved for those who seek Him and faithfully study His Word. I pray that you may know this great joy and that this book will encourage you to that end.

8. Old Growth Forest, Washington 9. Teton National Park, Wyoming

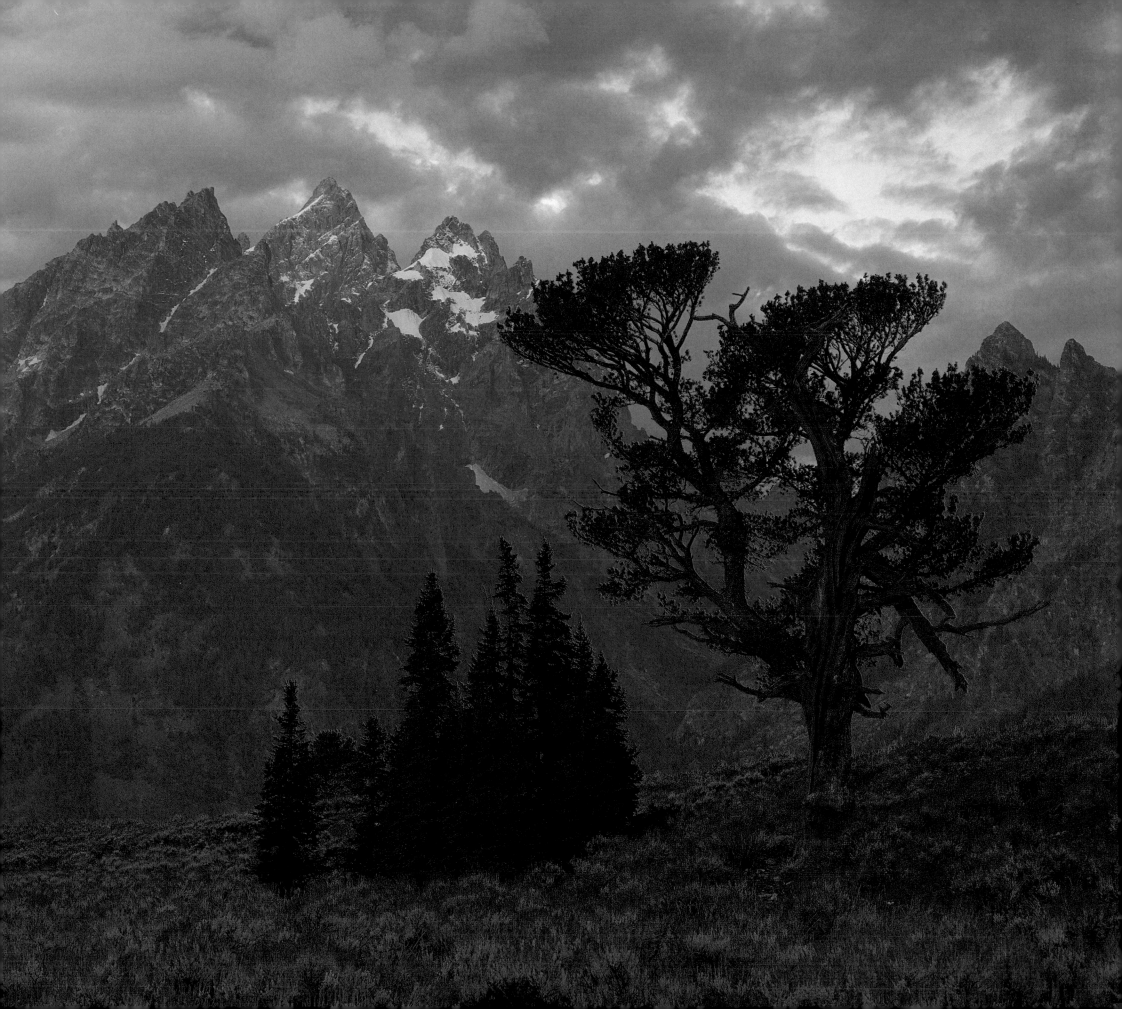

10. Del Norte Coast, California

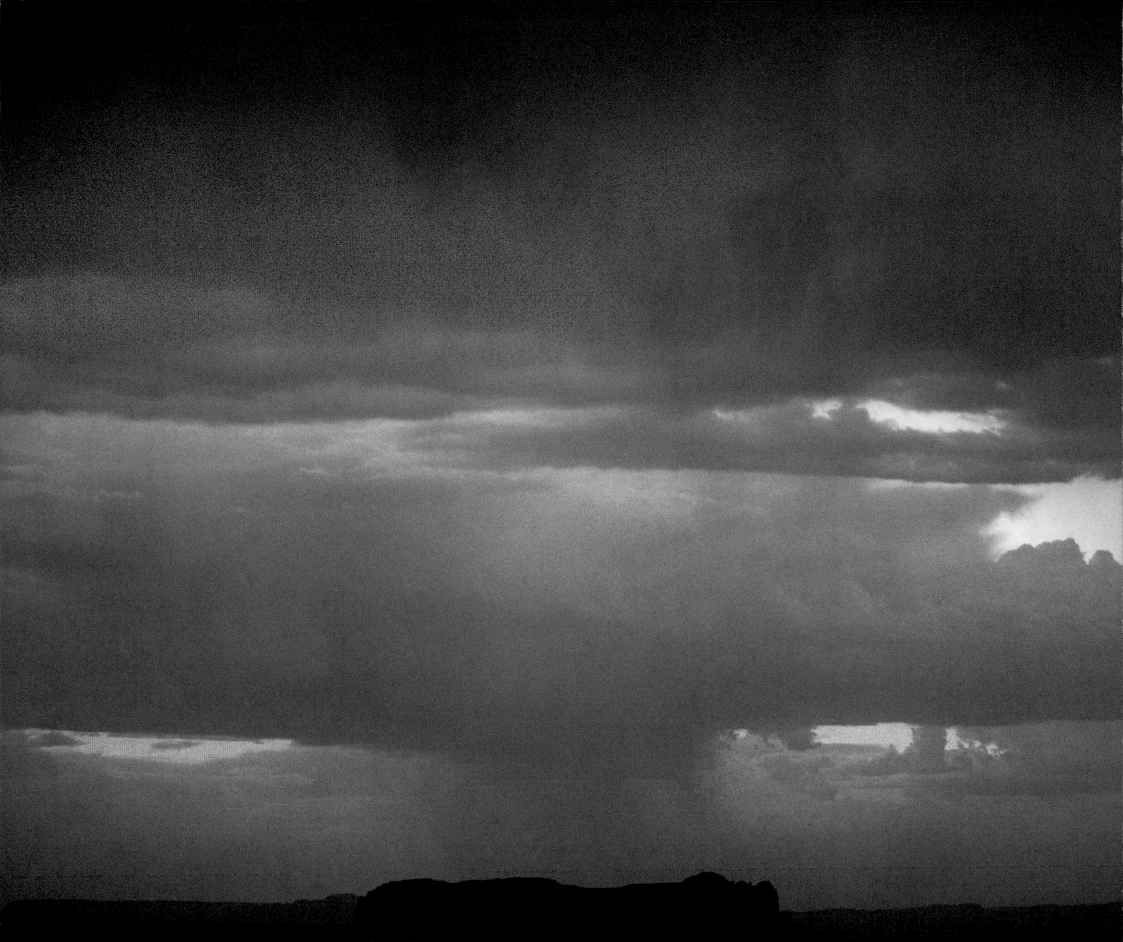

By faith we understand that the worlds were framed by the word of God, so that the things which are seen were not made of things which are visible. HEBREWS 11:3

The art of God was created by the Word of God, spoken outside of time and space, possessing the inherent power to bring forth visible physical matter from invisible spiritual energy. Hence, all that exists, from the whole of the cosmos to its subatomic particles, bears the clear impression of God.

This is unequivocally stated by the apostle Paul in Romans 1:20: "For since the creation of the world God's invisible qualities—his eternal power and divine nature—have been clearly seen, being understood from what has been made, so that men are without excuse" (NIV). Yet it is the natural response of mankind to ignore this truth and to deny God credit for His creation.

The root of this blindness is the human desire for autonomy, aided by the fact that God is the only Artist shown in the gallery. Because *all things* are the work of His hands, and nothing exists that He has not made, it is commonplace for us to take God's art for granted, or even to believe the critic who says it's really not art at all, but rather something that just happened—a serendipitous accident that simply stumbled into existence through a mindless meeting of time and chance.

Were this said of the Mona Lisa or the Sistine Chapel we would think it totally absurd. Why then, when even the simplest molecule in nature is infinitely more complex and perfect than these masterworks by da Vinci and Michelangelo, do we give less credence to the higher art form and spurn its Designer and Creator? Perhaps we need to take a closer look at the art of God before blindly accepting the critic's opinion of its origin and meaning.

The proper starting place for a visual study of the art of God is with its basic components or elements. And, as our concern is more with art than science, we will use the classical poetic model of air, fire, water, and earth to guide us through the exhibit.

From the beginning of time the art of God has displayed His infinite power and glory. With His Word and with light He has illuminated it for us to see and enjoy and understand. Now, using those same elements, we will take a closer look at its perfections.

11. Sunset Storm, Southern Utah

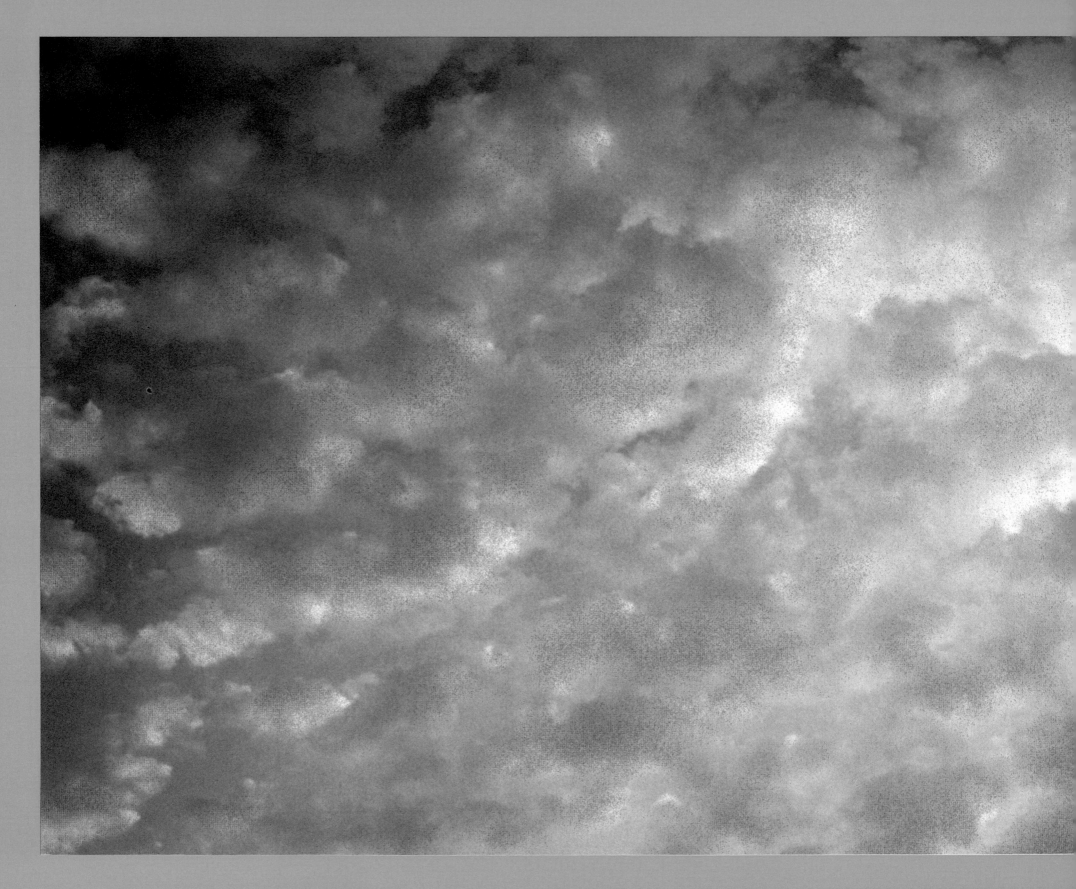

22

12. Sunrise Clouds

The wind blows where it wishes, and you hear the sound of it, but cannot tell where it comes from and where it goes. So is everyone who is born of the Spirit. JOHN 3:8

Using the natural characteristics of air to illustrate the supernatural attributes of God, the Bible frequently associates His presence with phenomena such as light, wind, clouds, rainbows, or thunder. Most prominent of these is the glory cloud of God, which is symbolic of His heavenly dwelling place. During the Israelites' exodus from Egypt, "the Lord went before them by day in a pillar of cloud to lead the way, and by night in a pillar of fire to give them light" (Exodus 13:21).

In Genesis 2:7 the creative activity of the Holy Spirit is identified as the breath of God who breathes life into man. And when Adam's sin brings death upon all his descendants, God graciously sends His Spirit again in the breath of Christ (John 20:22) and as a "rushing mighty wind" at Pentecost (Acts 2:2) to bring new life to those who believe in the name of His Son.

Just as air is essential for our physical life, so the Holy Spirit—the life-giving breath of God—is essential for our spiritual life.

23

24

Air has no color, yet the most spectacular colors in nature are seen in the sky. This is due to water droplets and impurities that act as tiny mirrors, prisms, or sponges reflecting, refracting, or absorbing different wavelengths of sunlight. Because the visible spectrum contains millions of colors, the display possibilities are virtually endless. At sunrise and sunset, when the oblique rays of the sun travel through more of the earth's atmosphere, the shorter blue wavelengths of the spectrum are absorbed, and red or yellow clouds result. At midday when the sun is perpendicular to the earth, the red wavelengths are absorbed, and the sky appears more blue.

13. Fire in the Clouds 14. Summer Sky 15. Sunset Cloud

*Do you know how the
clouds are balanced, those
wondrous works of Him who
is perfect in knowledge?*

JOB 37:16

We can't see it, feel it, hear it, or smell it, yet we would die in a matter of minutes without oxygen. We breathe it in and then breathe poisonous carbon dioxide out. Plants breathe the carbon dioxide in and then breathe oxygen out. Round and round it goes in perfectly balanced order.

For water vapor to change from an airborne gas to liquid droplets, which are the building blocks of clouds, it must first bond with microscopic particles in the air. These tiny nuclei are usually particles of salt lifted into the air with evaporating ocean water. Thus the salt in seawater, which makes it undrinkable, is an unexpected helper in supplying freshwater for the earth.

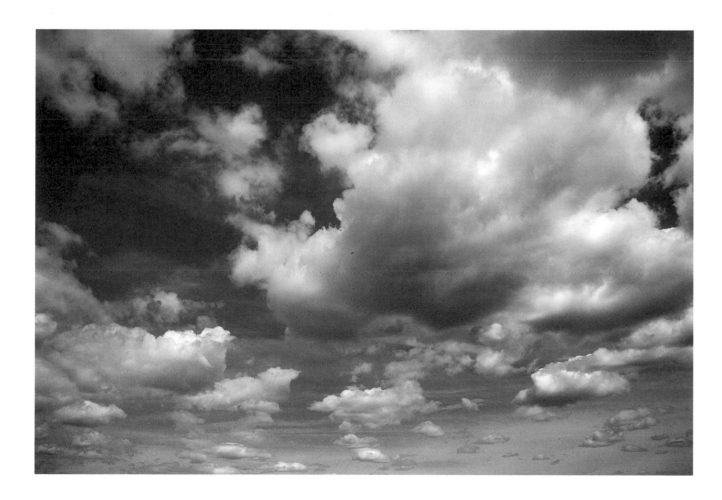

The most dramatic cloud displays frequently occur in late afternoon on hot summer days. As surface air is heated by the sun-warmed earth, it becomes lighter than the cool air aloft, and it rises and expands in a convectional current. If the lift is strong enough and ample water vapor is present in the expanding air (as is common in the plains), it will rapidly condense into clouds that can often build into huge cumulonimbus thunderheads, sometimes reaching heights as great as sixty thousand feet above their bases. Often occurring at the end of the day and reflecting the colorful light of sunset, these clouds present a glorious and fitting symbol of God's heaven.

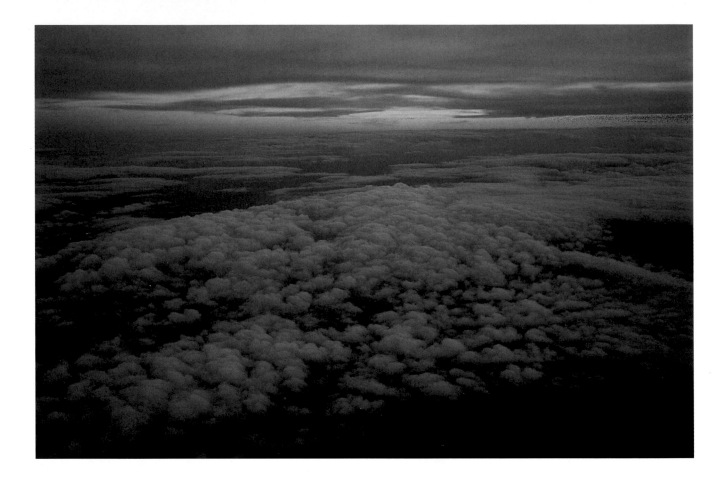

O Lord, our Lord, how excellent is Your name in all the earth, who have set Your glory above the heavens!

Psalm 8:1

16. Dawn Sky 17. Above the Clouds 18. Boiling Storm Clouds

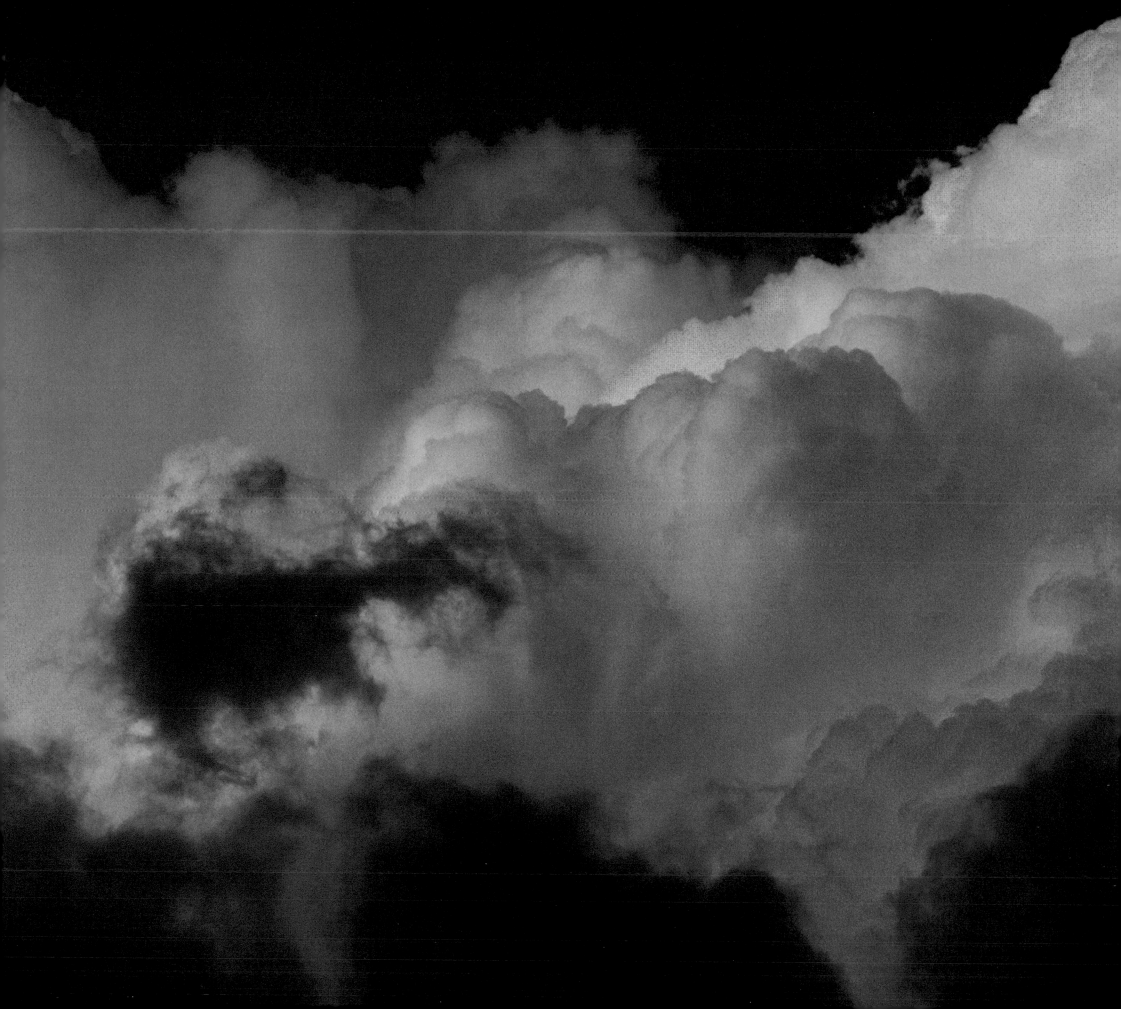

28

19. *Flowing Lava, by Rik Cooke*

The mountains melt like wax at the presence of the LORD, at the presence of the Lord of the whole earth.

PSALM 97:5

Fire is frequently used in the Bible to describe God's appearances, attributes, blessings, and judgments. He appeared to Moses "in a flame of fire from the midst of a bush" (Exodus 3:2); He went before the Israelites "by day in a pillar of cloud to lead the way, and by night in a pillar of fire to give them light" (Exodus 13:21); and He appeared as a "consuming fire on the top of the mountain" when He gave them His law at Mount Sinai (Exodus 24:17).

Malachi describes the coming Christ as "a refiner's fire" (Malachi 3:2); John the Baptist says, "He will baptize you with the Holy Spirit and fire" (Luke 3:16); and when the Holy Spirit was given to the apostles at Pentecost, He came in the form of "tongues, as of fire" (Acts 2:3).

Hebrews 12:29 tells us that "our God is a consuming fire," whose final judgment of those not in His Book of Life is the lake of fire (Revelation 20:15).

29

30

O Lᴏʀᴅ my God,
You are very great:
You are clothed with
honor and majesty,
Who cover Yourself with
light as with a garment,
Who stretch out the
heavens like a curtain.
He lays the beams of
His upper chambers
in the waters,
Who makes the clouds
His chariot,
Who walks on the wings
of the wind,
Who makes His angels
spirits, His ministers
a flame of fire.

Psᴀʟᴍ 104:1-4

20. Mt. Etna, Sicily 21. Pacific Sunset, Southern California

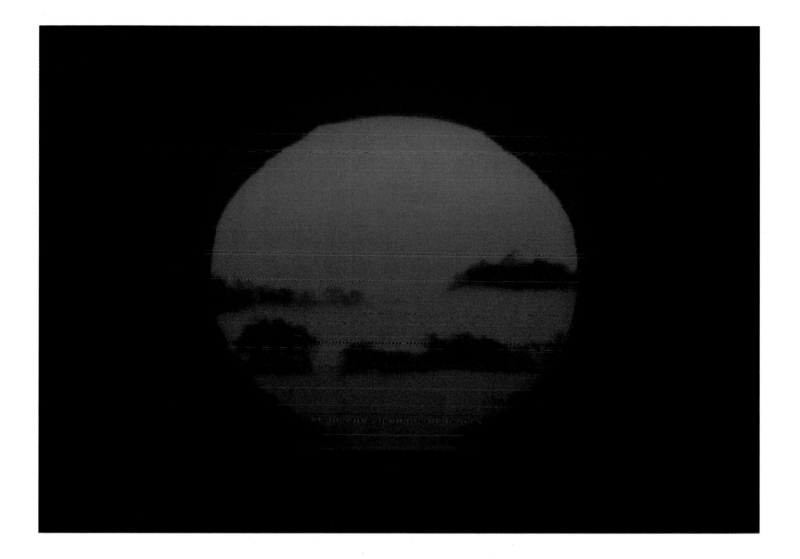

The vast majority of our heat is produced by the sun, a fiery furnace with an estimated core temperature of 27 million degrees. Yet only about one two-billionth of its energy reaches the earth. The rest is lost in the 93 million miles of space that separate the sun from the earth.

Only a medium-sized star in the Milky Way galaxy, the sun is still more than a hundred times larger than the earth. The largest stars, however, are a thousand times bigger than the sun, or big enough to fill the space between the sun and the earth. The closest star beyond the sun is over 25 trillion miles away—so far that it would take the fastest jet over a million years to get there. The most distant stars are more than a billion times farther than that.

The Milky Way is one of approximately 100 billion galaxies. The next closest galaxy is 160 thousand light-years away, and the farthest galaxies are billions of light-years from it. And beyond those galaxies, outside of the realms of space and time and yet throughout it all, is the Spirit of the living God. (Deuteronomy 10:14; 1Kings 8:27; Nehemiah 9:6; Psalms 113:4-6; 139:7; Isaiah 40:22, 26; 57:15; 66:1-2; Jeremiah 23:23-24; Acts 7:49-50; 17:24-28).

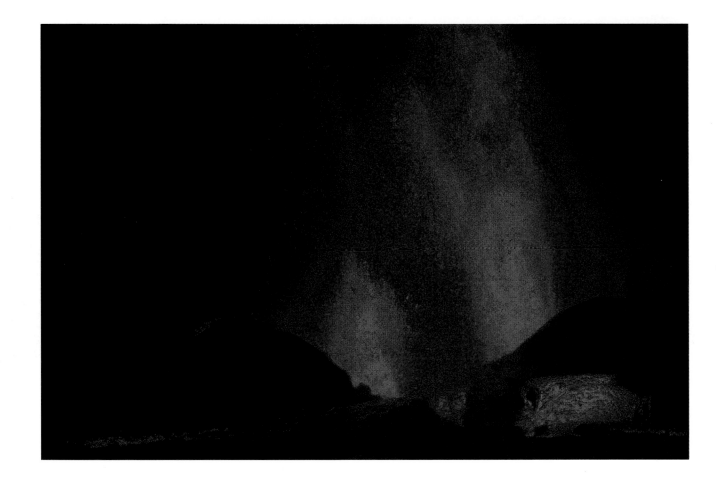

32

Occasionally I've been privileged to have a close-up view of God's mighty power in nature. The 1971 eruption of Sicily's Mount Etna provided one of those moments, when a truck-sized boulder was swept into the river of lava only fifty feet in front of me. Skidding over the fiery current like a small cork bobbing in a stream, it suddenly burst into a brilliant flame, then melted like wax into the flow. Such visions are a humbling reminder of David's question in Psalm 8:4: "What is man that You are mindful of him, and the son of man that You visit him?"

The mountains will melt under Him, and the valleys will split like wax before the fire, like waters poured down a steep place.

Micah 1:4

22. *Lava Fountain, by Rik Cooke* 23. *Mt. Etna, Sicily*

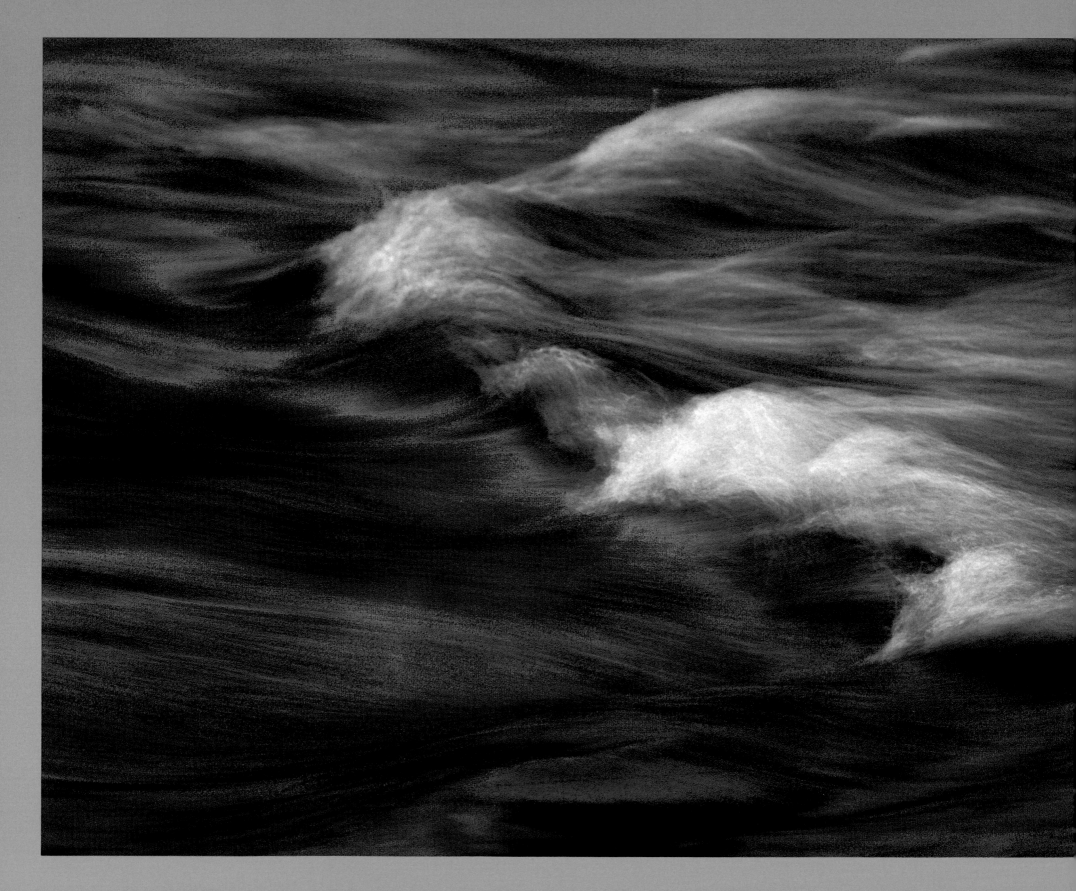

34

24. *Merced River Gold, California*

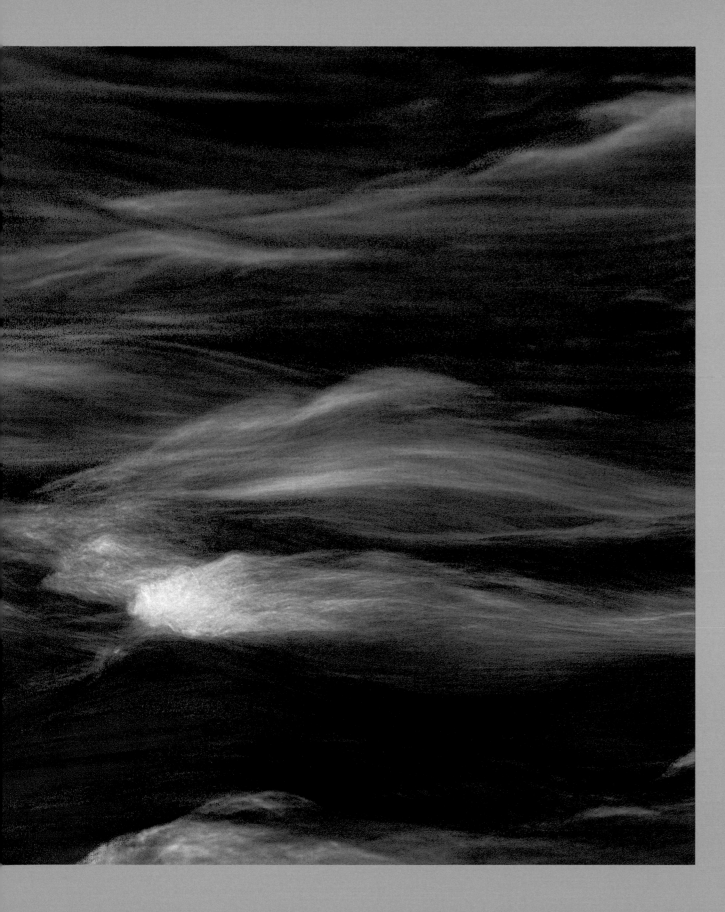

Jesus answered, "Most assuredly, I say to you, unless one is born of water and the Spirit, he cannot enter the kingdom of God."

JOHN 3:5

Earthly life cannot exist without water, and water is most frequently used in Scripture to symbolize God's free gift of eternal life.

As the recipients of God's Word, the ancient Hebrews were well versed in the meaning of its symbolic imagery. This is why Jesus rebuked Nicodemus as a teacher of Israel for not understanding His words about the source of eternal life (John 3:10).

Isaiah used water to signify God's free, gracious, and bountiful salvation (Isaiah 11:9; 32:2; 41:18; 55:1; 58:11) and the absence of water to symbolize separation from His blessings (Isaiah 3:1; 50:2).

The vivid imagery in Ezekiel's vision of the river flowing out from God's temple (Ezekiel 47:1-12) is a depiction of His Spirit spilling out to the ends of the earth, bringing life wherever it goes. As the temple is, in part, a symbol of paradise, this river also looks back to the rivers of Eden (Genesis 2:10-14) and forward to the river of life in the heavenly new Jerusalem (Revelation 22:1-5).

35

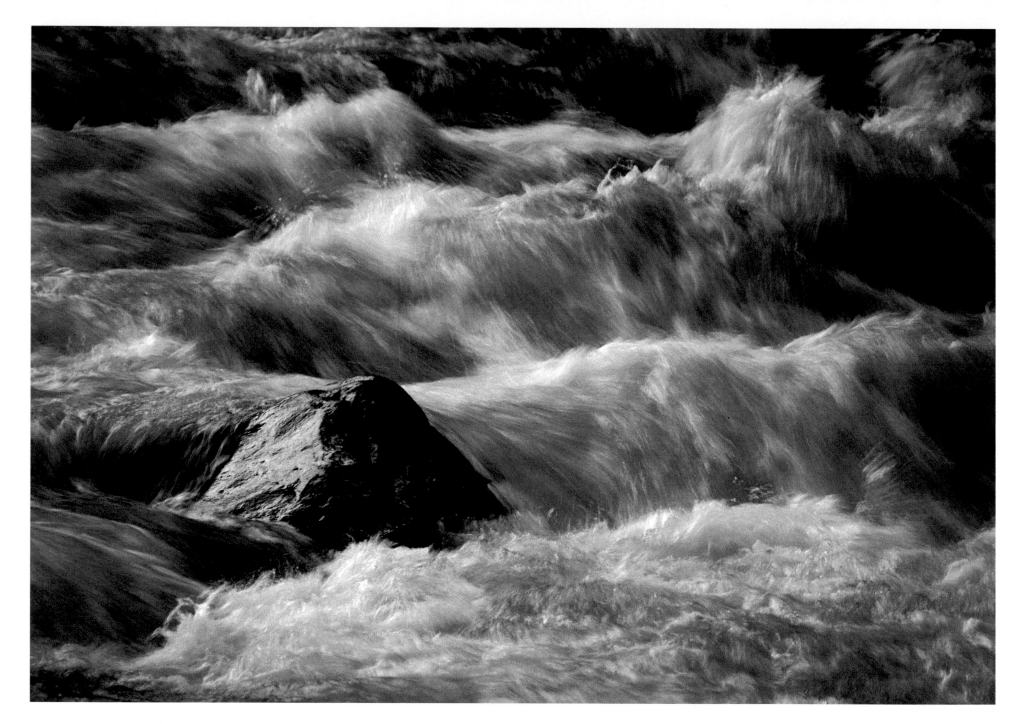

36

He who believes in Me, as the Scripture has said,
out of his heart will flow rivers of living water. JOHN 7:38

25. *Chujenzi River, Japan* 26. *Lostine River, Northeast Oregon* 27. *Proxy Falls, Oregon Cascades*

Covering more than 70 percent of the earth's surface, water is the most basic and vital element in nature. Although it is so common that we rarely think about it, there is no substance in creation with more amazing or important properties. Without it there would be no life on earth, for every living thing is largely made of water and requires its unique properties to function.

One of these vital qualities is water's extraordinary heat capacity, or its ability to absorb great amounts of heat without significantly increasing its own temperature. To illustrate this, if the same weight of water and iron are cooled to absolute zero (minus 460 degrees Fahrenheit) so that no heat remains, and equal energy is then applied to both substances, when the iron starts to melt at 2,370 degrees the water will only have reached 32 degrees. Thus, the oceans absorb and release heat from the sun more slowly than does the land, and onshore breezes bring warmth to the land in winter and coolness in the summer.

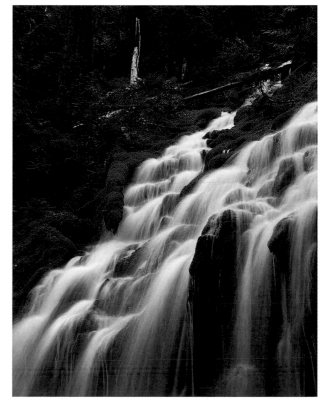

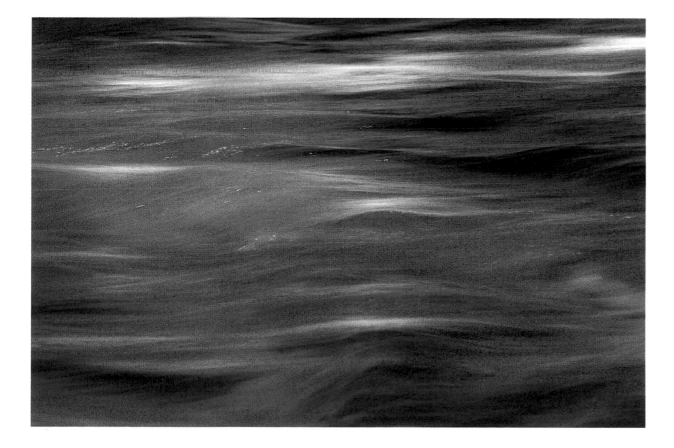

Another fascinating property of water is its expansion in cooling, which makes it less dense in its frozen state than in its liquid form. This unique characteristic allows ice to float, which is vitally important to all living things. For if ice sank to the bottom of lakes, rivers, and seas, it would gradually accumulate and lower the water temperature to a point that it could no longer sustain life. The earth would eventually freeze, and all life would cease.

Jesus answered and said to her, "Whoever drinks of this water will thirst again, but whoever drinks of the water that I shall give him will never thirst. But the water that I shall give him will become in him a fountain of water springing up into everlasting life." JOHN 4:13-14

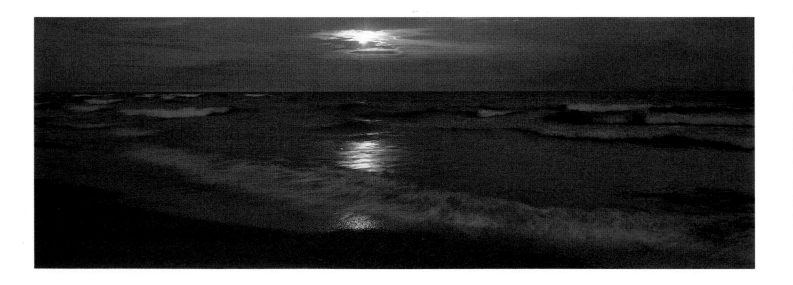

Water is liquid between 32 and 212 degrees Fahrenheit, and it is the only common substance that is liquid within the temperature range normally found on earth. If it behaved like its closest molecular relatives which are liquid between about 130 and 150 degrees below zero, there would be no liquid water—or life—on earth.

28. Lake Superior Sunset, Upper Michigan 29. McDonald River Detail, Montana 30. Deschutes River Blues, Central Oregon

Of old You laid the foundation of the earth,
and the heavens are the work of Your hands.

PSALM 102:25

31. Painted Hills, Central Oregon

He is the Rock, His work is perfect; for all His ways are justice, a God of truth and without injustice; righteous and upright is He.

DEUTERONOMY 32:4

We commonly think of rock as the solid foundational element of the earth, and it is most frequently used in the Bible to symbolize the strength, steadfast faithfulness, and unchanging nature of God (2 Samuel 22:2, 32, 47; Psalm 95:1; Isaiah 17:10; 44:8).

When Moses struck the rock that God stood upon at Massah, thus bringing life-giving water to the complaining and unbelieving Israelites (Exodus 17:5-7), the rock was symbolic of God and it prefigured Christ, His incarnate and blameless Son who endured the punishment of the cross for the sins of the world (1 Corinthians 10:4).

41

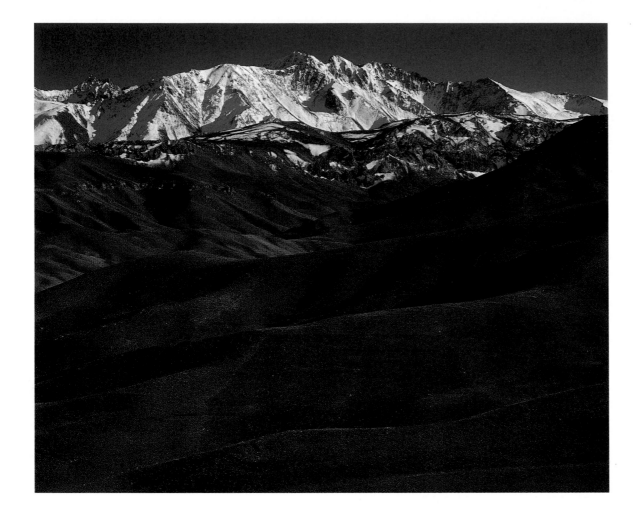

42

In His hand are the deep places of the earth; the heights of the hills are His also. The sea is His, for He made it; and His hands formed the dry land. PSALM 95:4-5

At ground level where our perspective is limited by the horizon, the elevation range between the world's lowest and highest points seems great. Yet compared to the earth's circumference, it is almost too small to measure— so small, in fact, that it is accurately represented by the thickness of the cover paper on a common twelve-inch globe.

32. Hindu Kush Range, Bamian, Afghanistan 33. View from Steens Summit, Eastern Oregon 34. Monument Valley Monolith

43

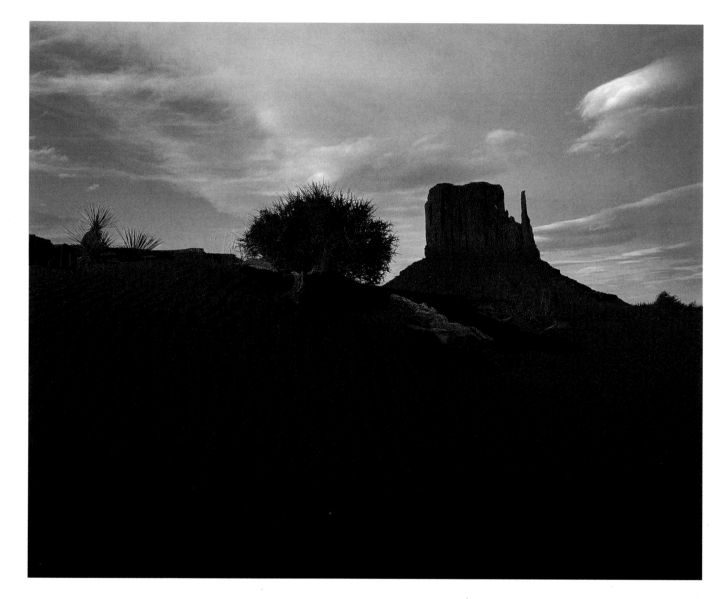

He has made the earth by His power; He has established the world by His wisdom, and stretched out the heaven by His understanding. Jeremiah 51:15

35. South Mitten, Monument Valley, Arizona 36. Canyonlands Overview, Southern Utah

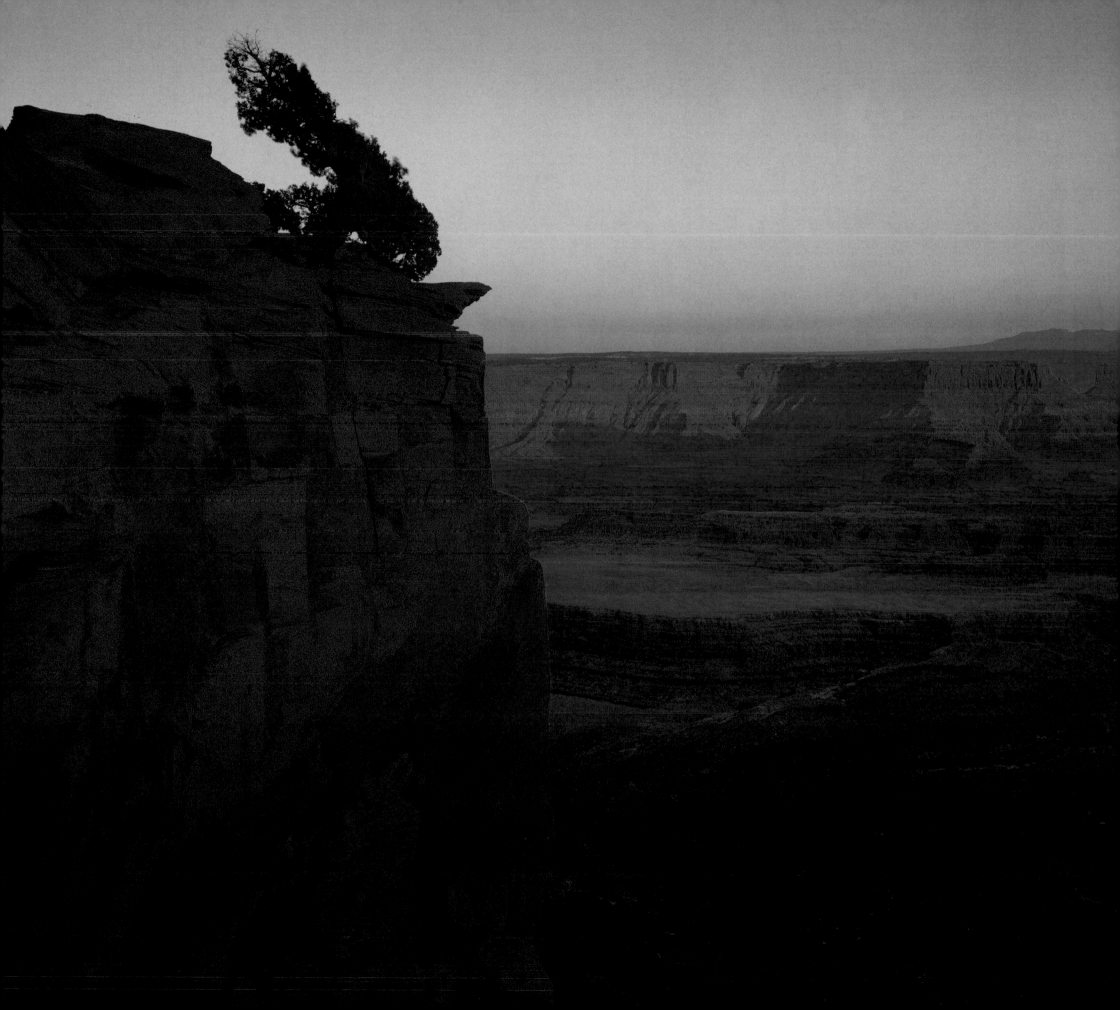

37. Rock, Sand & Wind, Olympic National Park, Washington

Design

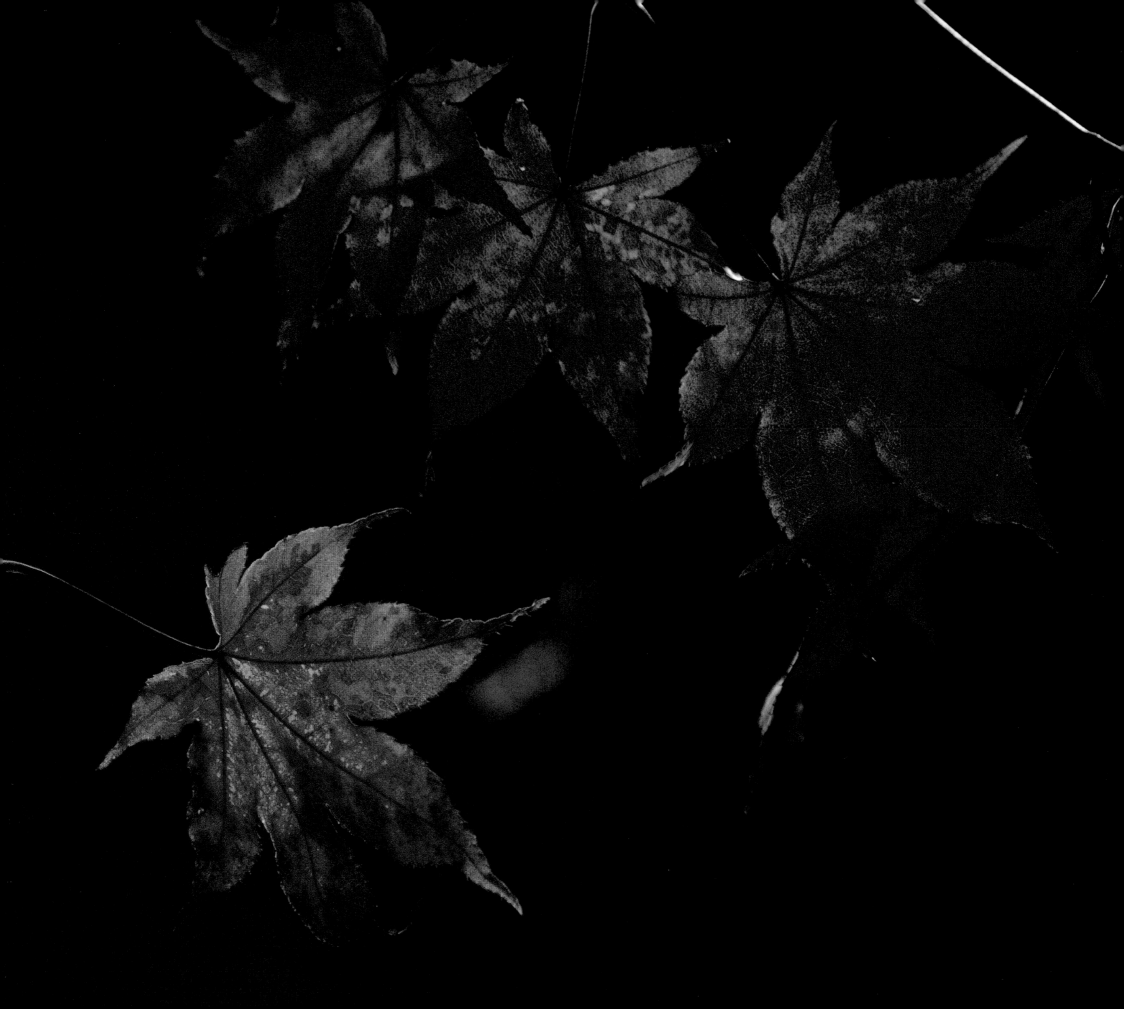

The heavens declare the glory of God; the skies proclaim the work of his hands.
Day after day they pour forth speech; night after night they display knowledge.
There is no speech or language where their voice is not heard.
Their voice goes out into all the earth, their words to the ends of the world.

<div align="right">PSALM 19:1-4, NIV</div>

What may be known about God is plain to us, because God has made it plain to us (Romans 1:19). "Ask the beasts, and they will teach you; and the birds of the air, and they will tell you; or speak to the earth, and it will teach you; and the fish of the sea will explain to you. Who among all these does not know that the hand of the LORD has done this?" (Job 12:7-9).

All design is born of a purpose, and the purpose of the world's design is to reveal God. We know this because He has told us so in His Word, which is the other half of His creation. Nature, in all its splendor, is incomplete apart from a biblical reference point, and unless it is seen through the eyes of Scripture, it can only be seen dimly.

This is well stated by James Jordan in his book, *Through New Eyes*: "When we look at the stars, we imagine millions of suns very far away from us. There are Cepheid variables, double stars, neutron stars, galaxies, and quasars. In the Bible, however, stars are given as 'signs and seasons, and for days and years' (Genesis 1:14), 'because the heavens declare the glory of God, and the firmament shows His handiwork' (Psalm 19:1). While the biblical perspective does not invalidate telescopic investigation of the starry heaven, could it be that we are not seeing all we should see when we look at the stars? Do we need new eyes?"

The vision of secular science is poor, and the consequences of its faulty worldview are serious. Denying God, it has blinded itself to His revelation in nature, and limited its view to half-truth: it can see the world's form, but not its function. It understands *how* things work, but not *why* they work—that knowledge can only come from their Designer. Truth comes from the Spirit of truth (John 16:13), and in His light we see light (Psalm 36:9).

Because design requires a designer, and the perfect design of nature cannot be denied, secular science is faced with a dilemma: to grant nature's design, it must acknowledge God, and to claim it is an accident, it must deny reality. Its solution is to defy logic and hold to both premises by worshiping nature as a self-created god. Thus, it has "exchanged the truth of God for a lie, and worshiped and served the creature rather than the Creator" (Romans 1:25). We have paid dearly for embracing this blindness, letting our eyes be dimmed to the full glory of God's creation. But by focusing on both halves of the art of God, we may again see its beauty.

The visual design of God's art uses line, shape, form, texture, color, and pattern to convey its message. Moving from simple to complex, each adds a new dimension to its predecessor, giving more information to the overall design.

Before looking at the elements in God's earthly design, however, we must consider His design of the Bible. It is the key that unlocks our understanding of the full art of God.

49

I will establish My covenant between Me and you and your descendants after you in their generations, for an everlasting covenant, to be God to you and your descendants after you. GENESIS 17:7

50

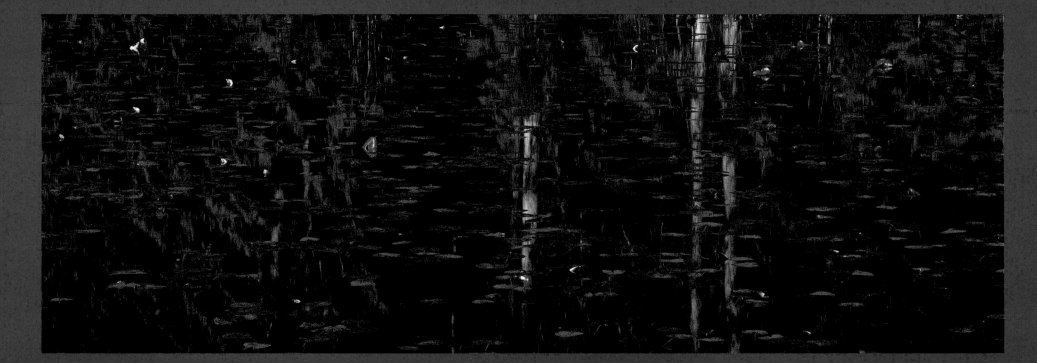

38a. Summer Pond, Oregon Cascades

The Bible's *purpose* is to glorify God. Its *goal* is to save His chosen people. Its *design* is to reveal Christ as the only means to that end. The Bible is able to give us "wisdom that leads to salvation through faith which is in Christ Jesus" (2 Timothy 3:15 NASB), and "there is no other name under heaven given to men by which we must be saved" (Acts 4:12 NIV). "All Scripture is inspired by God" (2 Timothy 3:16 NASB), and it has been flawlessly designed to accomplish its purpose and goal.

The scope of the Bible is vast and the diversity of its human authorship is great. In sixty-six books by thirty-six authors, written in three languages over sixteen-hundred years, it traces four-thousand years of history on three continents. Yet, despite its many voices, the Bible speaks in perfect harmony, as with one voice—the voice of God. "For no prophecy was ever made by an act of human will, but men moved by the Holy Spirit spoke from God" (2 Peter 1:21, NASB). The unifying element in the Bible's design is its repeating pattern of three themes: the holiness of God, the sinfulness of man, and God's redeeming grace through the atoning sacrifice of His sinless Son.

Of all God's perfections revealed in Scripture, only His holiness is elevated to the third degree: "Holy, holy, holy is the LORD Almighty; the whole earth is full of his glory" (Isaiah 6:3, NIV). His eyes are too pure to look upon evil (Habakkuk 1:13), and it is impossible for Him to ignore sin. Even an impure thought is evil in His sight, and His justice demands full punishment for sin.

When Adam broke the covenant of creation (Hosea 6:7), sin and death entered the world (Romans 5:12-14). As the father and spiritual head of the human race, Adam was also its representative before God. So when he disobeyed God (Genesis 3:6), the consequences of his unfaithfulness were borne by his entire seedline (Romans 3:10, 11, 23; 5:17; 6:23). The covenant penalty for Adam's sin was death (Genesis 2:17), which alienated man from God (Genesis 3:8) and sentenced him to return to the dust from which he was made (Genesis 3:19). All humanity was hopelessly separated from its Creator. With a dead spirit, a dying body, and a sinful nature, the seed of Adam now became the seed of the serpent—who is Satan—that Adam allied with in his rebellion in the Garden.

But in His curse upon the serpent, God showed mercy to a remnant of Adam's seed. By declaring that He would put enmity between the faithless seed of the serpent and the Seed of the woman (Genesis 3:15), God revealed that He would establish a faithful remnant. The division between the seeds began with Adam's sons, Cain and Abel, when "by faith Abel offered to God a better sacrifice than Cain" (Hebrews 11:4, NASB). Adam's seed was dead in sin, so Abel's faith had to come from God: "For by grace you have been saved through faith, and that not of yourselves; it is the gift of God" (Ephesians 2:8).

Cain and Abel were brothers, but they were of different seeds. Thus, seed is spiritual, not physical, and it is *seedline*—not *bloodline*—that defines the people of God. This is key to understanding God's curse upon the serpent and its role in the history of salvation. For not only did God declare a war between the faithless and faithful seeds of Adam, He decreed that the Seed of the woman would crush the serpent's head, but He would be bruised in doing so. Knowing the serpent is Satan, who was eternally defeated at the Cross (John 12:31), we know that the woman's Seed is Jesus Christ. Thus, in the curse, God foretold that He would pay the penalty for man's sin.

The perfection of the Bible's design is fully realized at the Cross, where all its themes converge and are resolved: God's holiness and justice are upheld; man's bondage to sin is broken; and Christ is exalted forever for His perfect obedience and love. From the curse to the Cross, man's salvation is entirely the work of the LORD. This is seen in the structure of His covenant of redemption, which we will consider in the pages that follow.

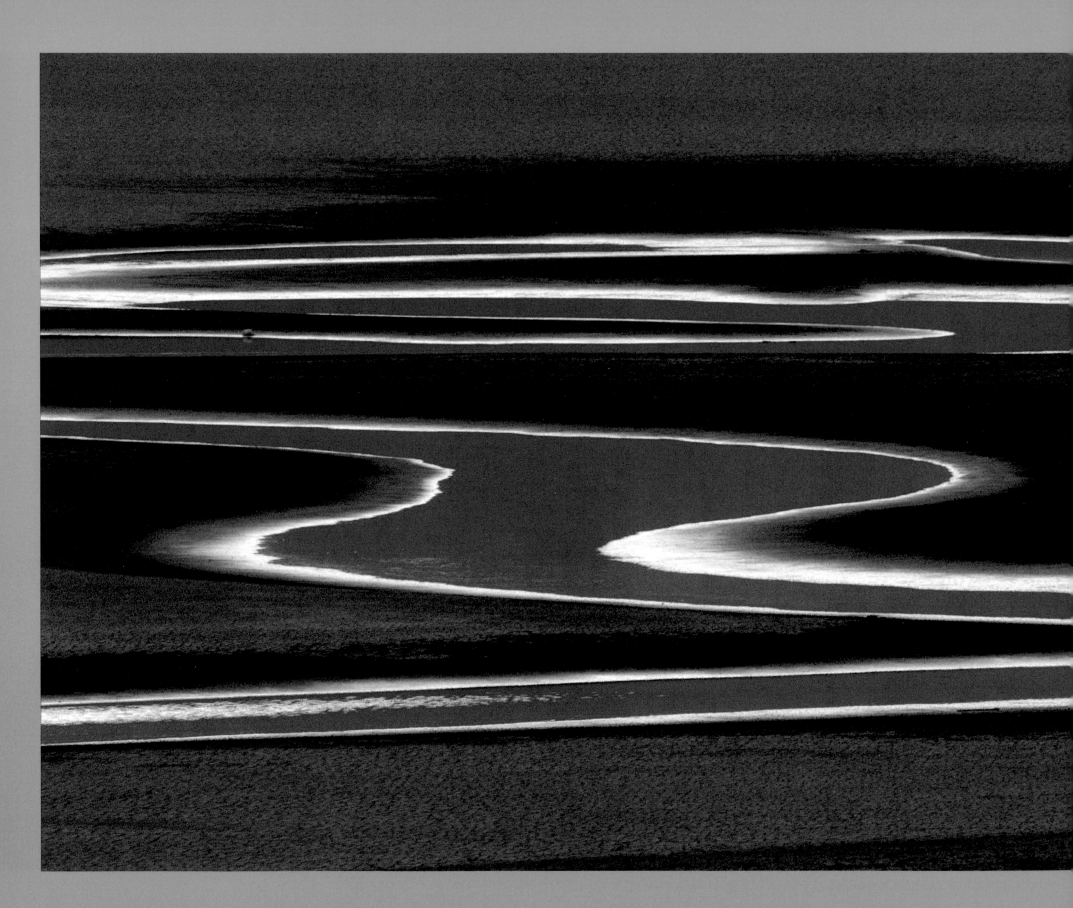

52

39. Snake River, Wyoming

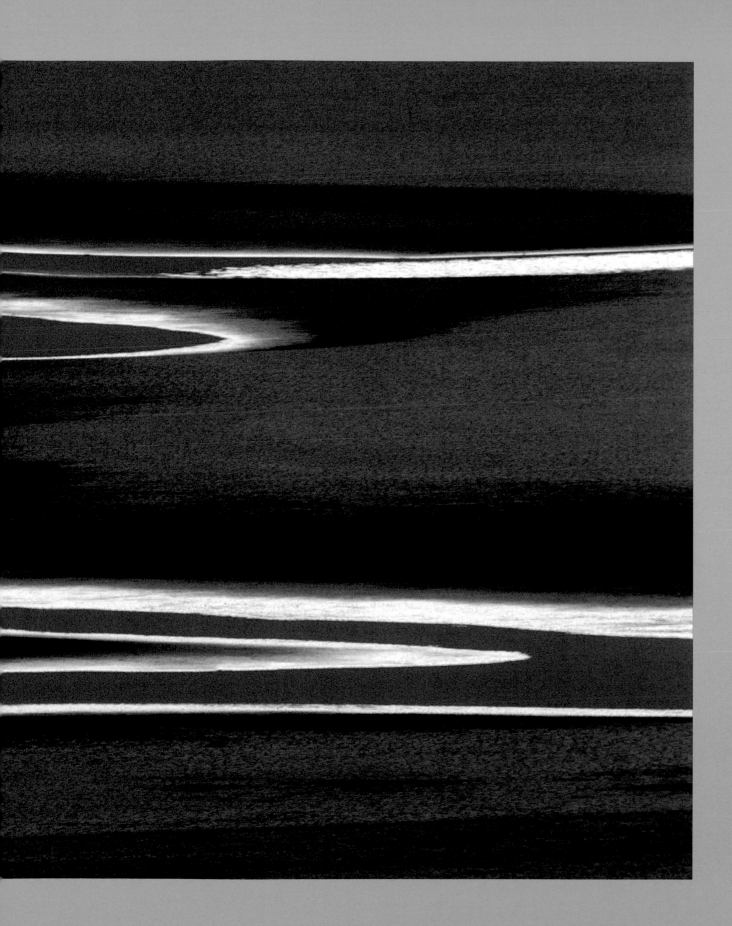

Line

Where were you when I laid the foundations of the earth? Tell Me, if you have understanding. Who determined its measurements? Surely you know! Or who stretched the line upon it? JOB 38:4-5

A line drawn in the sands of Eden and stretching to the end of time defines the beginning and end points of God's covenant of redemption by declaring a long-lasting holy war between the seed of the serpent and the Seed of the woman. The Seed of the woman (Christ) will crush the head of the serpent (Satan), but he will bruise His heel (Genesis 3:15). Within God's curse He shows mercy to the future family of Adam and Eve, declaring that One will come from the woman who will triumph over the enemies of God. That victory is ultimately realized at Calvary, where Christ is bruised by Satan at the cross but He rises truimphantly on the third day to crush Satan and his seed forever, and all authority in heaven and on earth are then given to Jesus (Matthew 28:18).

From the curse forward, the history of salvation is shaped by the growing enmity between the seeds, which is first seen in Cain's murder of Abel (Genesis 4:8), and then in the increasing wickedness of the entire human race (Genesis 6:5).

Continued on page 59.

53

Every good and perfect gift is from above, coming down from the Father of the heavenly lights, who does not change like shifting shadows. JAMES 1:17, NIV

54

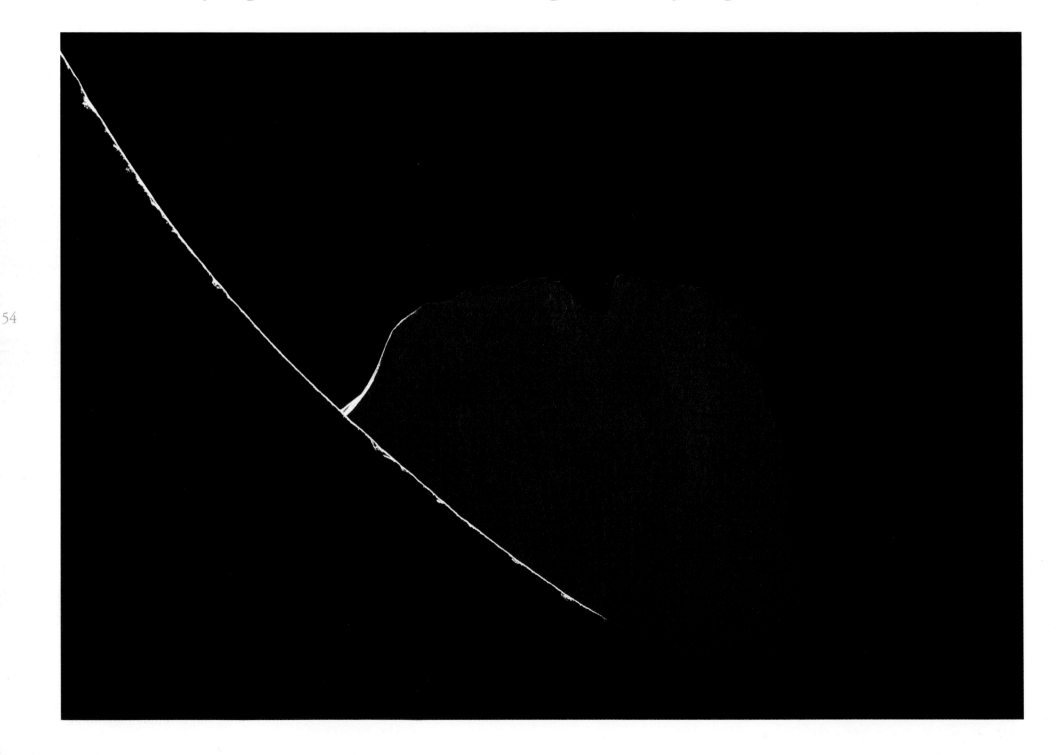

40. Edge of Light, Antelope Canyon, Arizona 41. Dunhuang Dunes, Western China

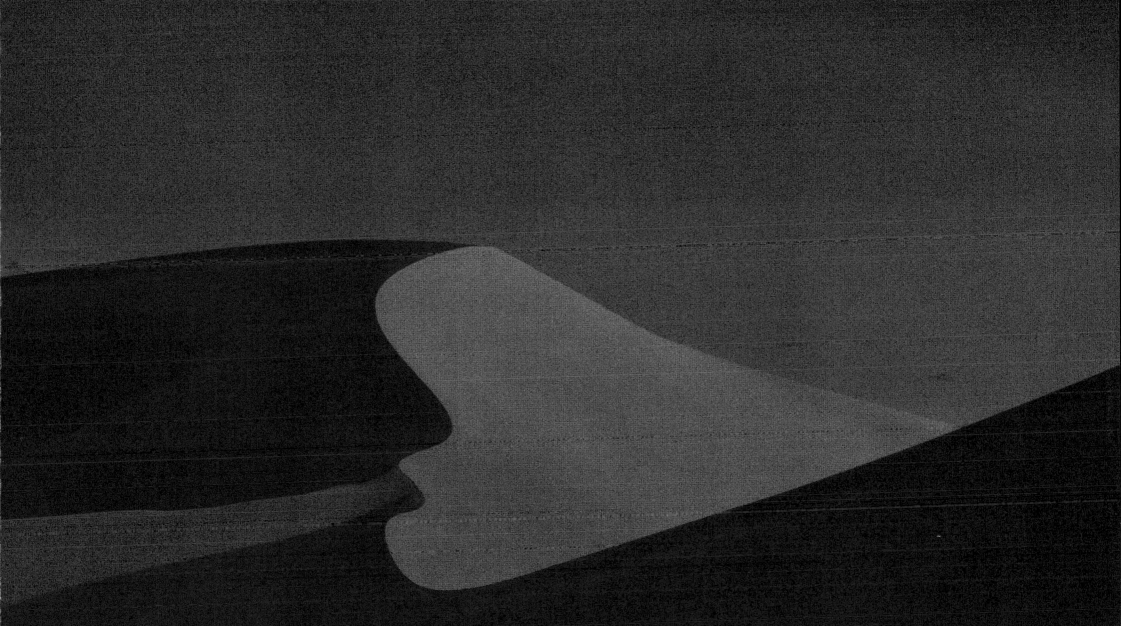

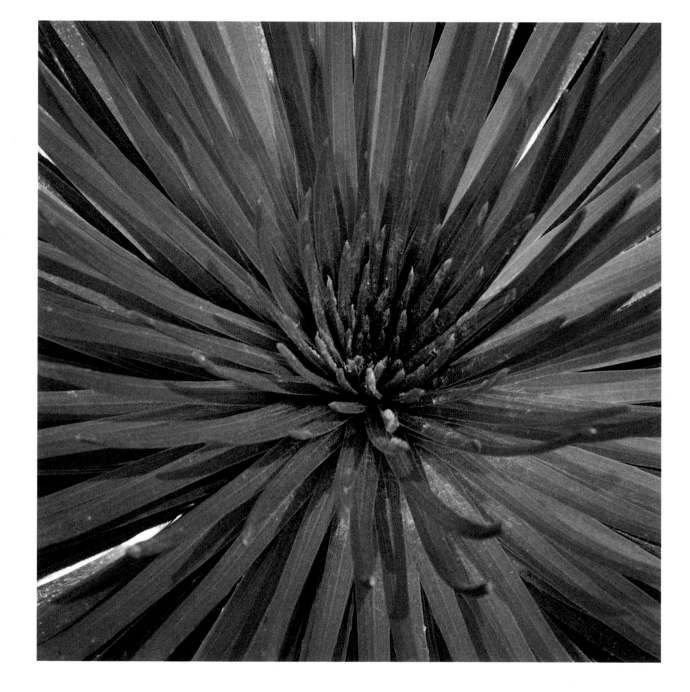

Great is our Lord, and mighty in power; His understanding is infinite.

PSALM 147:5

Line is the basic element of visual design: the continuous trace of a moving point—either straight or curved with no thickness or breadth—that connects two ultimate points. It is the foundational component that the other elements build upon to create the finished work, and it is a key factor in setting the overall tone or emotion of a piece.

Straight lines are usually static in character, angled lines are more dynamic, and curved lines tend to be restful. Examples of this expressiveness are seen in these pictures, as the angled lines of the silver sword evoke a sense of tension and the curved lines of the lily pond create a feeling of calm.

42. Silversword Detail, Hawaii 43. Reed Reflection, Montana

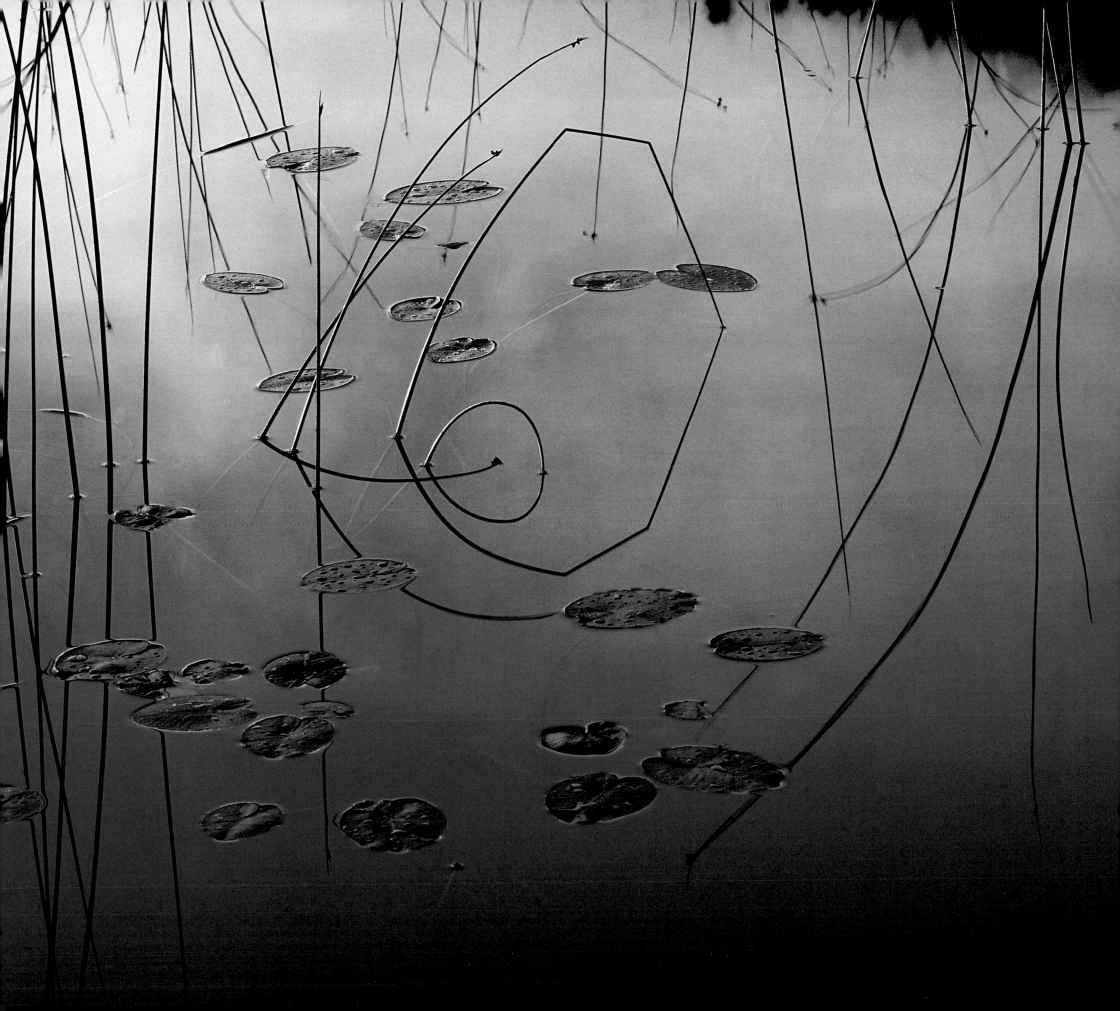

44. Sunrise, Monument Valley, Utah

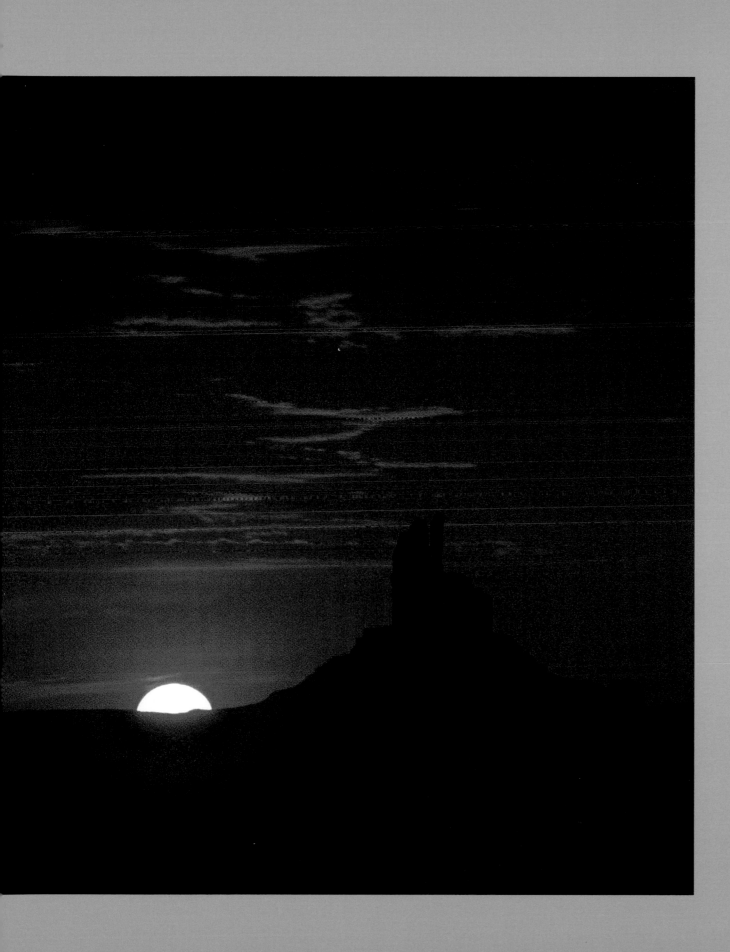

Then God said, "Let there be light"; and there was light. And God saw the light, that it was good; and God divided the light from the darkness.

GENESIS 1:3-4

Continued from page 53.

As contrast between light and dark sharply defines an object's visual shape, so God uses the same element to define the shape of the covenant line He has drawn at Eden. On one side of the line is the light of God's righteousness, and on the other side is the darkness of human sinfulness. The stark contrast between them defines the shape of the growing battle line between the seed of the serpent and the Seed of the woman.

In time, the wickedness on earth becomes so great that God judges the world with a mighty flood. "But Noah found grace in the eyes of the LORD" (Genesis 6:8), and God makes a covenant with him as a seed of the woman, perpetuating humanity through his family alone. Building on His covenant with Adam, with its decrees of fruitfulness and stewardship, God promises: to preserve the earth and all its vital cycles of life; to give man every living thing for food; and to demand the death penalty for murder, thereby saving humanity from self-destruction so God can continue His development of a more beautiful covenant form.

The war of the seeds rages on, and the faithful line of Shem is now chosen by God to carry His covenant blessing toward its ultimate fulfillment in Christ.

59

Continued on page 65.

The elements of design that we see in nature are revealed by the quality, quantity, and direction of light. This is especially apparent at sunrise and sunset, when the low angle of the sun puts the land into shadow while the sky remains light. The contrast in this situation is too great for the eye (or film) to resolve, and the resulting image is a silhouette of the earth's horizon, which outlines its shape.

60

Where is the way to the dwelling of light? And darkness, where is its place, that you may take it to its territory, that you may know the paths to its home? Do you know it, because you were born then, or because the number of your days is great? Job 38:19-21

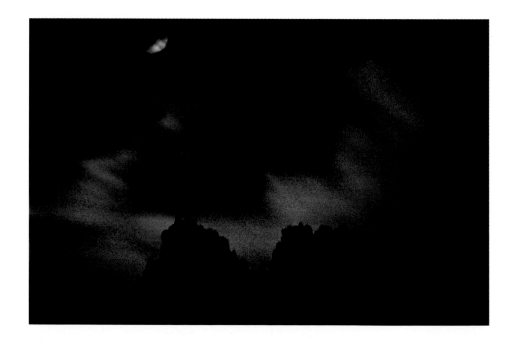

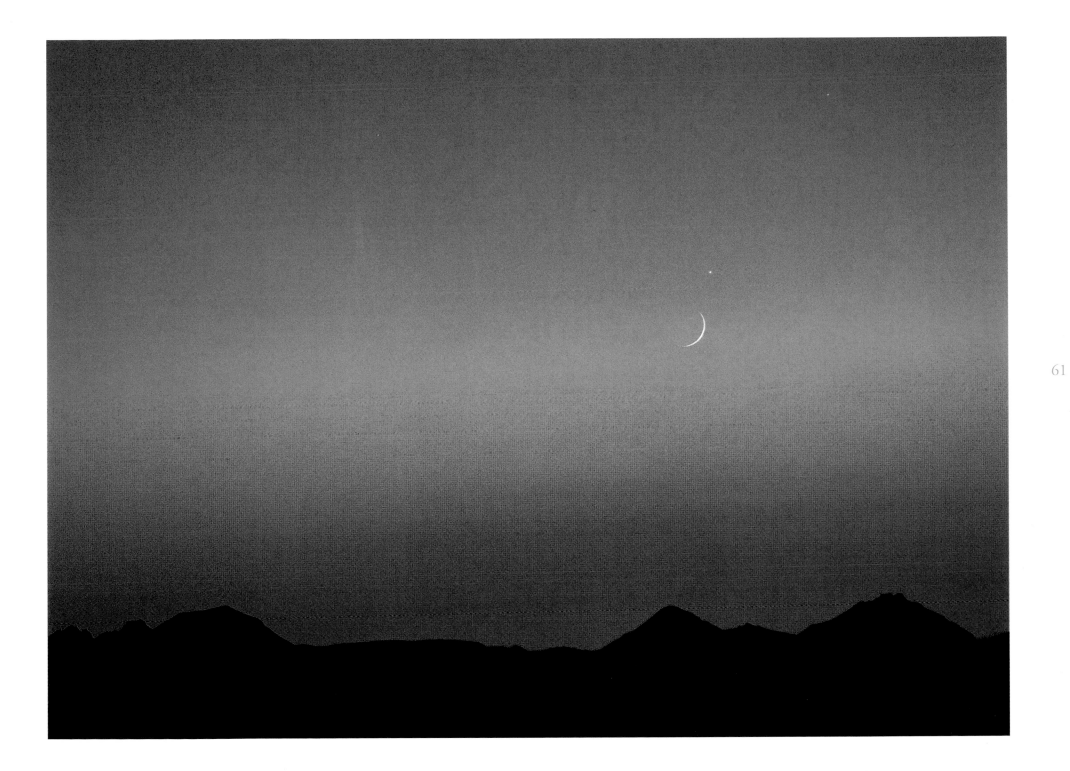

61

45. *Sunset Silhouette, Southern Oregon* 46. *Moonlight Silhouette, French Alps* 47. *Sunset Silhouette, Oregon Cascades*

When I want to emphasize a subject's shape, I frequently wait until sunrise or sunset to record the image. Low levels of light at the beginning and end of the day often limit visual information to light and shadow only, and the shapes of the earth's landforms are highlighted as they are silhouetted against the sky.

The striking similarity of shape in these geographically diverse subjects is emphasized by silhouette lighting. If more visual information were provided—revealing form, texture, and color—that emphasis would be greatly weakened.

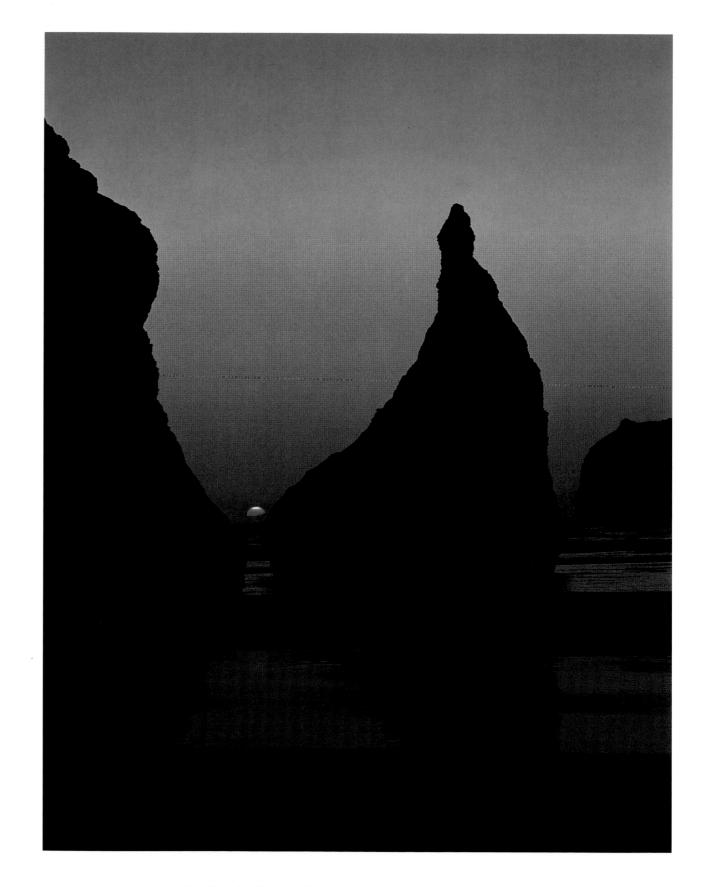

48. Face Rock Wayside, Oregon Coast 49. Rock Window, Monument Valley, Utah

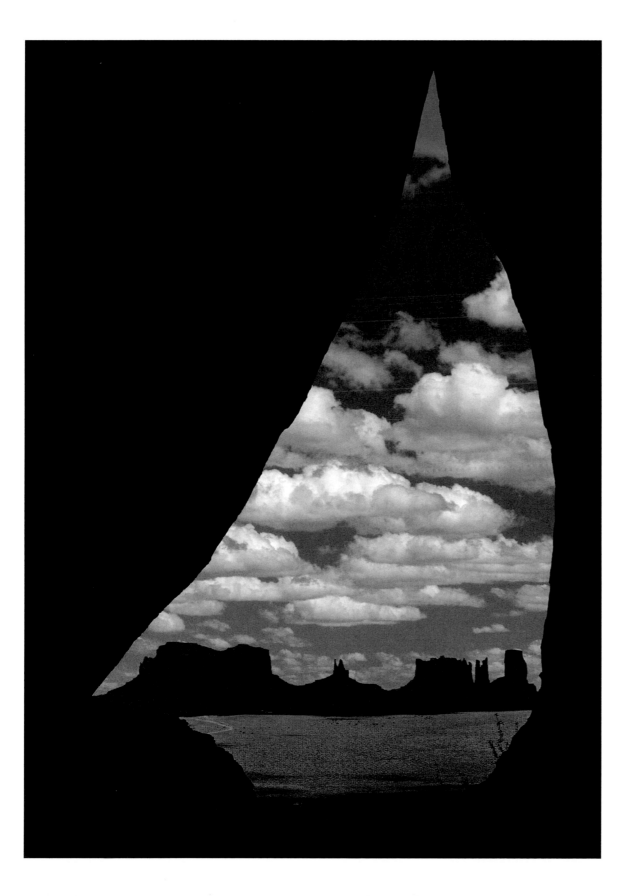

O Lord, how manifold are Your works! In wisdom You have made them all. The earth is full of your possessions.

Psalm 104:24

63

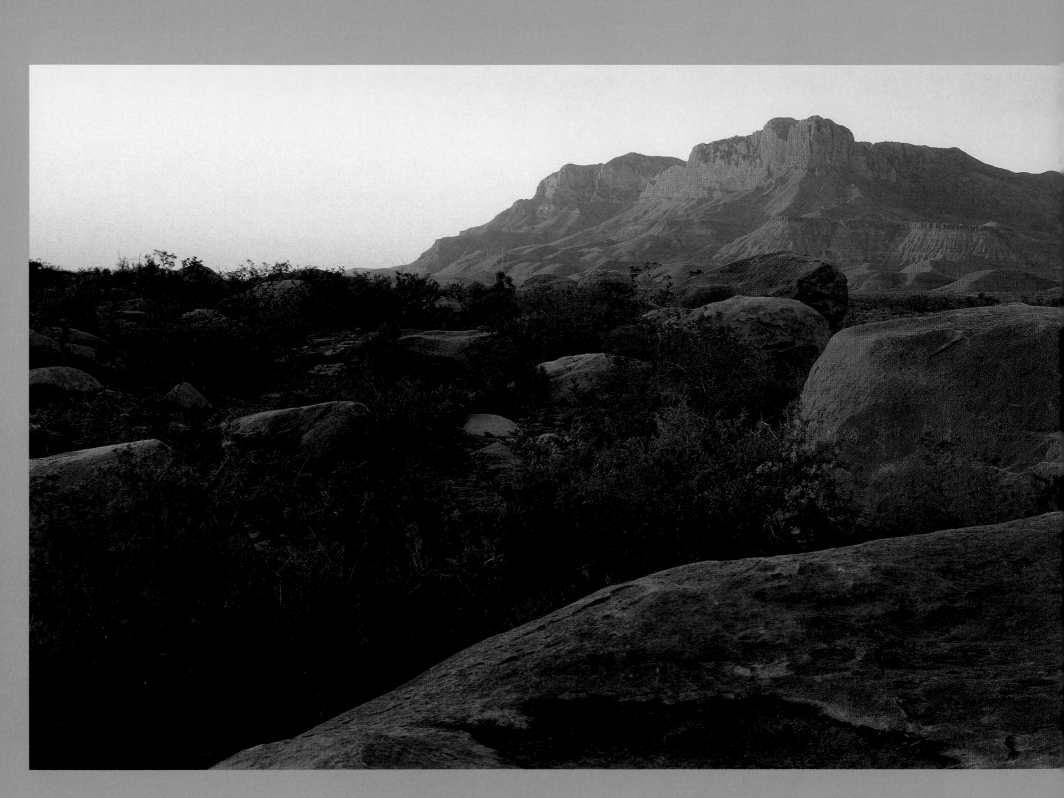

64

The LORD *lives! Blessed be my Rock!*
Let the God of my salvation be exalted. PSALM 18:46

50. Guadalupe Mountains, Texas

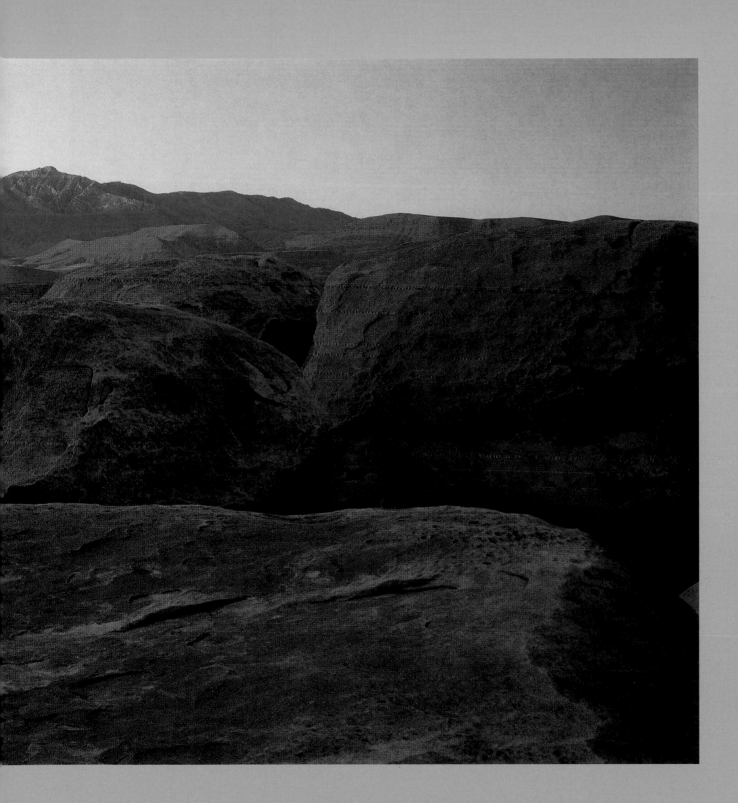

By wisdom the LORD laid the earth's foundations.

PROVERBS 3:19, NIV

Continued from page 59.

As shape adds dimension to line, so form adds depth to shape, progressively revealing a more complete picture. Likewise, it is the depth of God's promises to Abraham that reveals the future form of His unfolding work in salvation.

Continuing His covenant with the faithful seed of the woman, from Adam to Seth to Noah to Shem, God calls Abraham to be the one through whom God will redeem a people for Himself. In covenant with Abraham, God adds these promises to those He gave before: the inheritance of a glorious land; countless descendants, including kings, through whom all the families of the earth will be blessed (Genesis 12:1-3; 15:5; 17:6-7); and the assurance that He will be their God and they will be His people.

From Abraham on, the narrowing line and expanding scope of the woman's seed is defined by faith (Romans 4:13-25), as seen in the blessing of Isaac (Genesis 17:17-21) as heir to God's covenantal promise of a people and a land.

Continued on page 71.

65

Can you fathom the mysteries of God? Can you probe the limits of the Almighty? Job 11:7, NIV

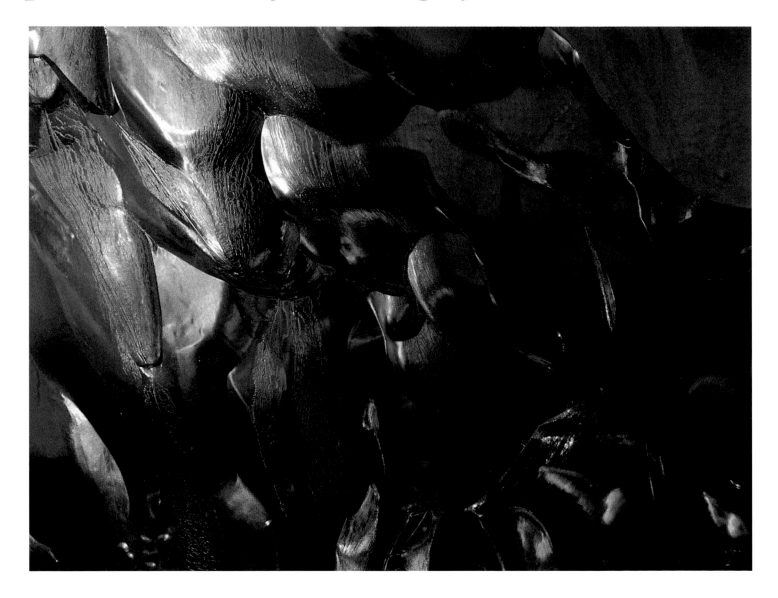

53. Iceberg Detail, Chile 54. Obsidian Detail, Oregon

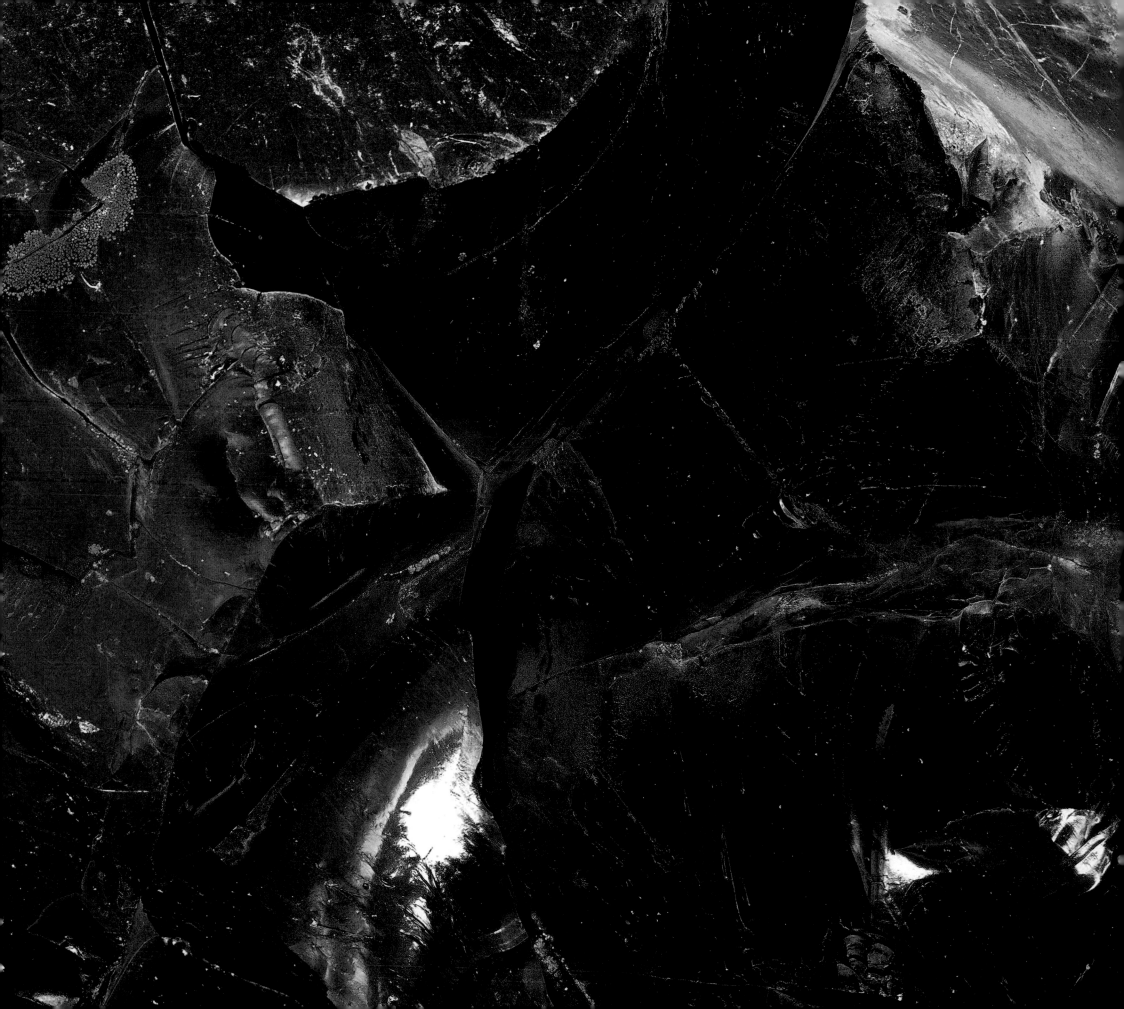

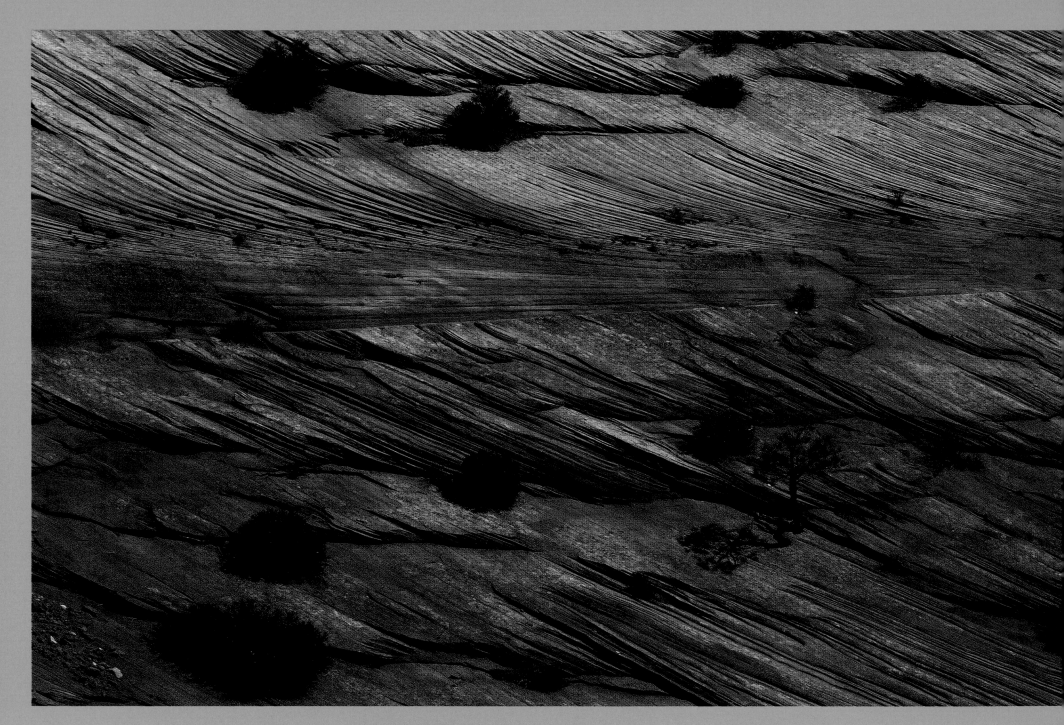

*The heavens are Yours, the earth also is Yours; the world
and all its fullness, You have founded them.* PSALM 89:11

55. Sandstone, Zion National Park, Utah

*I make known the end
from the beginning,
from ancient times,
what is still to come.*

ISAIAH 46:10, NIV

Continued from page 65.

Texture adds beauty and character
to form by increasing the detail in its design.
Similarly, after His covenant with Abraham,
God gives texture to its form by narrowing
the seed of the woman to the family of Jacob
(Genesis 25:23; 28:3-4)—called Israel—and
increasing them greatly during their four
hundred years of slavery in Egypt, as foretold
to Abraham in Genesis 15:13.

The LORD then calls Moses to lead
the Israelites out of Egypt to possess the land
of promise, and God judges the seed of the
serpent with mighty acts of power, as He
foretold (Genesis 15:14; Exodus 3:20).

After the Exodus God renews and
expands the Abrahamic covenant with Israel,
graciously dwelling among them and giving
them His law, so that they may be blessed by
keeping it. But their sinful nature makes this
impossible, revealing their need for a Savior,
who is the true Seed (Galatians 3:10-25) that
God promised in the Garden.

Continued on page 77.

71

72

Heaven is My throne, and earth is My footstool. What house will you build for Me? says the Lord, or what is the place of My rest? Has My hand not made all these things?

<div align="right">

Acts 7:49-50

</div>

56. *Sandstone Wall, Southeast Oregon* 57. *Bark Detail, Ponderosa Pine*

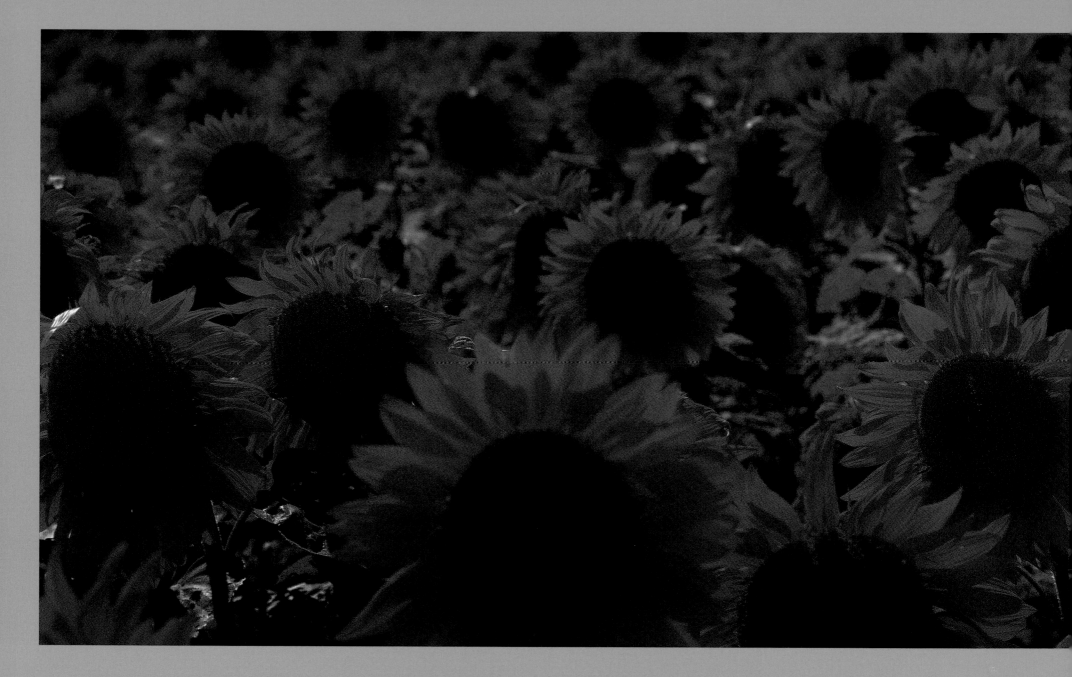

Bless the Lord, *all His works,*
in all places of His dominion.
Bless the Lord, *O my soul!* Psalm 103:22

60. Sunflowers, North Dakota

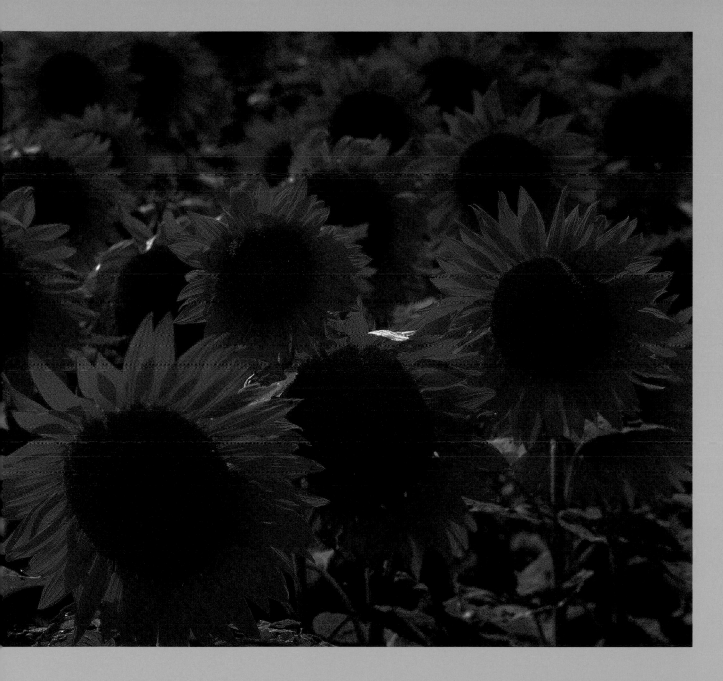

I set My rainbow in the cloud, and it shall be for the sign of the covenant between Me and the earth.

GENESIS 9:13

Continued from page 71.

The black-and-white character of Israel's repeated apostasy and God's grace after their conquest of Canaan contrasts sharply with the Bible's colorful depiction of David's devotion to the LORD. God greatly blesses David and renews and enlarges His covenant promises to include an eternal kingdom (2 Samuel 7:16) in which He will be their God and they His people.

But Israel again turns to idolatry after Solomon's death, and in judgment God gives them over to the serpent's seed and cuts off their inheritance.

Yet a faithful remnant is saved that God graciously upholds through the revelation of His prophets, foretelling the glorious fulfillment of His covenant in the coming of One from David who, as prophet, priest, king, and kinsman-redeemer, will rescue His people and bless every nation on earth.

Continued on page 83.

Though we often speak about the color of an object and use it as a primary means of identification and classification, we do not really see color at all. Instead, we see the light that is reflected from the surface of object, which our eyes change into electrochemical signals that are then transmitted through nerve fibers to the brain, which interprets them as the colors we see. Thus, an object's color is really determined by the reflective or absorbent nature of the pigments it contains.

However, there is still a great deal that scientists don't know about the way our eyes and brain work together to create the sensation of color.

78

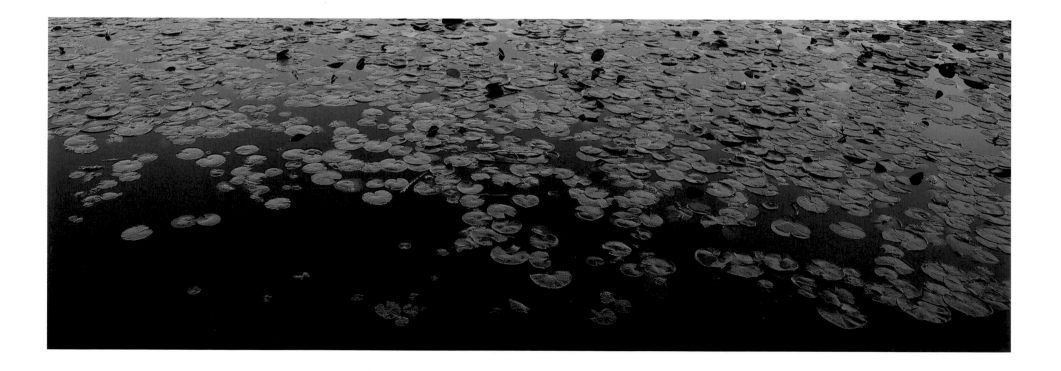

61. Cape Cod Lily Pond 62. Autumn Detail, Northern Japan 63. Tiger Lily, Northern California

Consider the lilies, how they grow: they neither toil nor spin; and yet I say to you, even Solomon in all his glory was not arrayed like one of these. If then God so clothes the grass, which today is in the field and tomorrow is thrown into the oven, how much more will He clothe you, O you of little faith? LUKE 12:27-28

79

82

65. *Common Sorel, Redwood National Park*

"For My thoughts are not your thoughts, nor are your ways My ways," says the LORD. ISAIAH 55:8

Continued from page 77.

Pattern is the highest expression of design, because it reflects the reality of the template that determines an object's structure and gives it ultimate meaning.

The pattern of God's covenant from start to finish is a reflection of the reality of its fulfillment in Jesus Christ, who is the archetype for all its promises. He is the sinless last Adam, the victorious Seed of the woman, the unblemished Lamb of God, the faithful prophet, the Good Shepherd, a Melchizedek priest, the Prince of Peace, Mighty God, and eternal Davidic King. Notably, He is also our kinsman-Redeemer who was made in the likeness of men to be a blood relation, so He could 1) pay the ransom price of death to free us from our slavery to sin, 2) marry the widow of God's judgment, which is the church, 3) avenge it against the seed of the serpent, and 4) regain its forfeited inheritance of union and communion with God.

All these Old Testament covenant roles are fulfilled in Christ. His gracious work in the new covenant justifies us before God and grants us the privilege of being His adopted children, sharing in the original covenant promise of enjoying Him forever.

83

As for God, His way is perfect;
the word of the Lord is proven. 2 SAMUEL 22:31

 One of the most striking patterns of nature's many repeating designs is the dendritic, or branching, formation that is found in a wide variety of the earth's elements and environments. Although it is most commonly associated with the trunk-limb-branch-twig-leaf stucture of trees and vines, it is also seen in the river-stream-rivulet architecture of waterways, in the cardiovascular and pulmonary systems of humans and animals, and in many other realms of the created order.

66. Dendritic Branch Pattern, Central Oregon 67. Dendritic Mud Pattern, Colorado Plateau

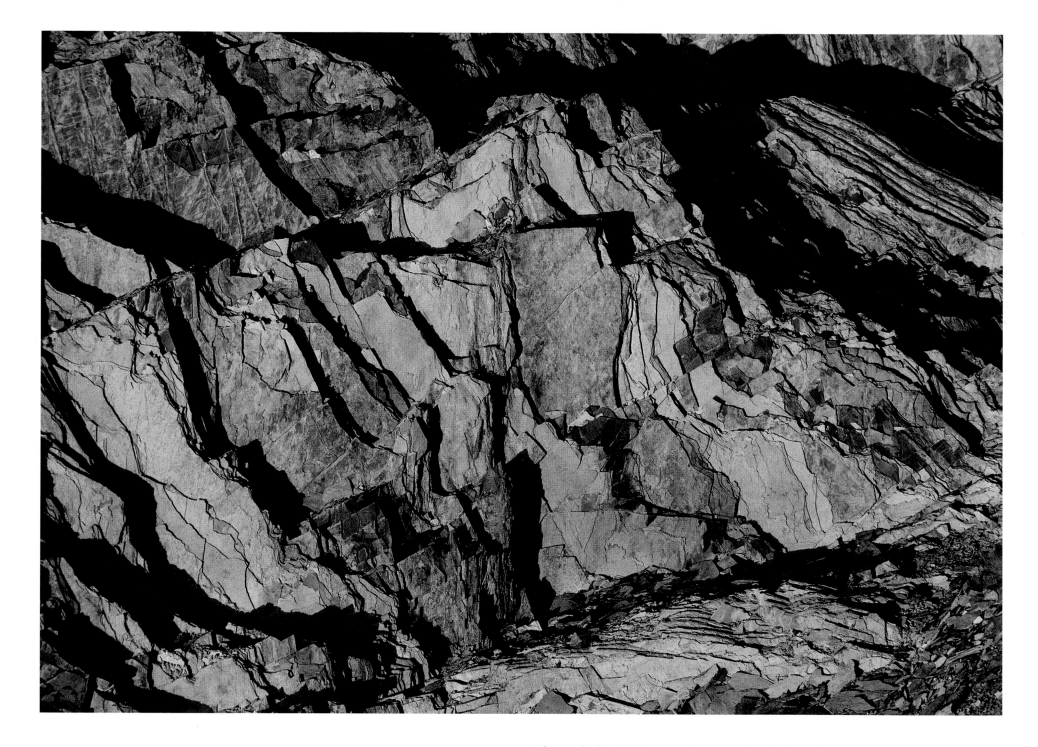

86

The rock detail above is about six feet high. The summit detail on the right page, which mirrors the smaller pattern, is more than twenty thousand feet high.

68. Rock Pattern, Zanskar Himalaya, Northern Kashmir 69. Summit Stucture, Hindu Kush Range, Northwest Pakistan

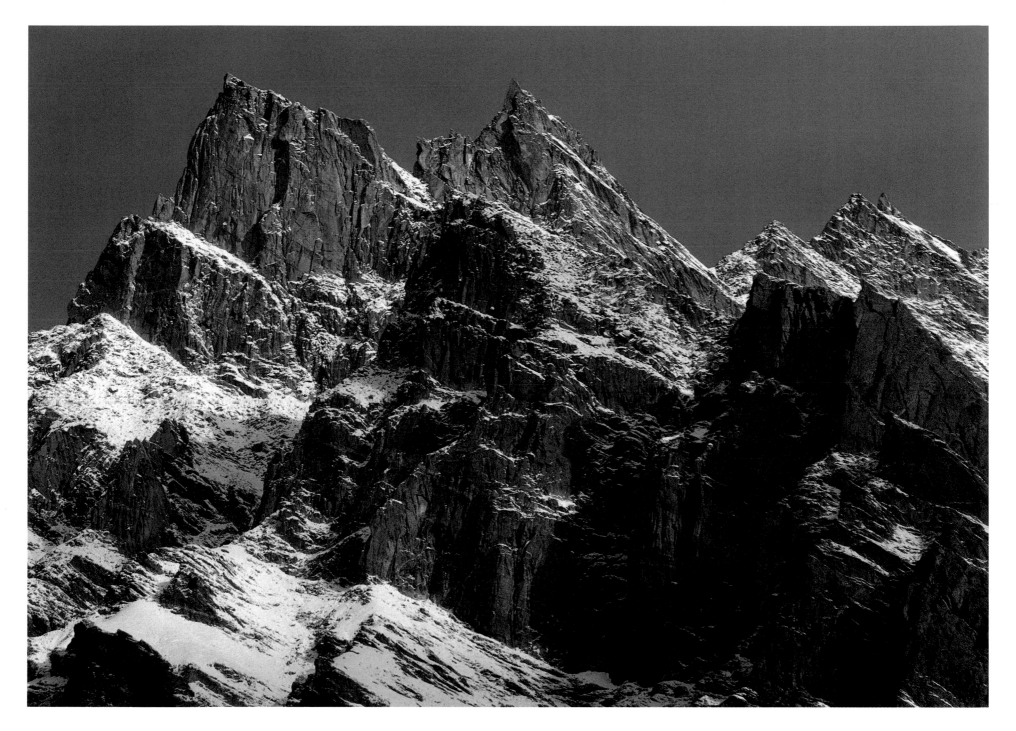

From the end of the earth I will cry to You, when my heart is overwhelmed; lead me to the rock that is higher than I. PSALM 61:2

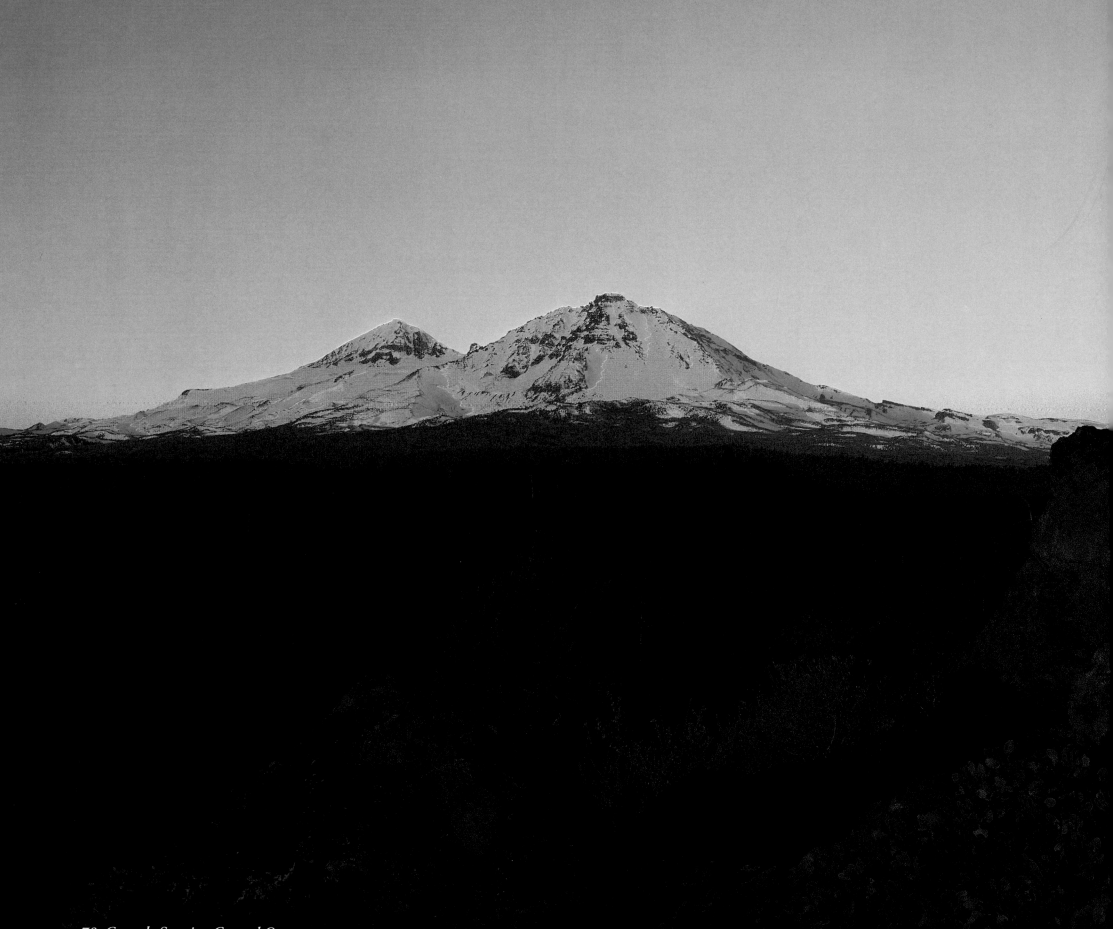

70. Cascade Sunrise, Central Oregon

Environments

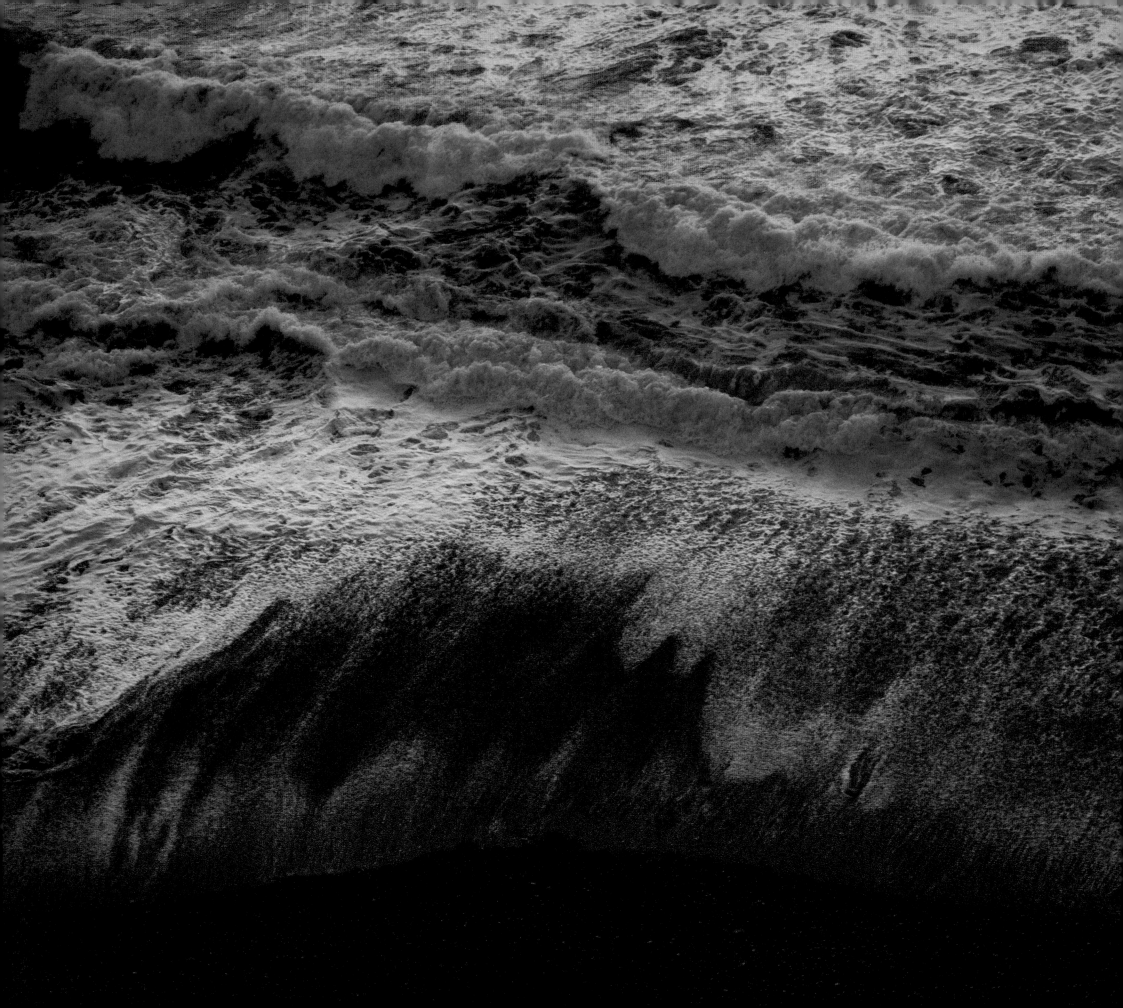

You alone are the LORD. You made the heavens, even the highest heavens, and all their starry host, the earth and all that is on it, the seas and all that is in them. You give life to everything, and the multitudes of heaven worship you.

<div align="right">

NEHEMIAH 9:6, NIV

</div>

The principal environments of the earth—its mountains, forests, deserts, coasts, and grasslands— can bc likened to separate galleries in a museum, each showing a distinct style or period of work in an artist's life. A special harmony of character is shared by the pieces in each room, yet they are unmistakably related to the entire exhibit by the unique vision and talent of the artist who created them.

In Psalm Twenty-Four David exclaims "The earth is the Lord's, and all its fullness" (Psalm 24:1). The entire world is God's museum—the permanent venue for the display of His magnificent creations—and its environments are theme-specific galleries that highlight a distinctive characteristic within the overall unity of the art of God.

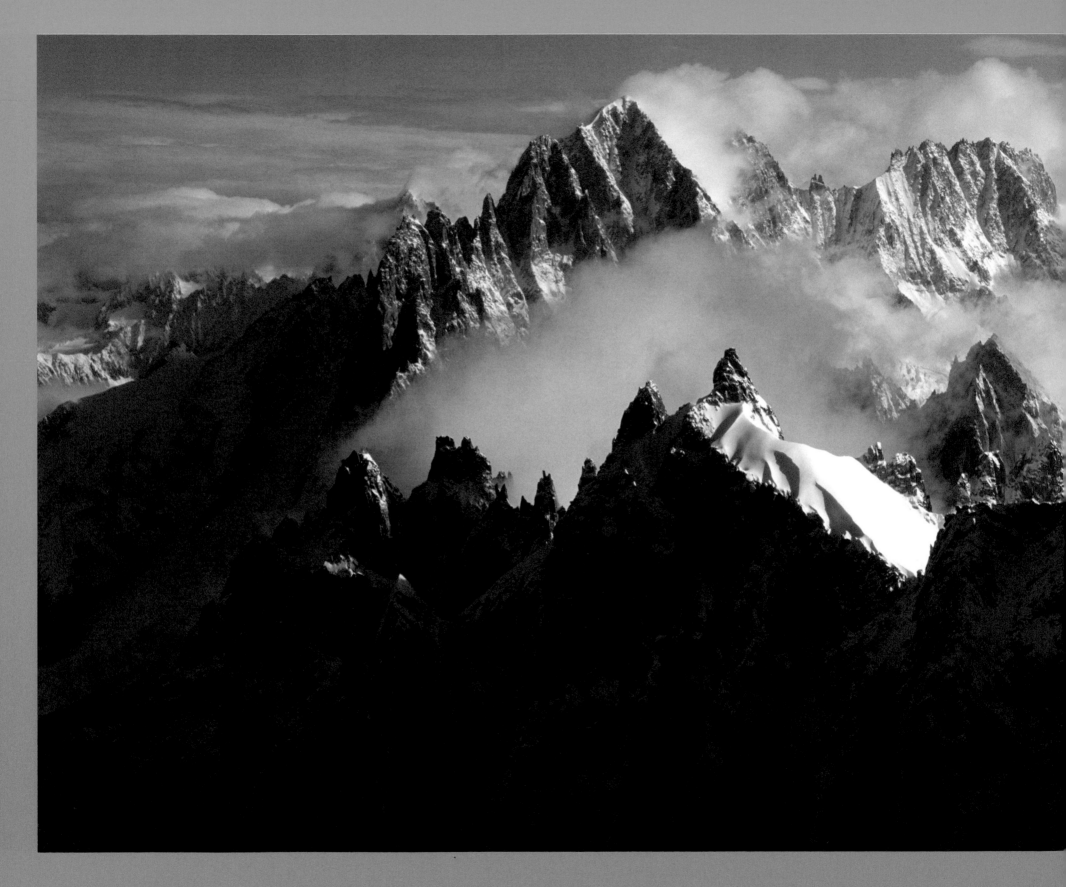

72. Aiguilles, Chamonix, France

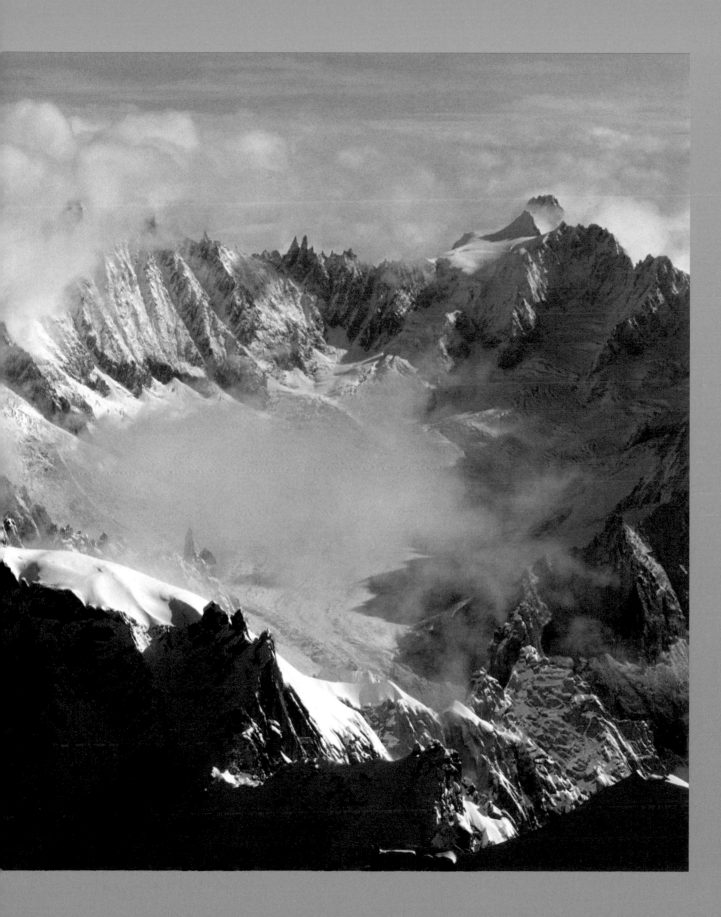

Your mercy, O Lord, is in the heavens; Your faithfulness reaches to the clouds. Your righteousness is like the great mountains; Your judgments are a great deep; O Lord, You preserve man and beast. Psalm 36:5-6

With poetic names such as "Roof of the World," "Abode of the Snows," and "Range of Light," mountains have stirred the human imagination since the beginning of time. The Bible frequently uses them as metaphors for heaven—symbolizing the true dwelling place of God—and as identifiers for the different stages of God's history of salvation.

The Old Covenant law, given to Moses at Mount Sinai during Israel's exodus from Egypt, is characterized by a fear of God's holy and righteous judgment, as depicted by the "consuming fire on the top of the mountain" (Exodus 24:17). Yet, it is by the impossible demands of His law that God reveals man's sin and his need for God's saving grace. In the New Covenant, symbolized by the church as the new Jerusalem on heavenly Mount Zion (Hebrews 12:18-24), God offers to believers what they can never earn—forgiveness of their sins and the gift of eternal life—by paying for it with the awful price of His sinless Son's crucifixion (John 3:16).

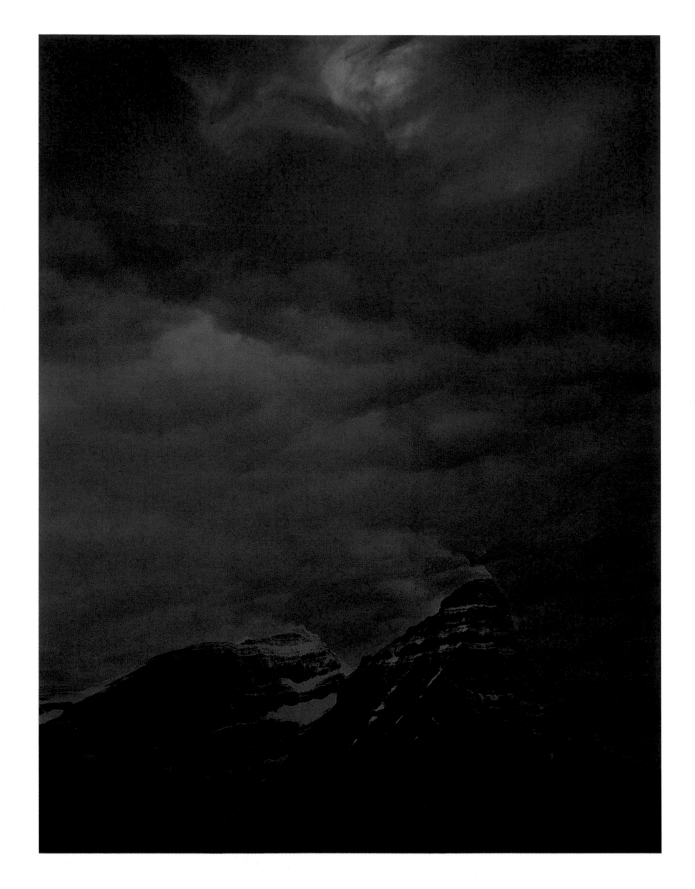

The sight of the glory of the LORD was like a consuming fire on the top of the mountain.

EXODUS 24:17

In addition to their significance as biblical symbols and their ability to stir the souls of artists and adventurers everywhere, mountains play a vital role in maintaining the equilibrium of the earth.

Because mountains force surface winds to rise over them, causing the air to cool and its moisture to condense into rain or snow, they have a strong influence on a region's climate. Most of this moisture is dropped on the windward side of the mountains, leaving the leeward side dry—thus creating many of the earth's deserts.

The mountains' windward sides, however, are frequently very wet: summit snowfields give birth to major rivers, and warmer lower slopes support large forests and an abundant variety of life forms.

96

75. Mt. Chephren, Alberta, Canada 76. Sunrise over Mt. Jefferson, Oregon Cascades

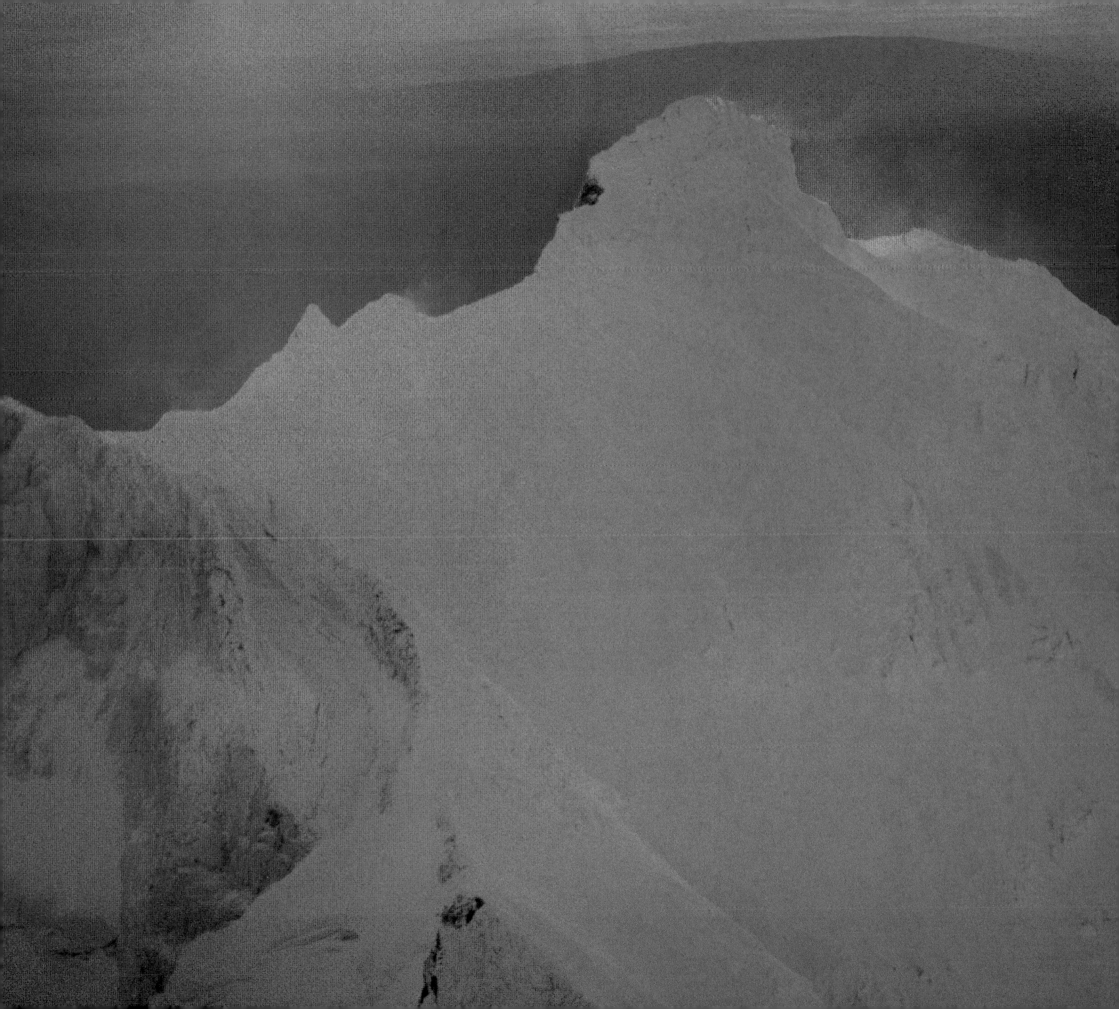

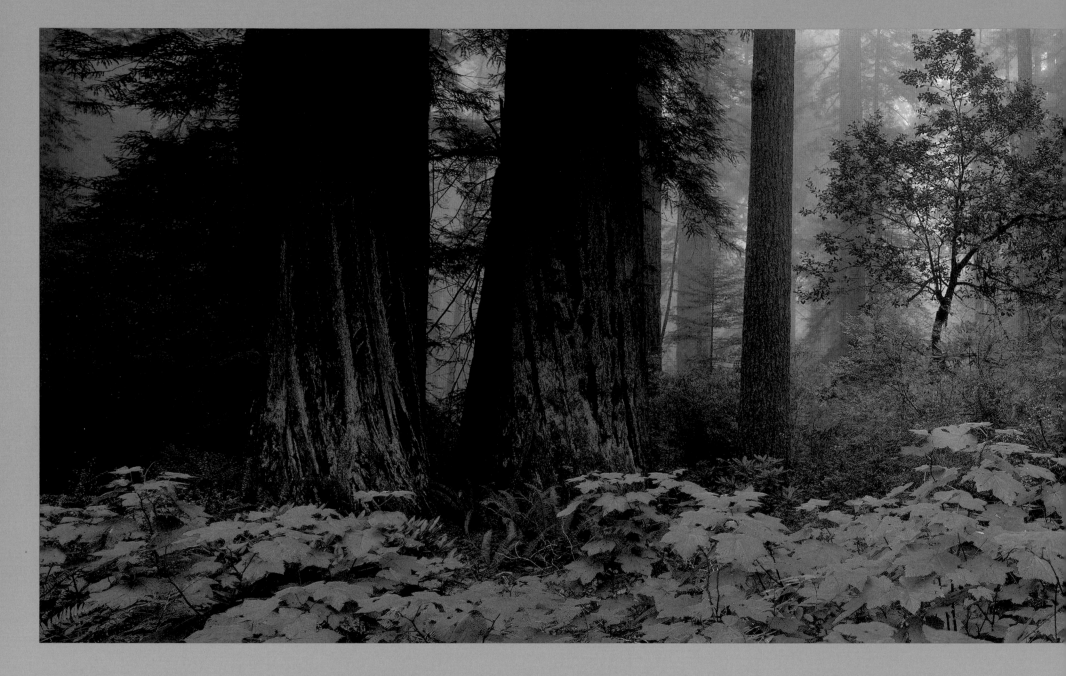

The God who made the world and everything in it is the Lord of heaven and earth and does not live in temples built by hands.

ACTS 17:24

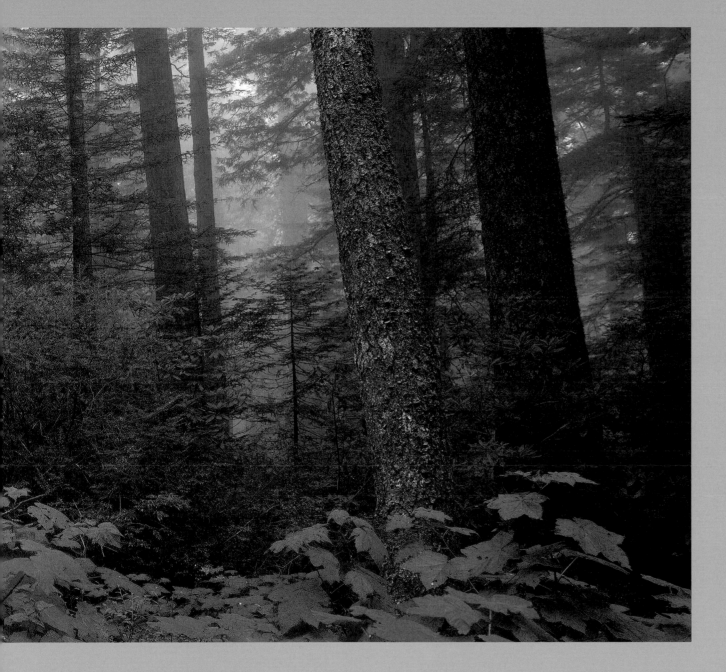

Out of the ground the LORD God made every tree grow that is pleasant to the sight and good for food. GENESIS 2:9

Trees play a variety of symbolic roles in Scripture, including a major part in the account of man's sin against God, and Christ's payment for that sin by His death on the cross, so that man might be credited with Christ's righteousness.

The symbol of Adam's sin was the fruit of the tree of the knowledge of good and evil, which he ate in defiance of God's command. Consequently, God fulfilled His covenant promise and banned Adam and his descendants from eating the fruit of the tree of life.

By God's grace, however, He sent His only Son, Jesus Christ, the Shoot of Jesse, to die on a tree (the cross), so that those who believe in His name might eat from the tree of eternal life.

99

77. Old Growth Redwoods, Northern California

Photosynthesis is the chemical process used by trees and plants to convert the sun's energy into food, releasing oxygen as a by-product. When sunlight hits the palisade cells, which are like tiny solar collectors on the surface of a green leaf, the chlorophyll in the cells changes water and carbon dioxide (which we exhale) into sugar and oxygen. The oxygen is released into the air (which we inhale), and the simple sugar in the leaf feeds the plant and a host of life-forms on the food chain above it. Caterpillars and other insects eat the leaves, shrews eat the caterpillars, owls eat the shrews, and so on. Thus we see a highly complex system of complete interdependence and perfect design.

Scientists have discovered a great deal about the intricate workings of photosynthesis but have never been able to reproduce it in the laboratory.

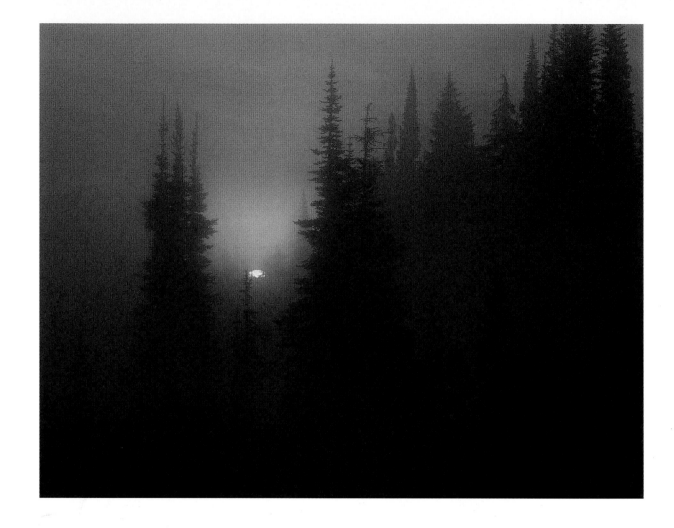

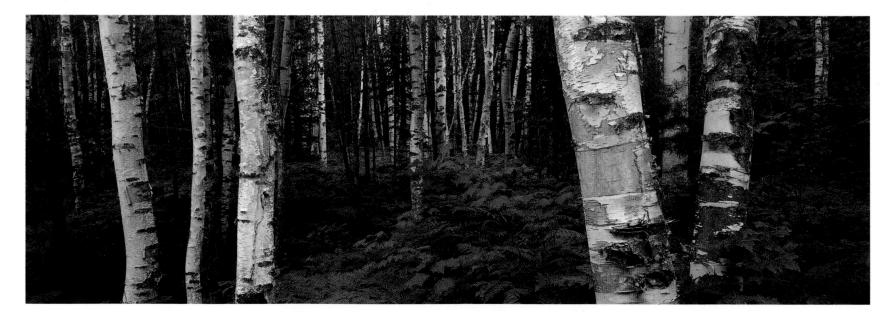

You are worthy, O Lord,
To receive glory and honor and power;
For You created all things,
And by Your will they exist and were created. REVELATION 4:11

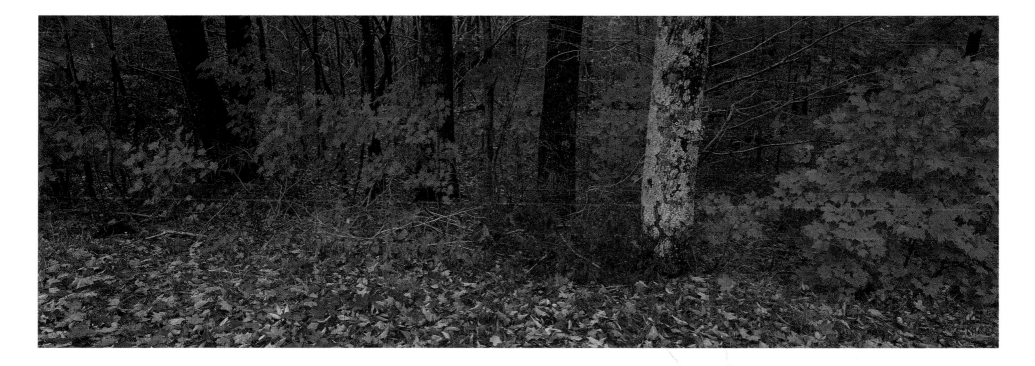

The chlorophyll that is responsible for photosynthesis is also responsible for a leaf's green color. The leaf has other colors as well, but they are hidden by the chlorophyll. When autumn approaches, however, and the shorter days and cooler nights cause the chlorophyll to break down, the hidden pigments are revealed. The variety of colors in different deciduous broad-leaved trees is determined by which pigments are most plentiful in their leaves.

78. Birch Forest, Upper Michigan 79. Sunrise & Fog, Three Sister's Wilderness 80. Autumn Forest, Catskill Mountains, New York

*Sing, O heavens, for the L*ORD *has done it!*
Shout, you lower parts of the earth;
Break forth into singing, you mountains,
O forest, and every tree in it! ISAIAH 44:23

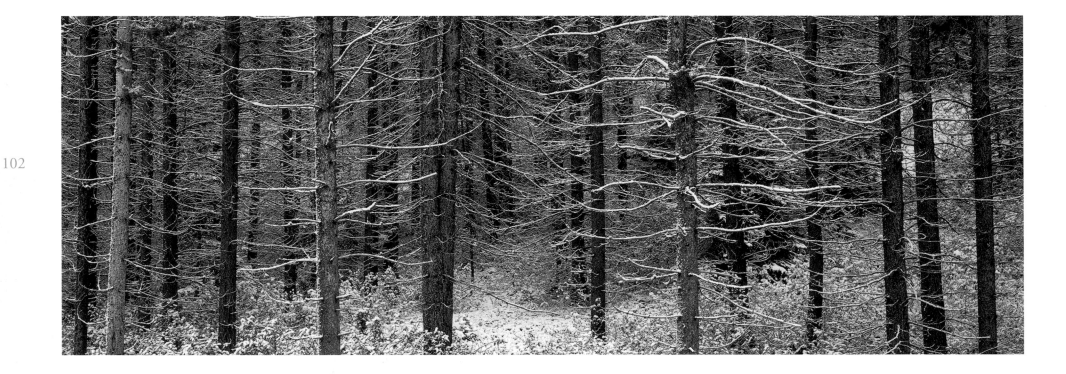

Plants account for more than 95 percent of the earth's living organisms, and the largest members of the plant kingdom are trees. Some, like these giant redwoods, grow to be more than three hundred feet tall and are over three thousand years old.

81. First Snow, Kananaskas, Alberta, Canada 82. Rhododendron & Redwoods, Northern California

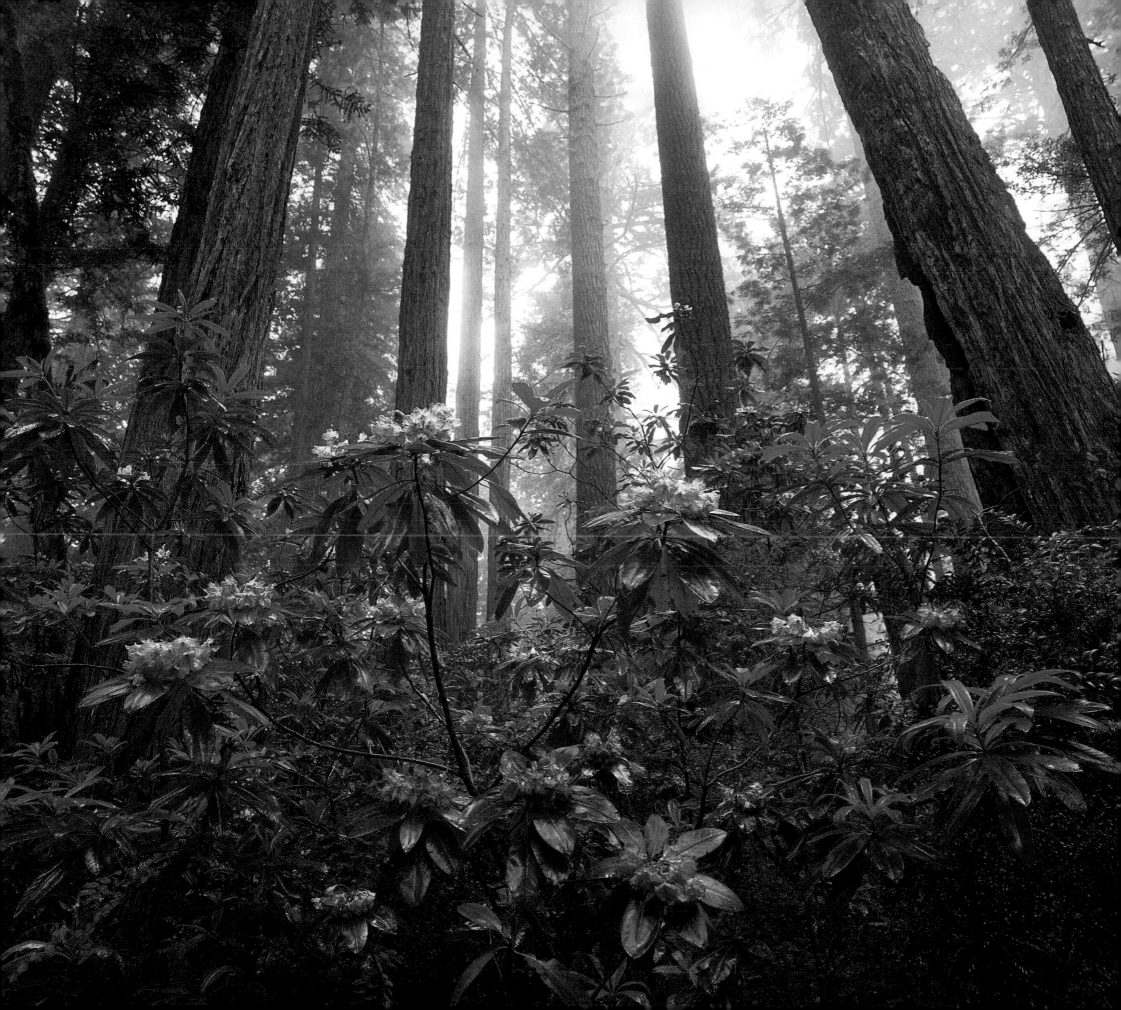

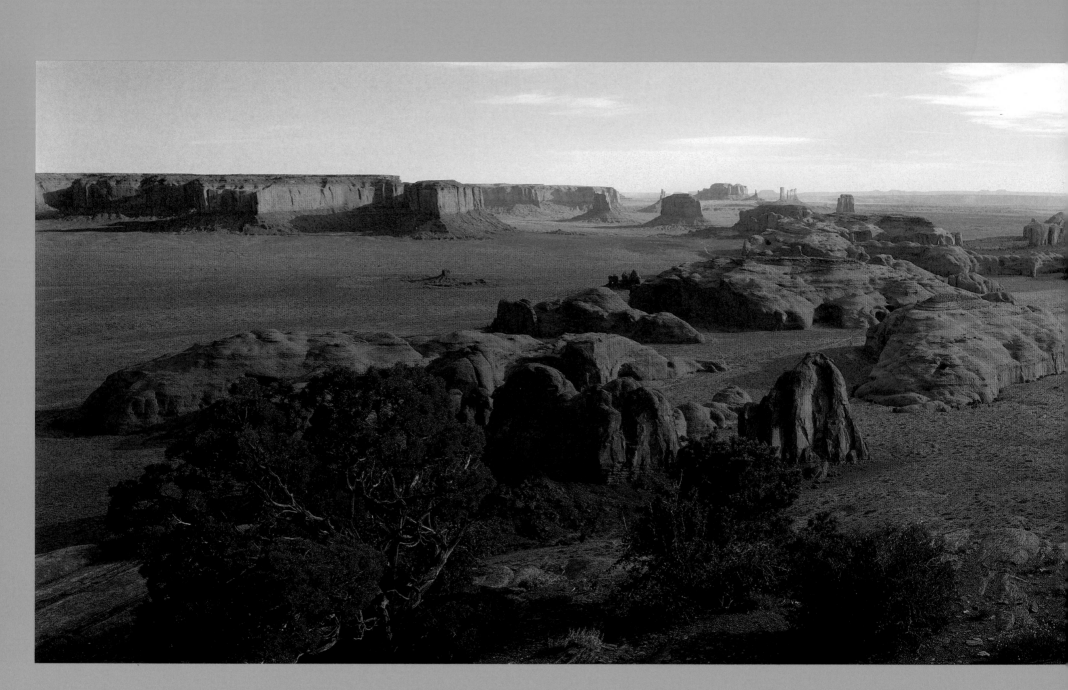

104

Ah, Lord God! Behold, You have made the heavens and the earth by Your great power and outstretched arm. There is nothing too hard for You. JEREMIAH 32:17

83. *Monument Valley from Hunt's Mesa, Arizona*

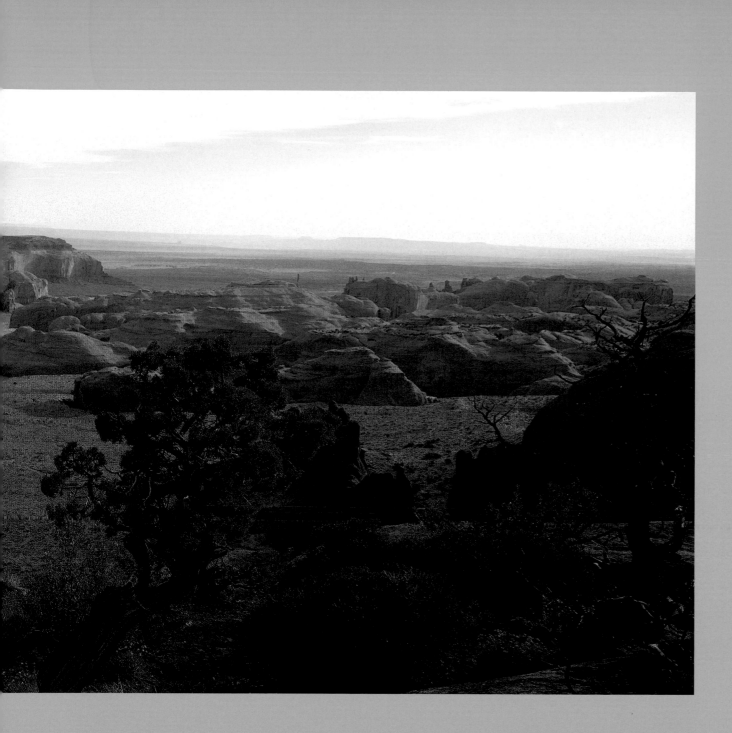

I will turn the desert into pools of water, and the parched ground into springs.

ISAIAH 41:18, NIV

The inhospitable character of the desert environment is frequently used in Scripture to emphasize people's need to rely upon God's sovereign grace for everything that sustains them.

It was a common testing ground of the Israelites' faith, as seen in Moses' reminder of their desert wanderings in Deuteronomy 8:3: "So He humbled you, allowed you to hunger, and fed you with manna which you did not know nor did your fathers know, that He might make you know that man shall not live by bread alone; but man lives by every word that proceeds from the mouth of the LORD." Jesus Himself used this very passage when He was tempted by Satan in the desert.

105

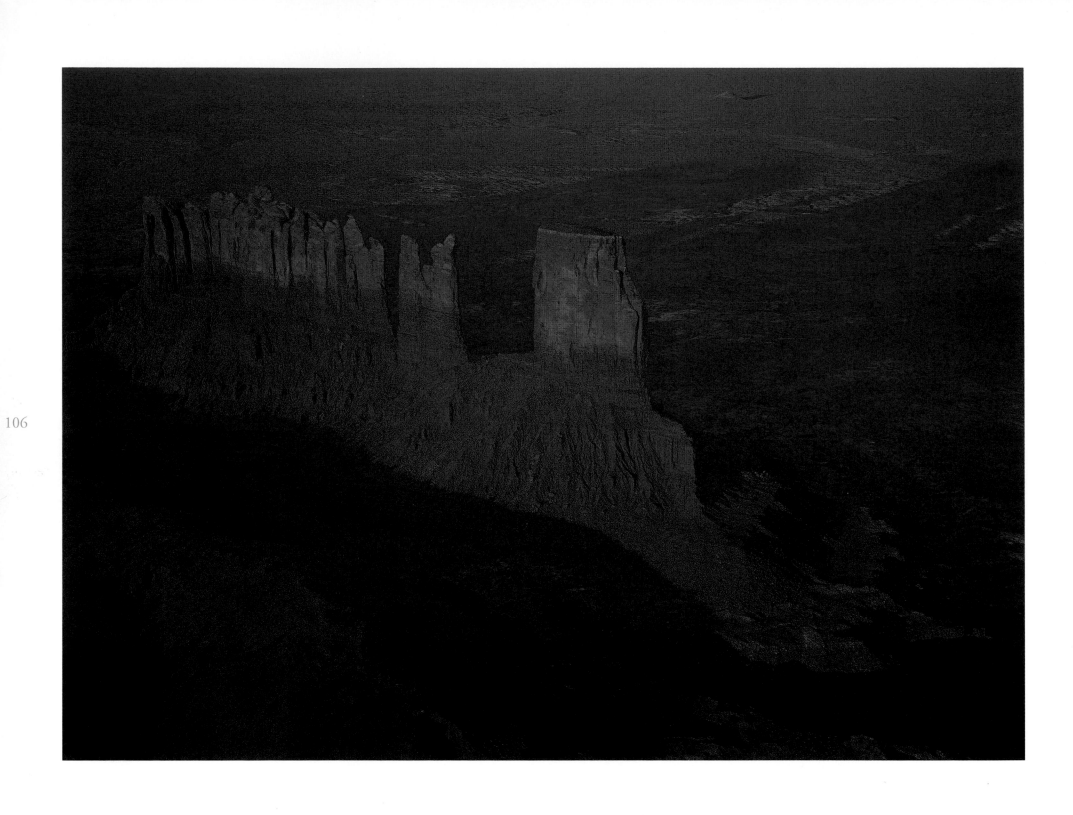

He spoke, and it was done; He commanded, and it stood fast.

<div align="right">PSALM 33:9</div>

Covering approximately 20 percent of the earth's land surface, deserts vary greatly in appearance, as shown in these photographs of Monument Valley and the northern Great Basin. This is because their defining characteristic is not their physical makeup but a chronic lack of water. Some deserts, like Chile's Atacama, have never even had a recorded rainfall. As a result of this dryness, deserts are unable to support the abundance of plant life found in wetter climates, and individual plants tend to be widely scattered to compete for the limited supply of water, which is often deep below the surface. The roots of west Texas mesquite trees sometimes reach down more than 250 feet.

The Sahara, in northern Africa, is the world's largest desert, covering an area that is almost as large as the United States. All the deserts in North America would take up less than 15 percent of the Sahara.

84. Sunset Aerial, Monument Valley 85. Desert Bloom, Southeast Oregon

The improbable sight of wildflowers blooming in the desert is a good reminder of the biblical truth that God controls everything in our lives according to His perfect wisdom, knowledge, and love. While it may sometimes seem we are stranded in the middle of a spiritual desert, far removed from God, we are graciously given the hope and power to persevere in our faith by the certain promise of Romans 8:28: "We know that in all things God works for the good of those who love him, who have been called according to his purpose" (NIV).

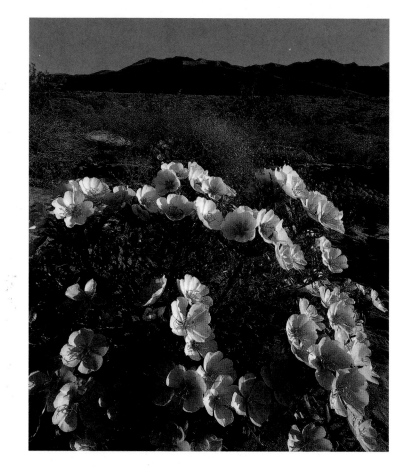

He has made everything beautiful in its time. He has also set eternity in the hearts of men; yet they cannot fathom what God has done from beginning to end.

ECCLESIASTES 3:11, NIV

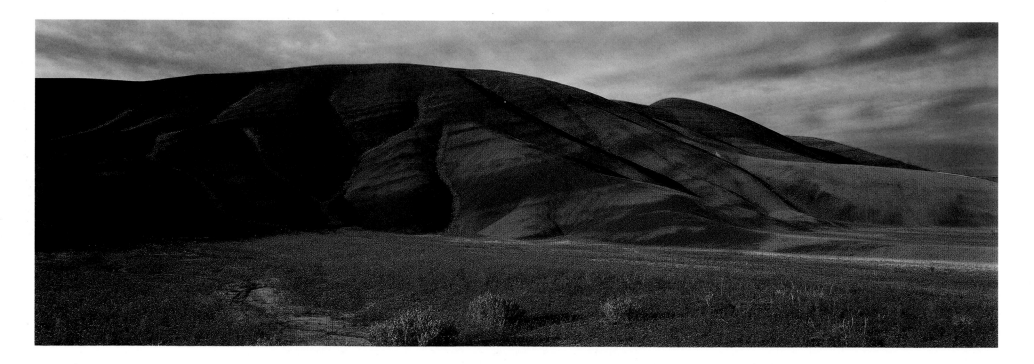

86. Evening Primrose, Sonoran Desert 87. Painted Hills, Central Oregon 88. Sunset, Grand Canyon National Park

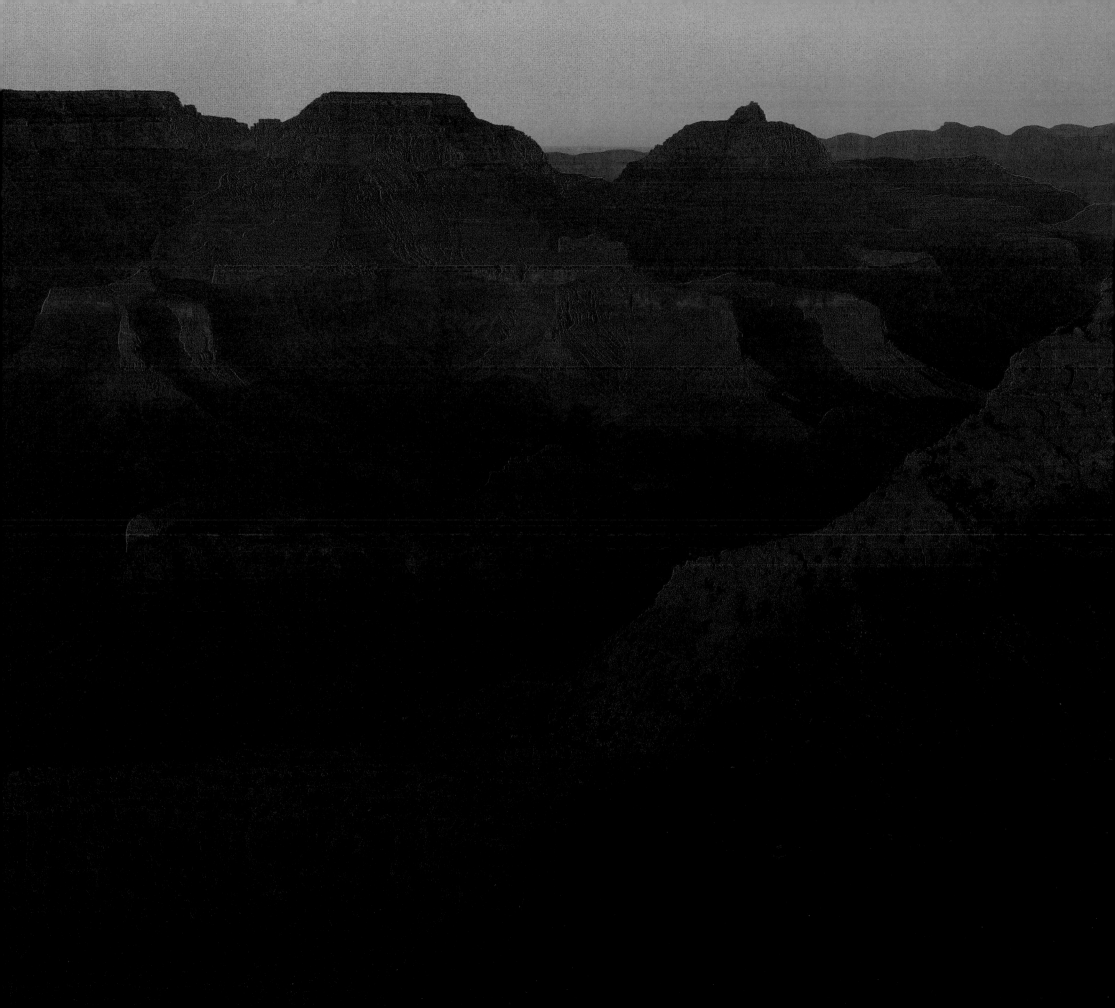

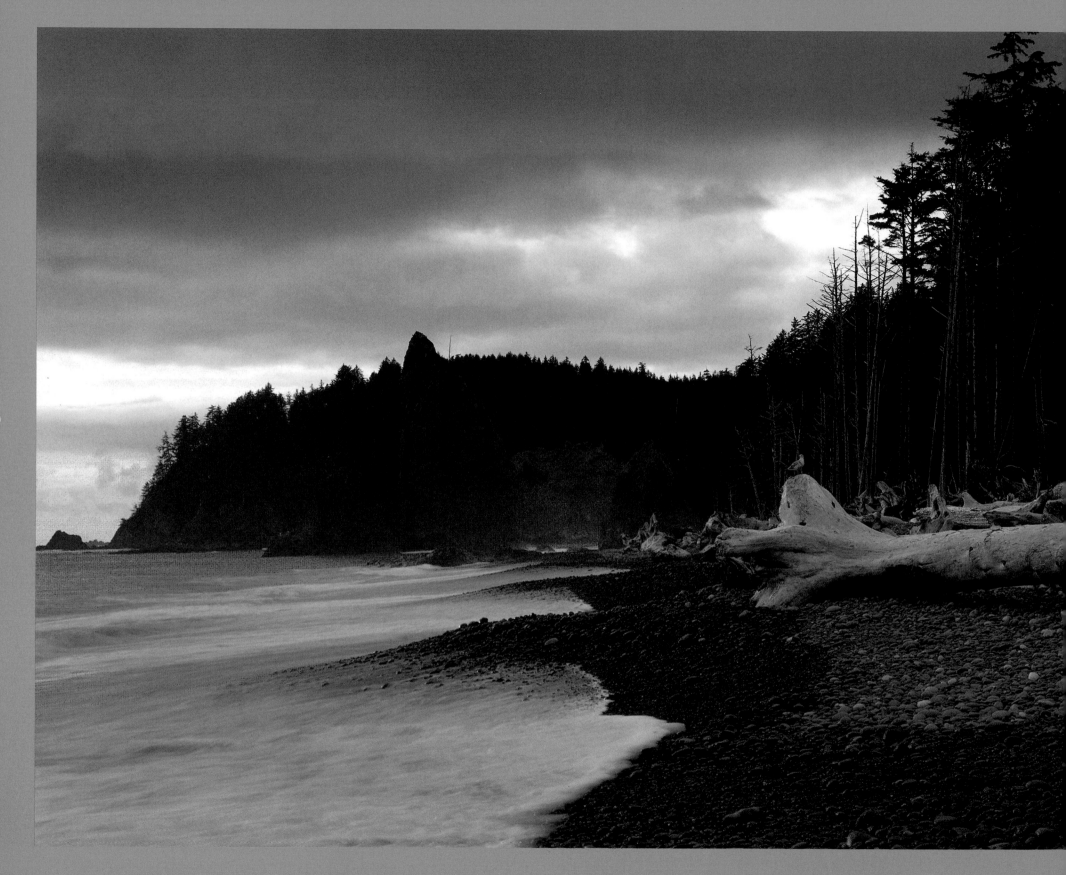

110

89. *Rialto Beach, Olympic National Park, Washington*

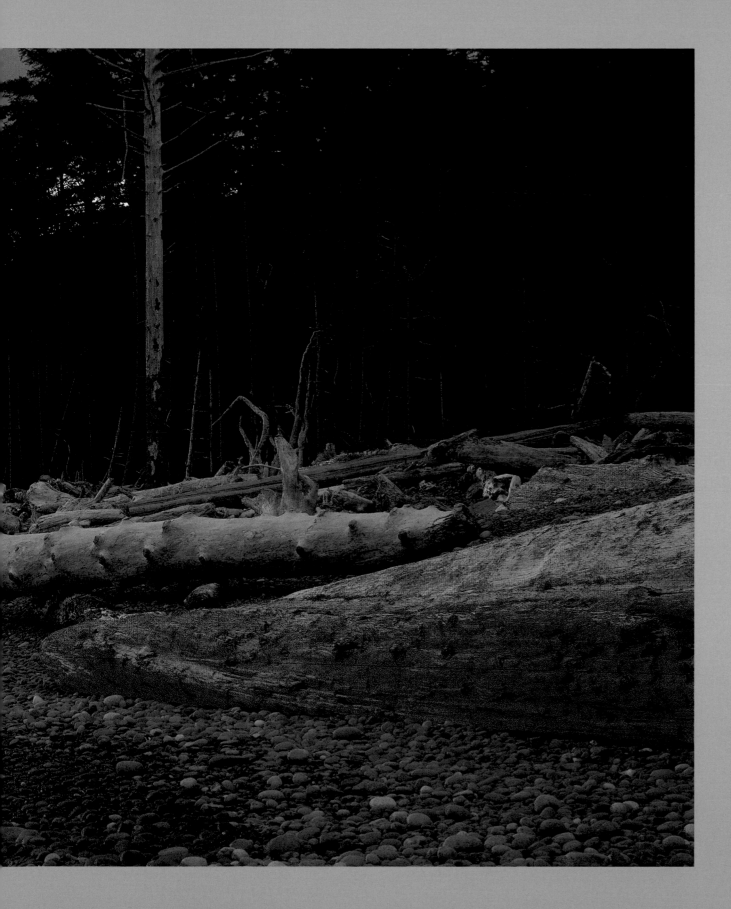

Who can this be, that even the wind and the sea obey Him! MARK 4:41

In the ancient Near East, oceans were a common symbol for the powers of chaos and death. In the Bible, however, the sea is no threat to God, for He created it and it obeys His commands. When Jesus "arose and rebuked the wind, and said to the sea, 'Peace, be still!' And the wind ceased and there was a great calm," it is not surprising that His disciples "feared exceedingly," for they were suddenly aware that they were in the very presence of God (Mark 4:39-41).

Living on land, we rarely consider that the vast majority of the earth's surface is ocean, and it is the primary controller of our daily environment. Acting as both heart and lungs for the planet's intricate circulatory system, it supplies the water, air, and temperature that we need to live. Containing 97 percent of the earth's water, the ocean drives the hydrologic cycle that gives us freshwater. Its currents cool the land in summer and heat it in winter, and its continental shelves are home to 80 percent of the world's plants, which provide the bulk of the oxygen that we breathe.

111

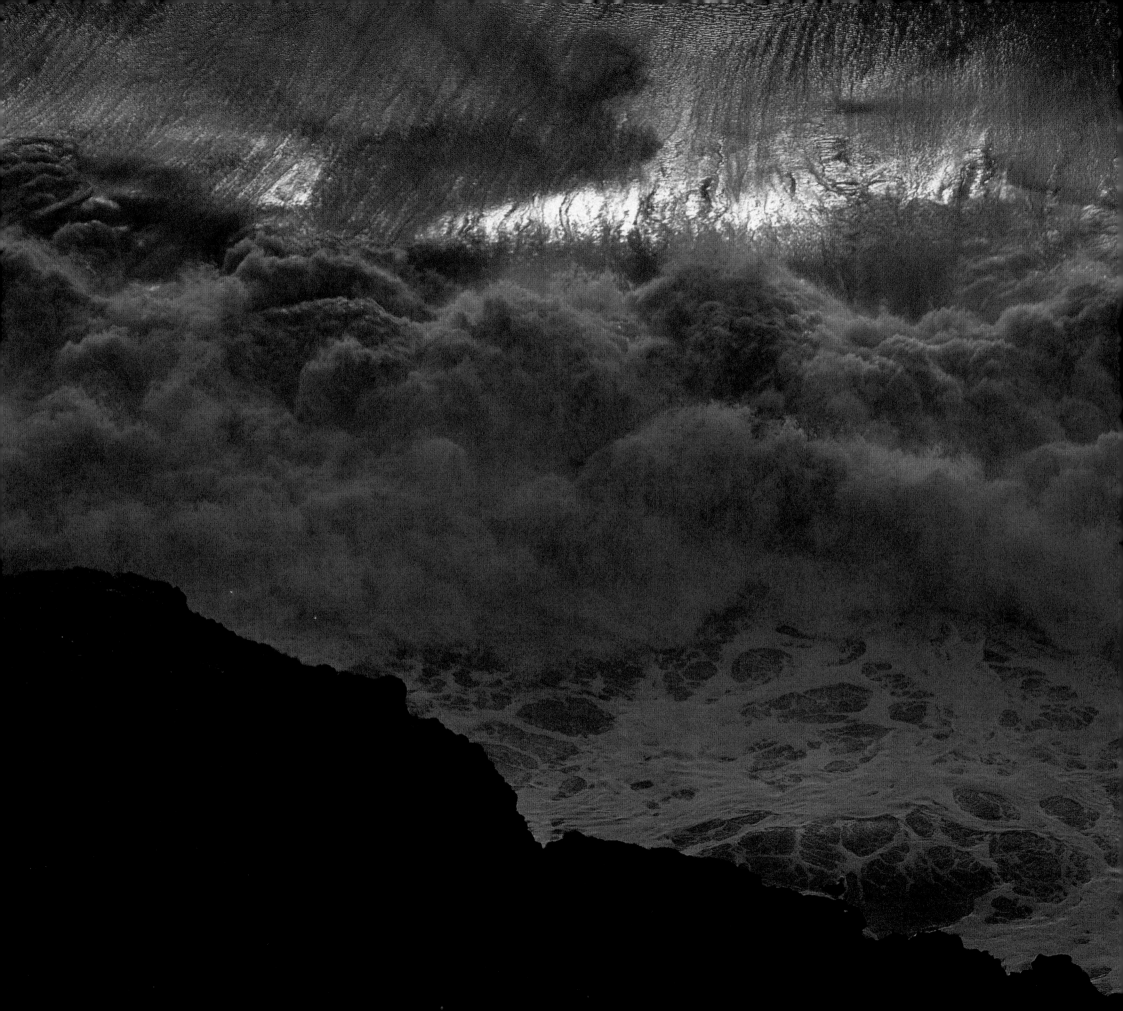

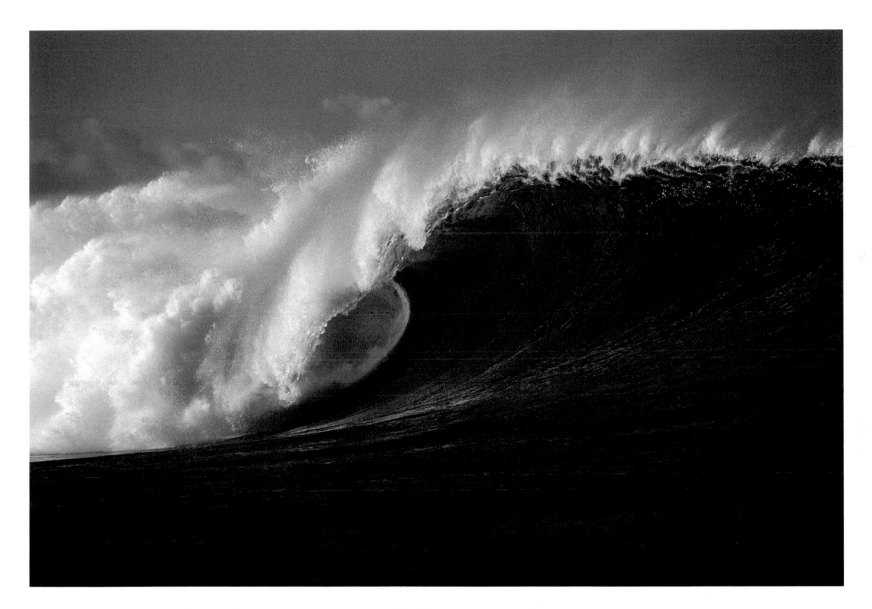

*You rule the raging of the sea;
 when its waves rise, You still them.* PSALM 89:9

90. Seagull & Surf, Oregon Coast 91. Cloudbreak, Tavarua Island, Fiji

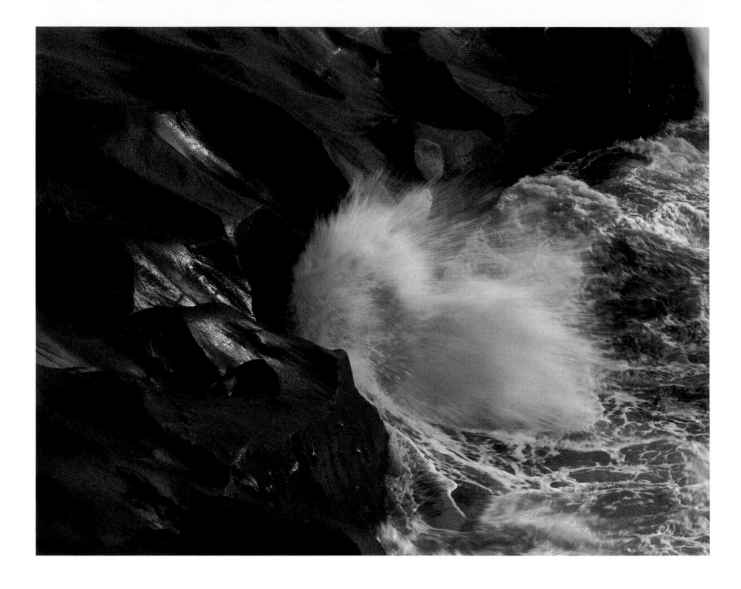

114

Who shut in the sea with doors, when it burst forth and issued from the womb; when I made the clouds its garment, and thick darkness its swaddling band; when I fixed My limit for it, and set bars and doors; when I said, "This far you may come, but no farther, and here your proud waves must stop!" JOB 38:8-11

92. Crashing Wave, Cape Kiwanda, Oregon 93. Sunset, Face Rock Wayside, Oregon Coast

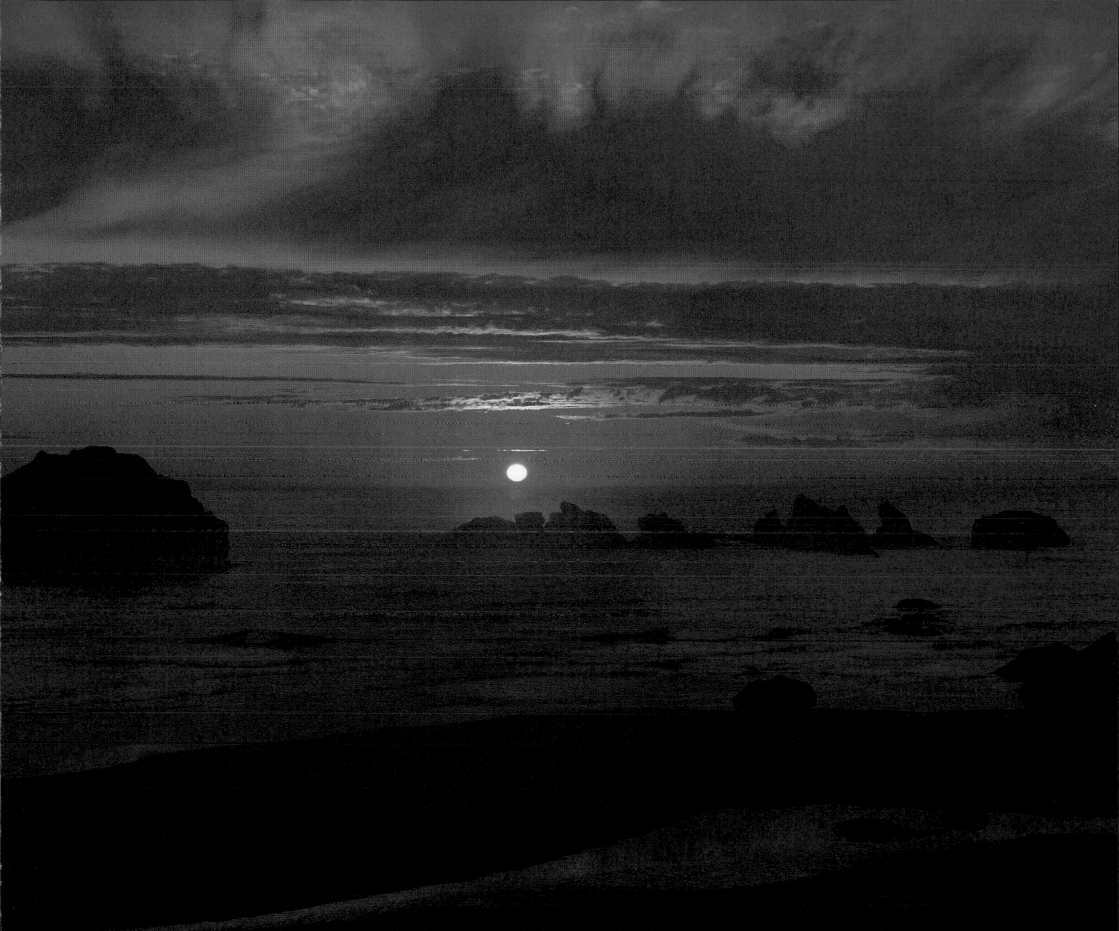

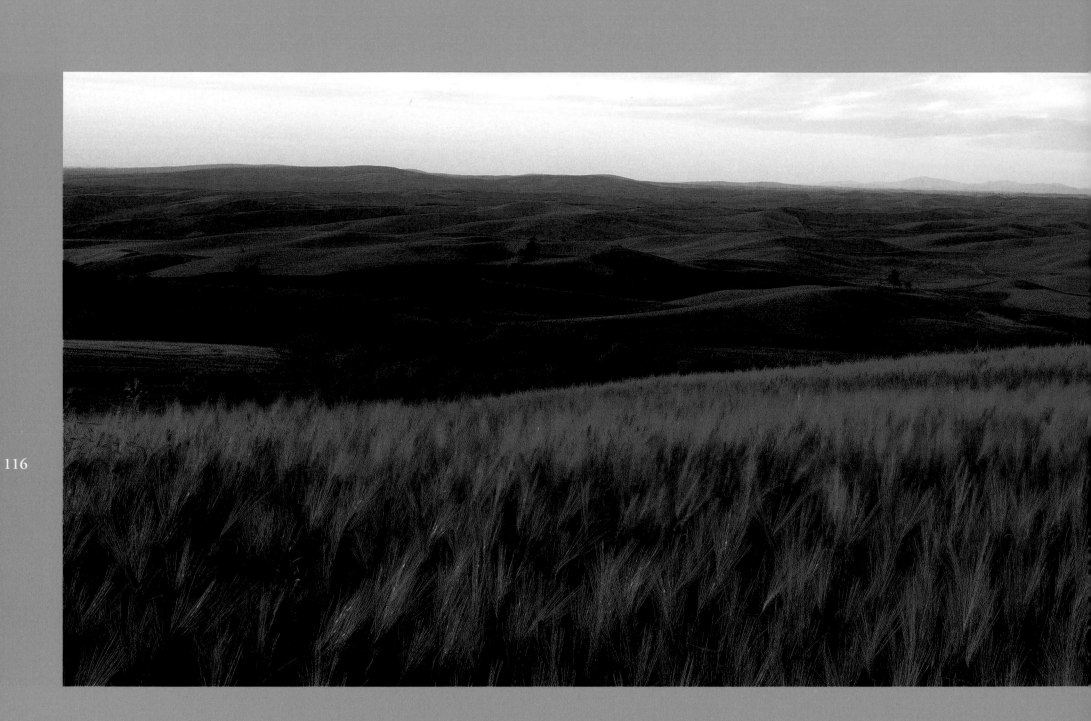

Then God said, "Let the earth bring forth grass, the herb that yields seed, and the fruit tree that yields fruit according to its kind, whose seed is in itself, on the earth"; and it was so. GENESIS 1:11

94. *Palouse Wheatfields, Eastern Washington*

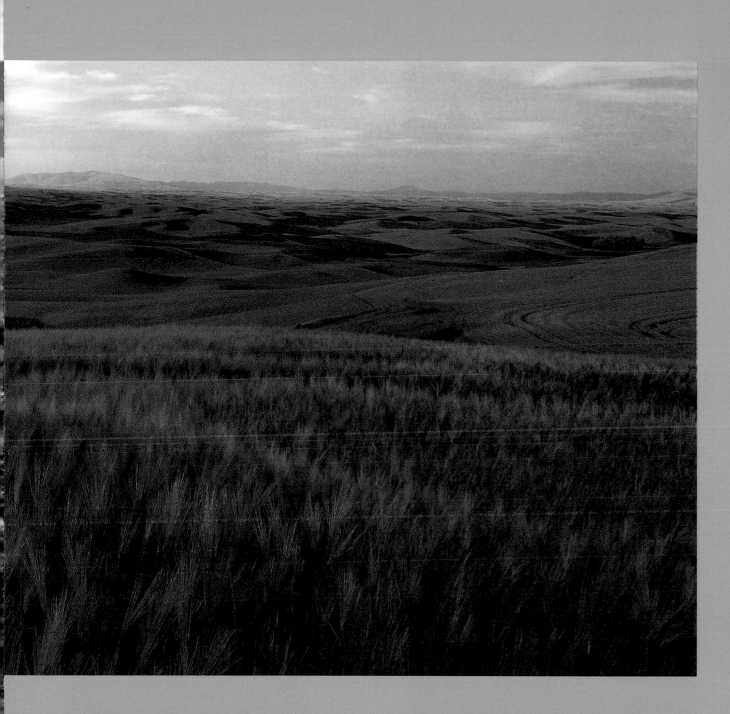

If then God so clothes the grass, which today is in the field and tomorrow is thrown into the oven, how much more will He clothe you, O you of little faith? LUKE 12:28

Grass is a common scriptural metaphor for the brevity of human life, which is usually contrasted with the permanence and glory of God. Jesus uses the same illustration in His Sermon on the Mount, addressing the weak faith of His followers. It's not that they have no faith, for He is speaking to believers; rather, it's that they show "little faith" by their pursuit of the things of the world.

To understand and apply His message is to rejoice in God's promises and fully trust in His sovereignty, wisdom, and love. "Consider the lilies" (Luke 12:27).

117

99. Big Sur Sunset, California

Ebb & Flow

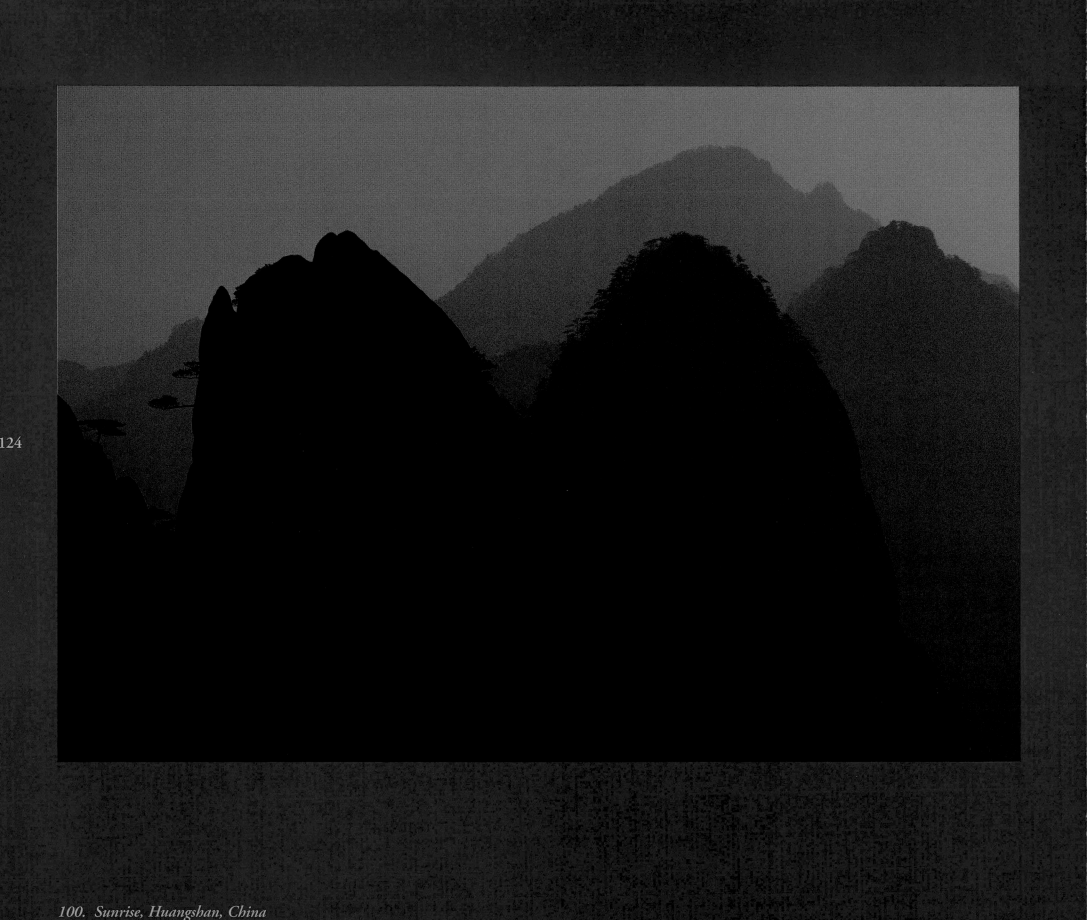

100. *Sunrise, Huangshan, China*

The sun rises and the sun sets, and hurries back to where it rises. The wind blows to the south and turns to the north; round and round it goes, ever returning on its course. All streams flow into the sea, yet the sea is never full. To the place the streams come from, there they return again.

<div align="right">

ECCLESIASTES 1:5-7, NIV

</div>

The cycles of the earth, which King Solomon described so eloquently in the book of Ecclesiastes more than three thousand years ago, are among its most intriguing characteristics. All of creation is one unified body breathing in and breathing out, little systems connected to bigger systems connected to bigger and bigger systems. Each is complete in itself but meaningless apart from its relationship to the others. From subatomic systems to solar systems, they work together in perfect harmony, born of one Creator in Christ and relying upon the sustaining power of His constant will for their minute-to-minute existence. "For by Him all things were created, both in the heavens and on earth, visible and invisible, whether thrones or dominions or rulers or authorities—all things have been created through Him and for Him. He is before all things, and in Him all things hold together" (Colossians 1:16-17, NASB).

"Ebb and Flow" is about the repeating cycles in nature that we live with every day and often take for granted: the unending play of shadow and light, the changing of the seasons, the endless journey of water, and the rising and setting of the sun. Its focus is the systems of perpetual motion that bind the multifaceted art of God into one holistic creation. Ever changing, it never changes. "The plans of the LORD stand firm forever, the purposes of his heart through all generations" (Psalm 33:11, NIV). And He has said, "While the earth remains, seedtime and harvest, cold and heat, winter and summer, and day and night shall not cease" (Genesis 8:22).

126

You will light my lamp; the L<small>ORD</small> *my God will enlighten my darkness.* P<small>SALM</small> 18:28

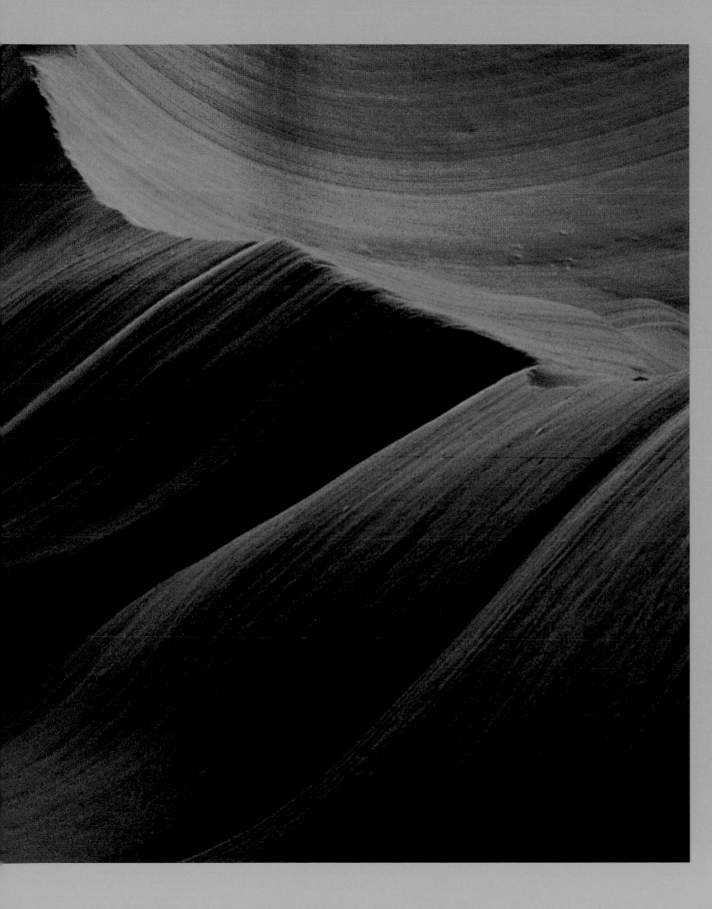

God is light and in Him is no darkness at all. 1 John 1:5

The descriptive power of the contrast between darkness and light makes it one of the most effective and frequently used metaphors in the Bible. Illustrating God's blessings, presence, and revelation, light is opposed to darkness, which represents judgment, alienation, and blindness (Isaiah 9:2; 60:1-3).

Significantly, the division of light and darkness into alternating days and nights is the first of nature's cycles created by God. We are reminded that the ultimate source of light on earth is God, rather than the sun, which He introduced later as light's immediate cause.

The natural properties of light and shadow present some interesting concepts that can aid our understanding of both the physical and spiritual realms of creation; for example, without light there is no shadow. Likewise, it is only by the light of God's truth that the darkness of sin is revealed. The light of God's law convicts us of our desperate need for His saving grace in Christ (Galatians 3:10-14).

As a body turned from the light is in shadow, so we must turn to God to live in the light of His truth (John 3:20-21).

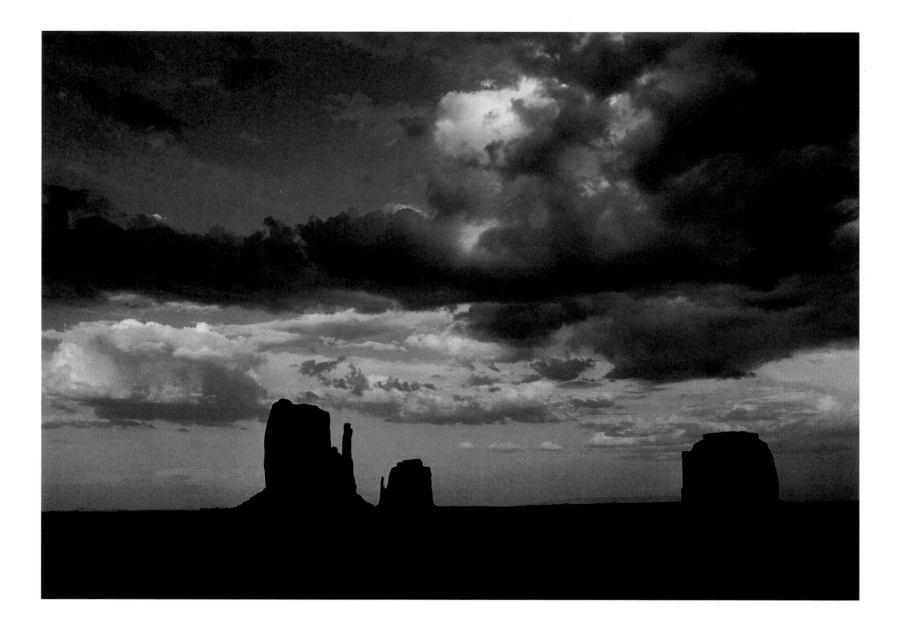

Although they are identical in perspective and angle of view, these two photographs were taken on separate trips more than two years apart, in different seasons, at opposite ends of the day, and with different camera systems. I was not aware of the match until I began researching images for this book.

102. & 103. The Mittens and Merrick Butte, Monument Valley

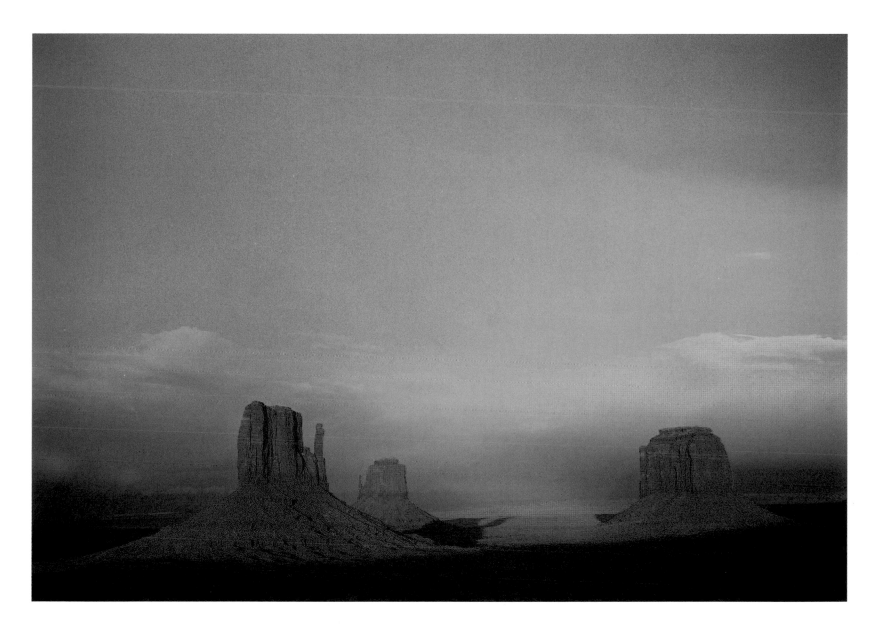

I am the light of the world. He who follows Me shall not walk in darkness, but have the light of life. JOHN 8:12

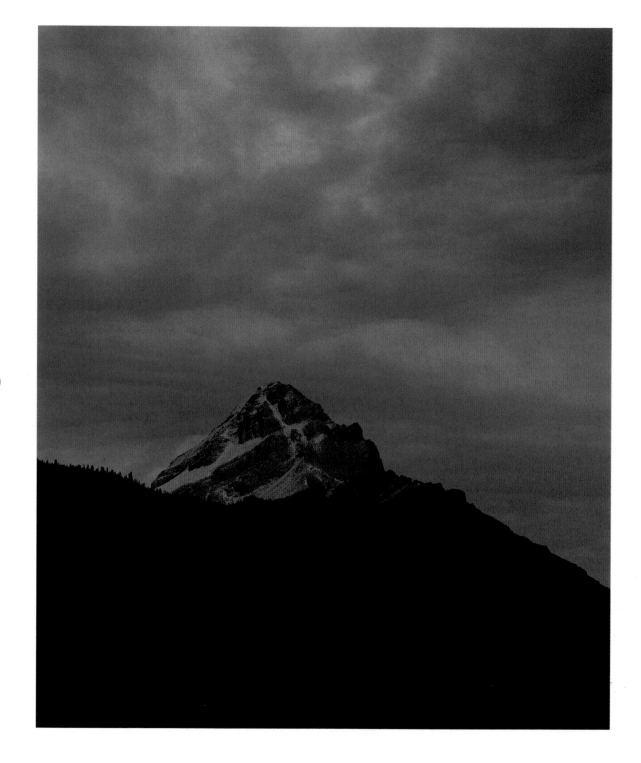

130

You are the light of the world. A city that is set on a hill cannot be hidden. Nor do they light a lamp and put it under a basket, but on a lampstand, and it gives light to all who are in the house. Let your light so shine before men, that they may see your good works and glorify your Father in heaven.

MATTHEW 5:14-16

104. Sunset, Mt. Willingdon, Alberta, Canada. 105. Sunrise, Nun Kun Peak, Zanskar Himalaya

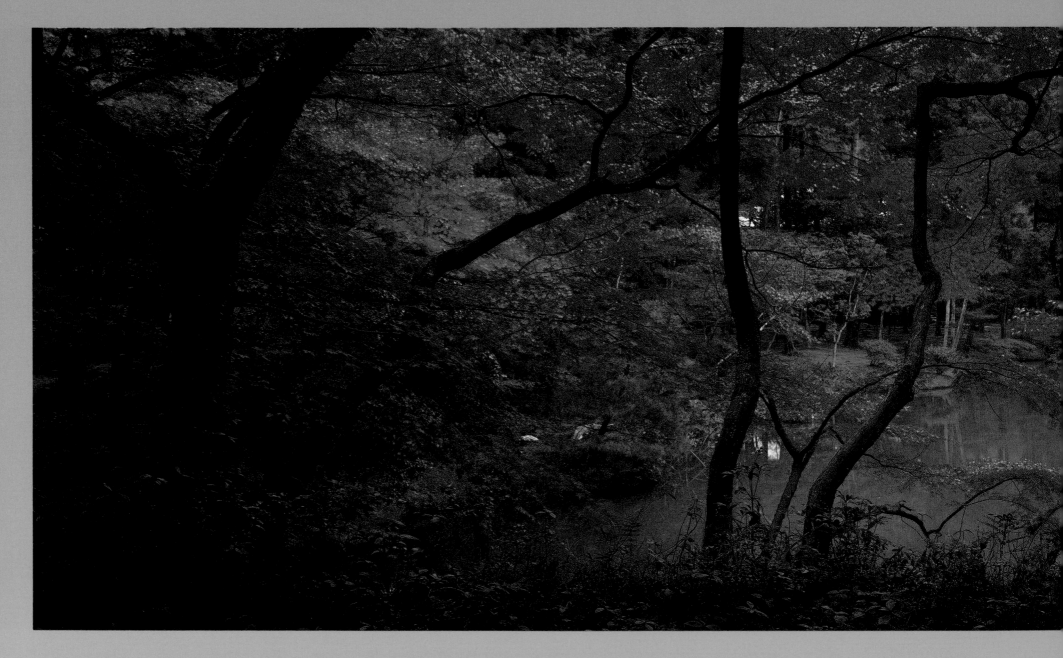

132

To everything there is a season, a time for every purpose under heaven: A time to be
pluck what is planted; a time to kill, and a time to heal; a time to break down, and a
time to mourn, and a time to dance; a time to cast away stones, and a time to gather
embracing; a time to gain, and a time to lose; a time to keep, and a time to throw away
and a time to speak; a time to love, and a time to hate; a time of war, and a time of peace

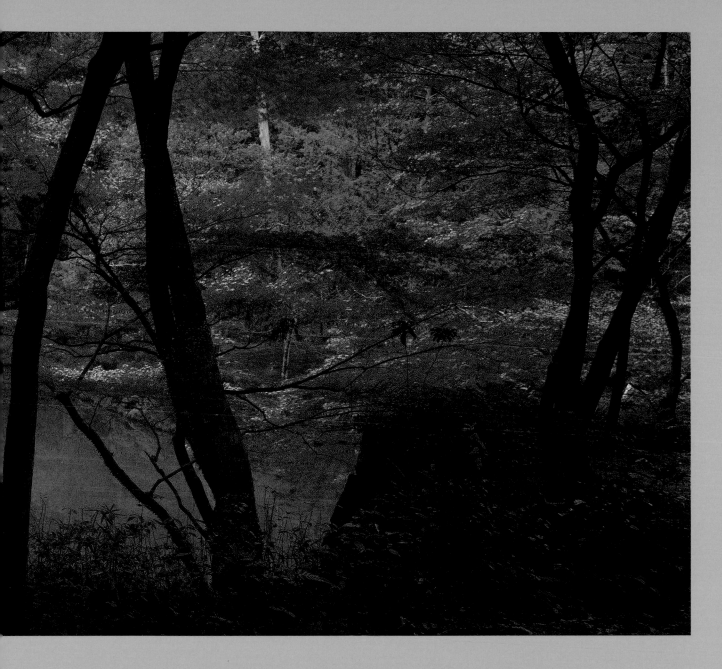

Nevertheless He did not leave Himself without witness, in that He did good, gave us rain from heaven and fruitful seasons, filling our hearts with food and gladness.

ACTS 14:17

Seasonal symbolism in the Bible frequently deals with agricultural activities such as seedtime and harvest. Christ uses the metaphor of a plentiful harvest field with few laborers to illustrate that a vast number of people are ready to hear and respond to the gospel; but His disciples must first pray for God to send more workers, as no one can do the work of harvesting without being called to it and equipped for it by God (Matthew 9:37-38).

133

born, and a time to die; a time to plant, and a time to
time to build up; a time to weep, and a time to laugh; a
tones; a time to embrace, and a time to refrain from
a time to tear, and a time to sew; a time to keep silence,

ECCLESIASTES 3:1-8

106. Moss Garden, Kyoto, Japan

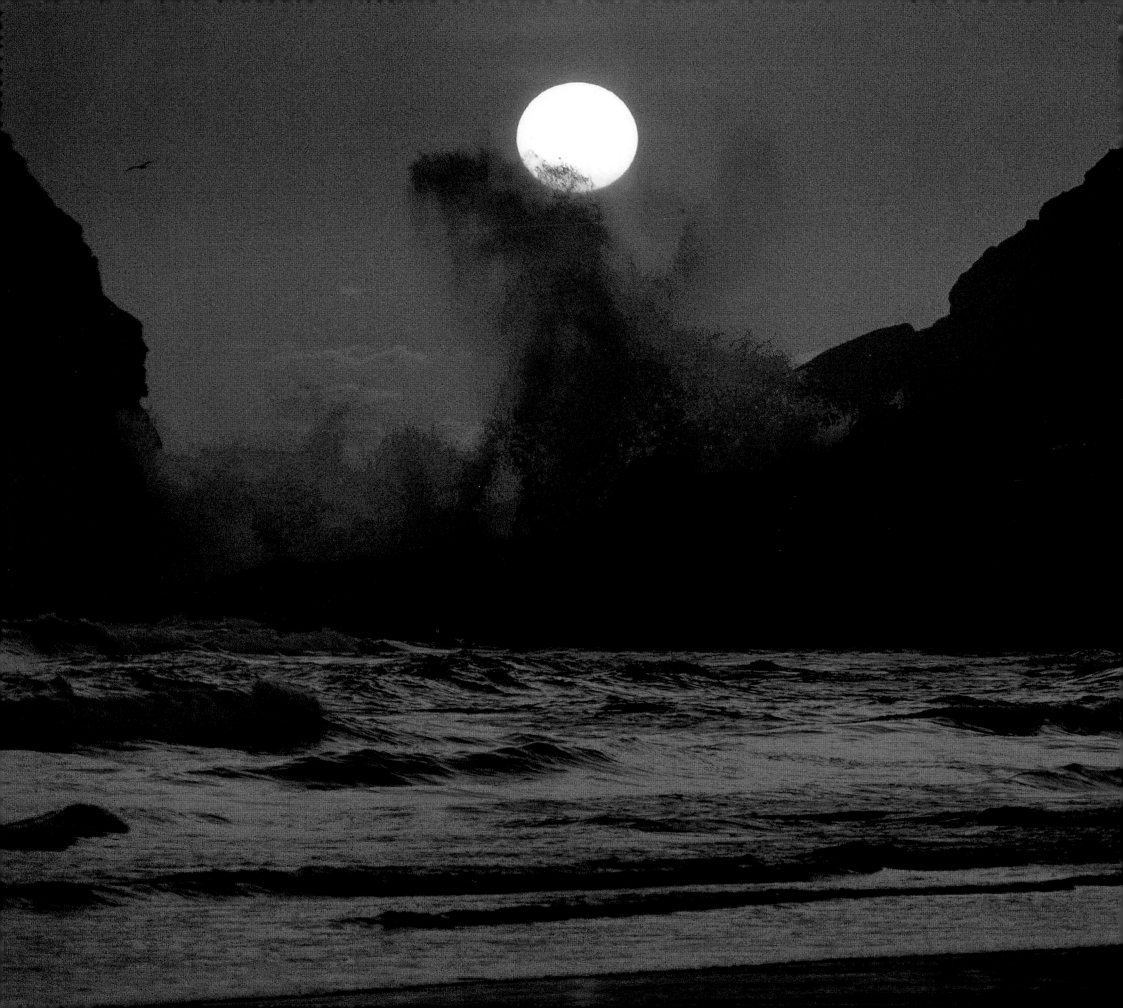

You have set all the borders of the earth;
 You have made summer and winter. PSALM 74:17

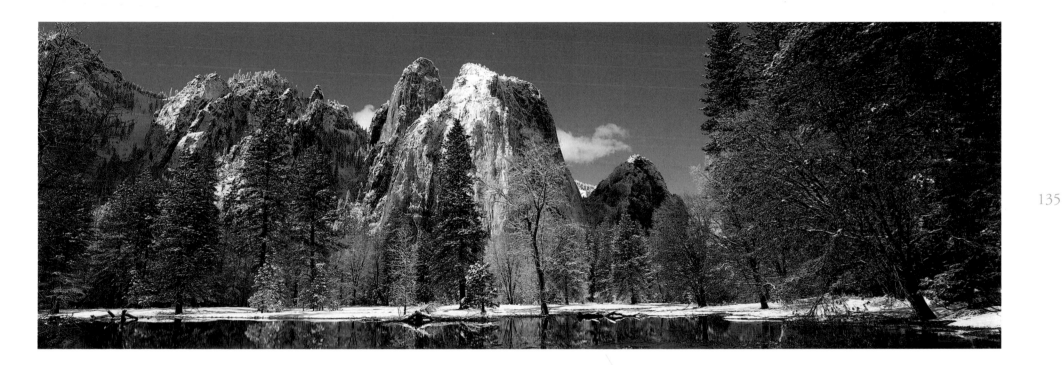

Because the earth is tilted at a fixed angle of 23.5 degrees, its Northern and Southern Hemispheres receive varying amounts of sunlight as the earth orbits the sun in the course of a year. As a result we enjoy a regular rotation of seasons; summer comes to the Northern Hemisphere when the North Pole has its maximum tilt toward the sun, and winter arrives when it is tilted farthest away from the sun. The seasons are reversed in the Southern Hemisphere and virtually nonexistent at the equator.

107. Sunset, Heceta State Park, Oregon 108. Winter, Yosemite Valley, California

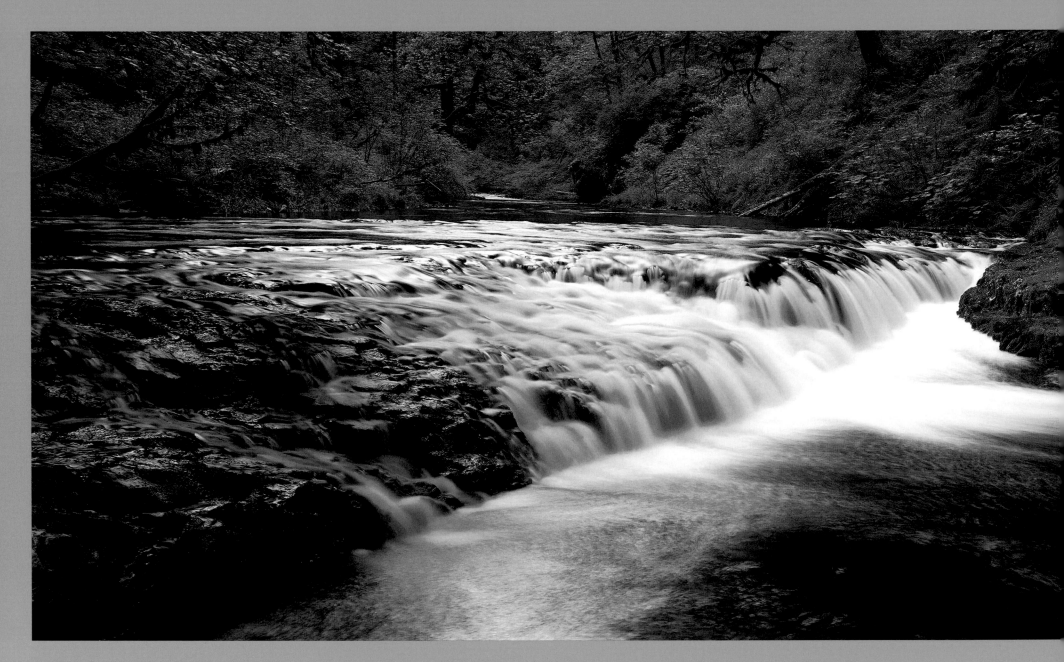

He draws up drops of water, which distill as rain from the mist, which the clouds drop down and pour abundantly on man. JOB 36:27-28

110. Silver Falls Creek, Oregon

At this also my heart trembles, and leaps from its place. Hear attentively the thunder of His voice, and the rumbling that comes from His mouth. He sends it forth under the whole heaven, His lightning to the ends of the earth. After it a voice roars; He thunders with His majestic voice, and He does not restrain them when His voice is heard. God thunders marvelously with His voice; He does great things which we cannot comprehend. For He says to the snow, "Fall on the earth"; likewise to the gentle rain and the heavy rain of His strength. He seals the hand of every man, that all men may know His work. The beasts go into dens, and remain in their lairs. From the chamber of the south comes the whirlwind, and cold from the scattering winds of the north. By the breath of God ice is given, and the broad waters are frozen. Also with moisture He saturates the thick clouds; He scatters His bright clouds. And they swirl about, being turned by His guidance, that they may do whatever He commands them on the face of the whole earth. He causes it to come, whether for correction, or for His land, or for mercy. JOB 37:1-13

139

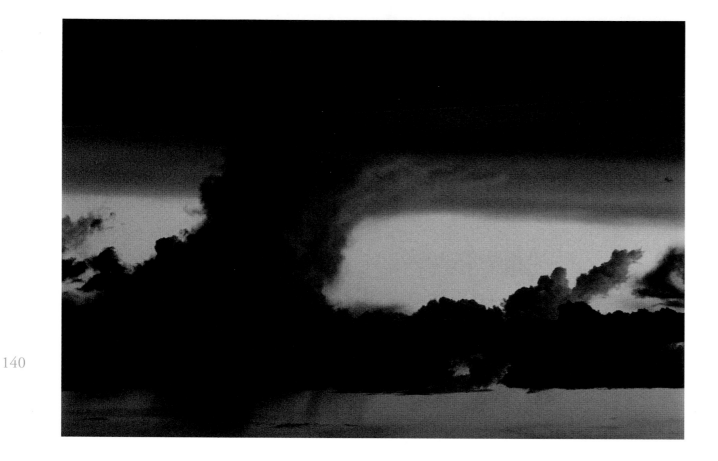

All the water that has ever been on earth is still on earth. There has never been or will there ever be any more or less. Always moving, always recycling, it changes from liquid to gas to solid to liquid again—visiting oceans, air, clouds, mountains, glaciers, lakes, rivers, plants, animals, humans, soil, and oceans again. What a story it might tell if it could talk; the water you drank this morning may have been calmed by Jesus on the Sea of Galilee almost two thousand years ago.

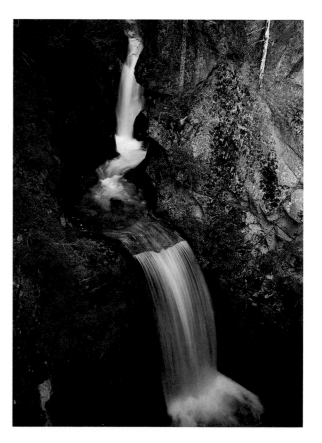

Does the rain have a father? Who fathers the drops of dew? From whose womb comes the ice? Who gives birth to the frost from the heavens when the waters become hard as stone, when the surface of the deep is frozen? Job 38:28-30, NIV

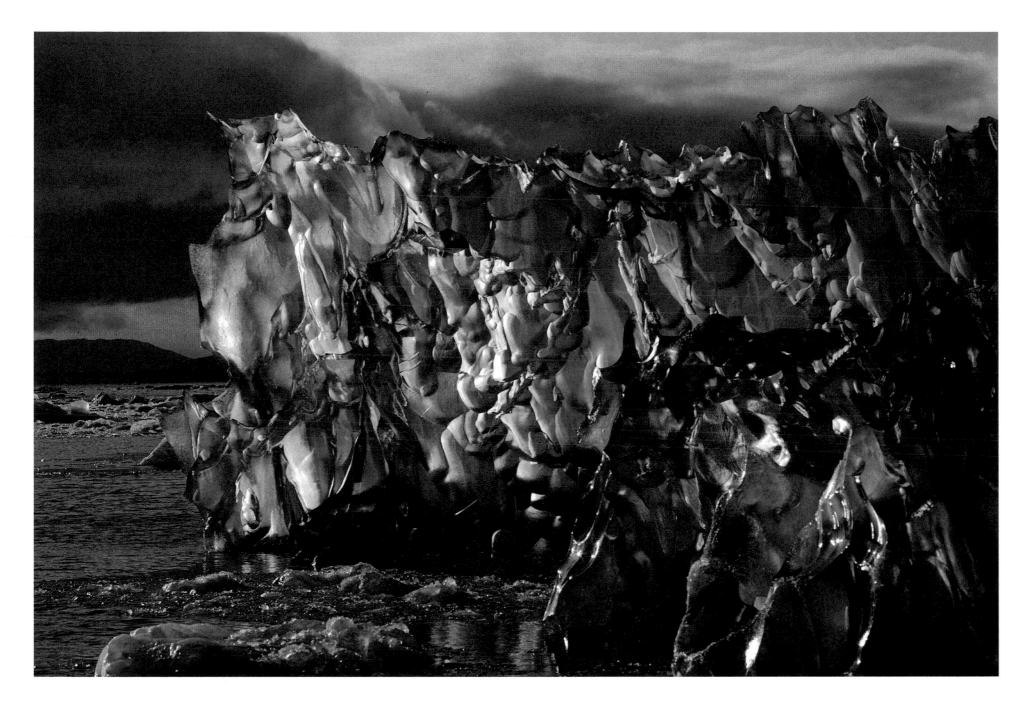

Seen from a small wooden boat in an ice-laden lagoon, the sixty-foot face of San Rafael Glacier looked especially large, particularly when a fifty-ton chunk broke loose and crashed into the water in front of us. Rolling over and resurfacing as an iceberg, it displayed its jewel-like beauty to the world. But its newborn splendor was brief, as its finely cut edges and deep clear color were quickly dulled by the warmth of the sun.

Frontlit and seen from a distance, the iceberg looked black and void of form. But when we maneuvered behind it so that it was backlit by the sun, we were shown the full glory of God's fleeting creation.

111. Thunder Storm, Grand Canyon, Arizona 112. Christina Falls, Mount Rainier, Washington 113. San Rafael Lagoon, Southern Chile

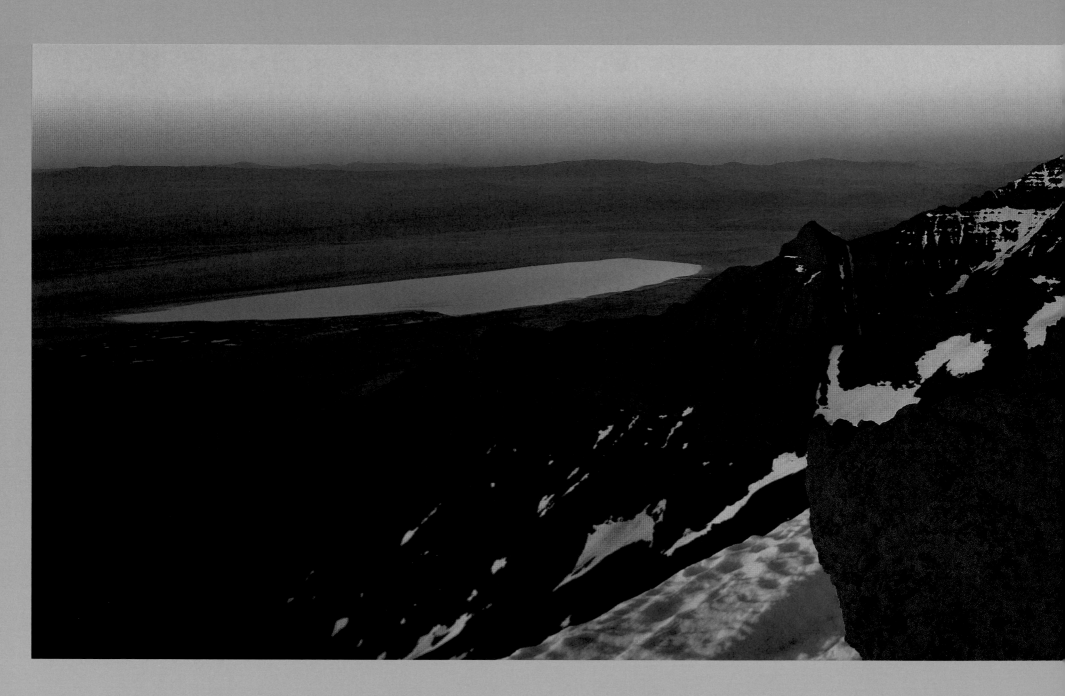

144

The day is Yours, the night also is Yours;
 You have prepared the light and the sun."

Psalm 74:16

116. Sunrise, Steens Summit, Eastern Oregon

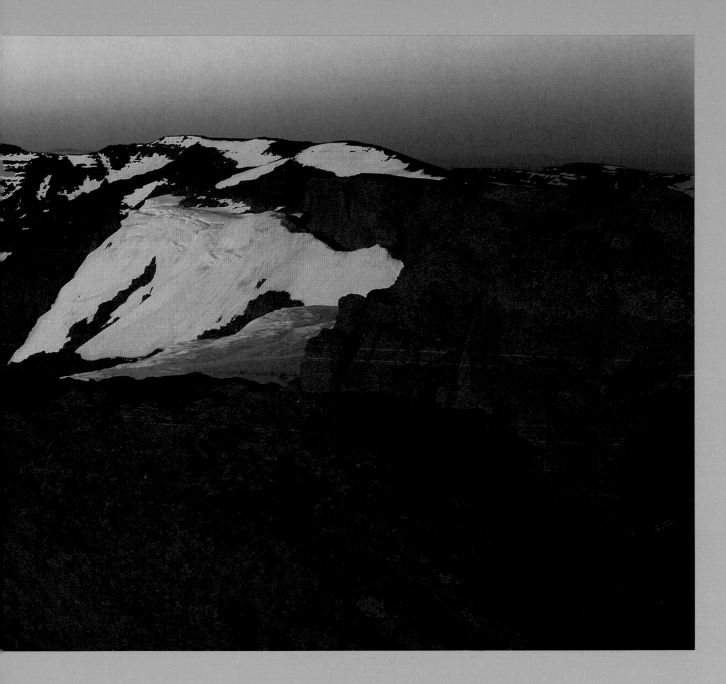

In the heavens he has pitched a tent for the sun, which is like a bridegroom coming forth from his pavilion, like a champion rejoicing to run his course. It rises at one end of the heavens and makes its circuit to the other; nothing is hidden from its heat.

PSALM 19:4-6, NIV

The sun, moon, and stars were the principal deities in pagan pantheons of the ancient Near East, but the Bible emphatically taught that they were mere creations of the true God of Israel (Deuteronomy 4:19; 17:3). This antithesis is clearly seen in Genesis 1:16, where the sun and moon are not even named and the stars are only mentioned as an afterthought—effectively demoting them and emphasizing their subservience to the Creator's will.

Making its daily sweep across the heavens and pouring its heat on every creature, the sun is the supreme metaphor for the glory of God (Psalm 84:11; Isaiah 60:19-20).

145

For God, who said, "Let light shine out of darkness," made his light shine in our hearts to give us the light of the knowledge of the glory of God in the face of Christ. 2 Corinthians 4:6, NIV

146

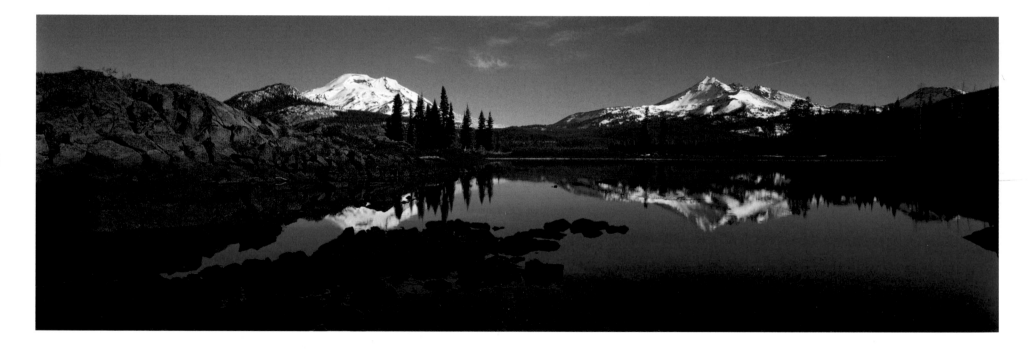

It was clear, cold, and silent when I finished shooting and sat back to enjoy the beauty before me. The ever frantic rush to capture the fleeting light of dawn was over, and now I could relax and soak up the natural splendor of my surroundings. Like Jonathan Edwards I felt "wrapt and swallowed up in God"—on the verge of sensory overload—when the perfect stillness was suddenly shattered by a shrill cry and a sudden rush of wind as a bald eagle swooped close overhead and soared out over the lake. All I could do was laugh. The day had barely begun, but I'd already been shown a lifetime of beauty.

117. Autumn Sunrise, Sparks Lake, Oregon 118. Sunrise Aerial, Monument Valley

147

148

May the glory of the LORD endure forever;
May the LORD rejoice in His works. PSALM 104:31

119. Sunset, Olympic National Park, Washington 120. Summer Sunrise, Cascade Lakes, Oregon

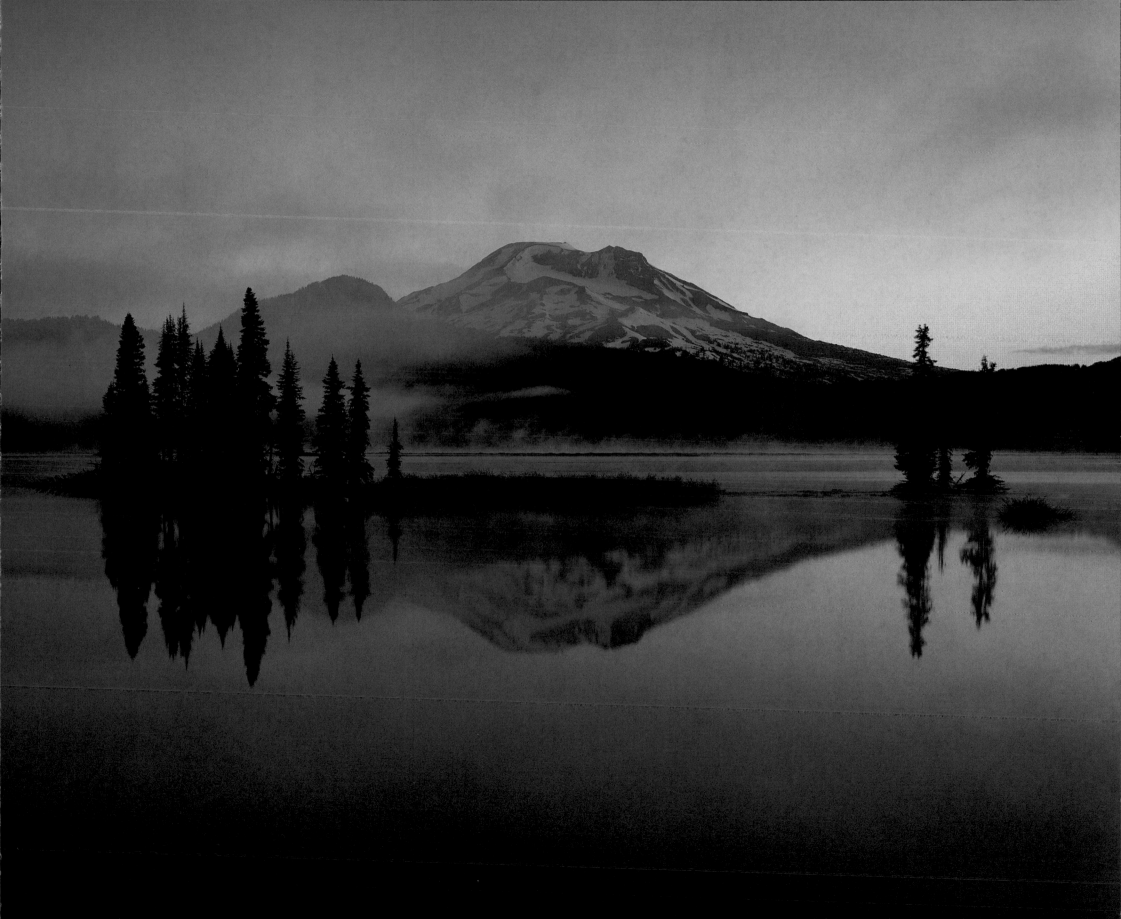

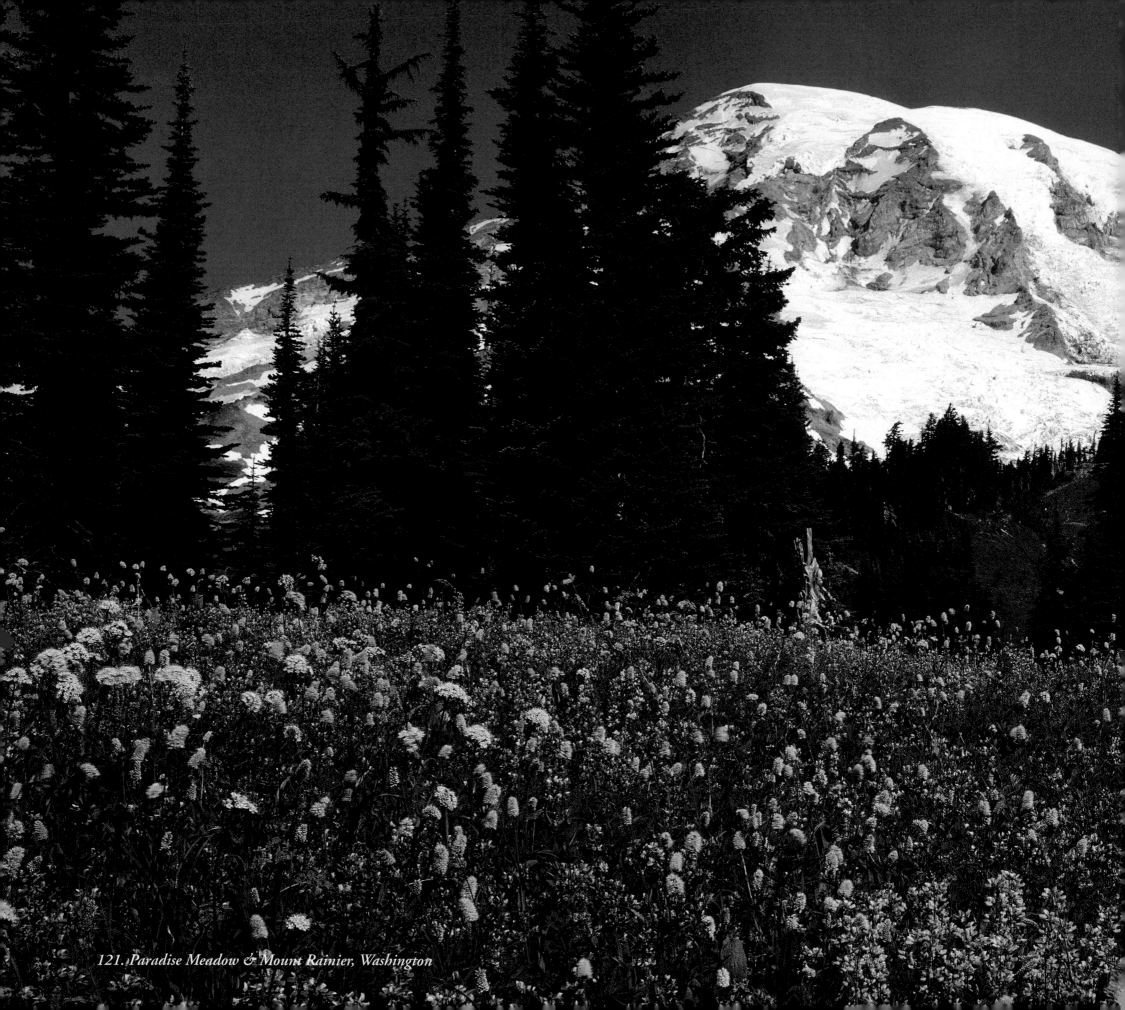

121. *Paradise Meadow & Mount Rainier, Washington*

Notes

PHOTOGRAPHIC NOTES

The following notes are provided for readers with a special interest in photography or geography who would like to know more about how and where the images in this book were made. Before discussing the individual pictures, however, I'd like to offer some general observations about equipment, film, and technique that may help you better understand my comments about each photograph.

EQUIPMENT & FILM

Because the images in *The Art of God* span my entire thirty-year career and it is my practice to frequently upgrade my camera systems, I used a wide variety of equipment to create these pictures. Although no man-made equipment can approach the perfection of the human eye, the proper selection and use of modern photographic tools enable the photographer to more powerfully and artistically express his God-given vision to others. The focus of my comments, therefore, will be on those aspects of equipment or technique that had the greatest influence on the outcome of the individual pictures in this book.

During the last decade most of my travel and landscape work has been done with large or medium format cameras, slow-speed transparency film, and a substantial tripod. The reasons for this deal more with marketing than creative concerns, as larger transparencies are easier for art directors and editors to view, and that often translates into increased sales. From an aesthetic standpoint, however, larger format equipment is a definite disadvantage, as its cumbersome size and glacial speed of use make it anything but a spontaneous and responsive extension of the eye, which has long been the photographic ideal. For this reason

and because today's films and printing methods make format size a nonissue in the final quality of reproduction (i.e., compare the plates in this book that were shot on 35mm against those taken on larger film), I recommend the 35mm format as the best choice for serious creative photography. I've noted the 35mm equivalents of my large and medium format lenses so that the images in the book might be more easily compared with the standard 35mm format that most people use. The following is a brief overview of the equipment used in creating the photographs in *The Art of God*, which will simply be listed by name in the plate descriptions:

35mm Systems: Until the early 1980s most of my work was done in 35mm. This was a period of extensive travel to remote foreign locations, when size, weight, and speed were the key factors in my choice of equipment. I used many different systems during this time, all of which were basically the same in design and ability, but with different "personalities" in their handling. All were single lens reflex systems with lenses ranging from 20 to 200mm, usually in fixed focal lengths rather than zooms. Included in this list were the Leicaflex SL and SL2; Olympus OM1, OM2, and OM4; Nikon F3; Canon F1 and EOS1. A lot of ink has been used by photo magazines exalting one brand of camera or lens over another, but I've never seen any significant difference in the final image. Given an adequate lens choice and control of exposure, most of today's entry-level SLR systems are light-years ahead of even their most famous predecessors. For this reason I consider the handling comfort of a camera to be the most important criteria in its selection. The size, weight, shape, and fit of today's

cameras vary widely, and no one system is right for everybody. It is something you'll know when you feel it. That is why I still have my old Olympus OMs—they just fit me.

Medium Format Systems: In 1983 the focus of my photography began to shift from international locations and cultures to the American landscape. With this change came a new set of equipment ideals. Image size and control became more important than equipment size and comfort, and I began using medium format cameras more than 35mm. A list of those systems follows:

• Hasselblad 500C (1968–1974): A very versatile 6 x 6cm SLR with interchangeable 120mm film backs (twelve exposures per roll) and top-quality Zeiss lenses. The "normal" 80mm lens is the equivalent of a 52mm on a 35mm camera.
• Pentax 67 (1986–present): Looking like a 35mm SLR on steroids, this tank-tough 6 x 7cm camera offers great handling and outstanding lenses but no interchangeable film backs. Ten shots to a roll of 120mm film. Standard 105mm lens equates to a 55mm on a 35mm camera.
• Mamiya 7 (1996–present): A superb 6 x 7cm rangefinder that looks and feels like a grown-up Leica. Small and very comfortable, with almost silent operation and four excellent lenses from 43mm to 150mm (equals 21mm to 71mm on a 35mm camera), but no interchangeable backs.
• Pentax 645N (1998–present): First autofocus medium format system with interchangeable lenses and motor drive, with operating speed approaching that of 35mm. The 6 x 4.5cm format is 2.7 times bigger than 35mm, but only about 60 percent of a 6 x 7. With new film and printing

technology, this may soon become the "ideal" format for field and travel photography. Sixteen shots to a roll of 120mm film. Normal 75mm lens is equivalent to a 45mm on a 35mm camera. I just wish it weren't so noisy!

Large Format & Panoramic Systems: For critical landscape photography the preferred tool is the large format view camera, an instrument that has changed little since the earliest days of photography. These come in two primary types: the folding flatbed or "field" camera that, like a turtle, folds into its own hard shell to protect its delicate inner parts from the dangers of the outside world; and its svelte cousin, the monorail view camera, which is simply a light-tight bellows attached to front and back standards (one for the lens and the other for the film holder) that are mounted onto a long, thin focusing rail. As this version is obviously more vulnerable to accidental damage, it is primarily used in the studio and not in the field. View cameras are always used on a tripod, allowing for very long exposures that are often used with small apertures for greater control of image sharpness from the front to the back of a scene. This is also achieved by using the view camera's ability to tilt its front or back standard, thereby bringing the entire image into sharp focus at once. This is not possible with cameras lacking the tilt feature.

As these cameras vary in their form and function, I will simply list them, unless there is some notable feature that directly influences the photographic result:

• Linhof Technica IV (1975–1981)
• Tachihara 4 x 5 Wooden Field (1984–1992)
• Wista VX 4 x 5 Metal Field (1992–present)

• Linhof Technorama 6 x 17cm (1982–present): A hand-holdable panoramic camera with a fixed 90mm wide-angle lens, which is equivalent to a 25mm lens on a 35mm camera. It uses 120mm or 220mm film, giving four or eight shots. The image size is 2 1/4 x 6 3/4 inches.
• V-Pan 617 Monorail (1992–present): This is a metal monorail view camera with a 6 x 17cm film back, which uses a wide range of lenses, from 75mm to 720mm (or 21mm to 200mm on a 35mm camera).

Filters: I rarely use filters except in cases of high contrast between a dark foreground and a bright sky or mountain background. Then I use split neutral density filters to balance the light level. I also occasionally use a polarizing filter to reduce reflections and increase color saturation.

Films: Like most nature photographers, I use Fuji Velvia transparency film almost exclusively. It is a slow film (ASA 50), offering extremely fine grain, superb sharpness, and very saturated colors. It is especially good for greens and reds, which is great for forests, southwest deserts, or sunset skies.

Tripods: A rigid tripod is a must for good results, as it gives total control over the creative process. Although its obvious application is the support of long telephoto lenses, its primary use is in allowing slower shutter speeds and smaller apertures for greater artistic control, as discussed below.

TECHNIQUE

Creative photographic technique comes from understanding the capability of equipment and applying it to achieve a previsualized result.

The key factors in image control are lens choice, camera position, aperture, and shutter speed.

Lens Choice & Camera Position: I've linked these items because they work in tandem to control the spatial relationships in a photograph. A wide-angle lens effectively expands a scene, pushing the background further away, and a telephoto compresses it, drawing the background closer. In practice this means that a wide-angle is best used to emphasize the foreground and a telephoto the background. Consider plate 114 on page 142. Because I desired to accent the water, I moved in close with a wide-angle lens to exaggerate its relative size to the mountain. If I wanted to accent the mountain, I would back up and use a telephoto to enlarge the mountain in relation to the waterfall. The first technique is often used to make hotel rooms look bigger than they really are, and the second to make a resort property look closer to the mountains than it really is.

Aperture & Shutter Speed: A small aperture (such as f16) is used to obtain the greatest range of sharpness from foreground to background, which is called depth of field. A large aperture (such as f2.0) is used to make only one plane sharp, with all other planes being blurred, which is called selective focus. The first technique is usually used with wide-angle lenses, as described in the previous paragraph. The second is often used to accentuate the main subject in close-ups, as seen in plate 63 on page 79.

Fast or slow shutter speeds are used to give moving water a more realistic or impressionist feel, as seen in plates 114 and 115 on pages 142 and 143.

1. *Mt. Hood, Oregon.* Lost Lake, on the northwest side of Mt. Hood, is at an ideal angle for viewing alpine glow, which occurs when warm sunset light is reflected off the large open snowfields of the high Cascade peaks. V-Pan 617, 180mm, Velvia.

2. *Summer Storm Cloud.* Dramatic thunderclouds are a common summer sight on the east side of the Cascades, but this August afternoon in 1985 was the most spectacular I've ever seen. Nikon F3, 80–200mm, Kodachrome 64.

3. *Death Valley, California.* The best time to shoot sand dunes is at sunrise and sunset when the low angle of light defines even the smallest ripple. Thirty seconds after I took this shot, the light was gone. V-Pan 617, 180mm, Velvia.

4. *Sparks Lake, Oregon Cascades.* Only thirty miles from my house, Spark's Lake is one of my favorite haunts, especially in June when the columbine blooms. V-Pan 617, 75mm, Velvia.

5. *Star Trail, Huangshan, China.* This is a seven-hour exposure at f/2, and the rotation of the earth makes the stars look like they are moving across the heavens. Canon F1, 85mm, Kodachrome 64.

6. *Southern Oregon Coast.* A one-minute exposure accents the fading glow of sunset and turns the surf to a mist. Pentax 67, 400mm, Velvia.

7. *Lantana Blossom.* Selective focus and a large aperture emphasize the front blossom. Leicaflex SL2, 60mm Macro, Kodachrome 25.

8. *Old Growth Forest, Washington.* A wide-angle lens, small aperture, and close-in camera position increases the relative size and importance of the foreground, while keeping the background sharp. Mamiya 7, 43mm, Velvia.

9. *Grand Teton National Park, Wyoming.* A long-favored foreground for sunrise shots of the Tetons, this ancient cypress finally fell a few years ago. Pentax 67, 75mm, Fujichrome 50D.

10. *Del Norte Coast, California.* It was a Genesis 1:2 type of day on the "redwood" coast, and I was trying to capture its mood with some slow shutter speeds on the surf, when God suddenly spoke 1:3: "Let there be light." And it was very good! Linhof Technorama, 1/4 sec., Velvia.

11. *Sunset Storm, Southern Utah.* I'd just finished an afternoon shoot in Monument Valley and was headed to a Fourth of July fireworks display, when God put on a show of His own. Nikon F3, 400mm to compress perspective, Kodachrome 64.

12. *Sunrise Clouds.* Shooting clouds is like shooting waves; every one looks better than the last, and a roll of film never lasts as long as you expect. Canon EOS1, 80–200mm, Fujichrome 50D.

13. *Fire in the Clouds.* Central Oregon sunsets are sometimes hard to believe—and this is *not* filtered. Canon EOS1, 28–80mm, Velvia.

14. *Summer Sky.* July is the best "sky month" in northern Arizona, with great displays of cumulus clouds and colorful sunsets. Canon EOS1, 20–35mm, Velvia.

15. *Sunset Cloud.* Mamiya 7, 65mm, Velvia.

16. *Dawn Sky.* Pentax 67, 165mm, Velvia.

17. *Above the Clouds.* This was taken at thirty thousand feet above the Pacific, heading for a new day. Olympus OM4, 100mm, Kodachrome 64.

18. *Boiling Storm Clouds.* This was taken the same afternoon as plate 2. It was an "eight-roll storm." Nikon F3, 80–200mm, Kodachrome 64.

19. *Flowing Lava,* by Rik Cooke. Detail of the flow from Kilauea in Hawaii Volcanoes National Park, on the "big island" of Hawaii. Canon F1, 300mm, Kodachrome 64.

20. *Lava Detail, Mt. Etna, Sicily.* The blurred flow in the center of this photo is an indicator of the lava's speed, which was estimated at 35 mph. Hasselblad 500C, 150mm, Ektachrome 64.

21. *Pacific Sunset, Southern California.* Olympus OM2, 2,000mm Swift telescope, Kodachrome 25.

22. *Lava Fountain,* by Rik Cooke. This was taken during one of Kilauea's most dramatic eruptions, in Hawaii Volcanoes National Park. Canon F1, 300mm, Kodachrome 64.

23. *Mt. Etna, Sicily.* Using a large rock as a shelter to load film backs and escape the lava's heat, I'd step out and shoot several shots and then duck back. Hasselblad 500C, 50mm, Ektachrome 64.

24. *Merced River Gold, California.* This was taken in late afternoon when the walls of Yosemite Valley were in light, but the river was dark, providing a mirror for the colors around it. Pentax 67, 165mm, Fujichrome 50D.

25. *Chujenzi River, Japan.* Because the river was flowing fast, I wanted to show it as hard and cold. To do so, I used a fast shutter speed to freeze the water and a tight composition to give it more power. Nikon F3, 80–200mm, Kodachrome 64.

26. *Lostine River, Northeast Oregon.* Again the dark waters of the river reflect the colors on its lighted banks. Canon F1, 85mm, Kodachrome 64.

27. *Proxy Falls, Oregon Cascades.* A slow shutter speed "softens" the water and conveys a sense of peace. Pentax 67, 105mm, Velvia.

28. *Lake Superior, Michigan.* A split neutral density and warming filter balances contrast and increases the color temperature of the sunset. V-Pan 617, 180mm, Velvia.

29. *McDonald River Detail, Montana.* Shooting from a high vantage point with a long telephoto, I wanted to flatten the scene to accent its color and pattern. Pentax 67, 400mm, Velvia.

30. *Deschutes River Blues, Central Oregon.* Once again shadowed waters mirror sunlit surroundings —in this case, autumn aspens and a cloudless sunset sky. Pentax 67, 560mm, Velvia.

31. *Painted Hills, Central Oregon.* Wanting to stress the fluted pattern of the hills, I used a long lens to flatten the image and a tight composition to take it out of context. Pentax 67, 800mm, Velvia.

32. *Hindu Kush Range, Bamian, Afghanistan.* A long lens increases the relative size of the distant mountains to the foreground foothills. Hasselblad 500C, 250mm, Ektachrome 64.

33. *View from Steens Summit, Eastern Oregon.* The largest fault-block mountain in the United States, Steens Mountain overlooks the Alvord Desert to the east. V-Pan 617, 125mm, Velvia.

34. *Monument Valley Monolith.* Shooting from a small plane at low altitude in late afternoon light with slow-speed film requires fast lenses and a very quick focusing system. The Canon EOS1 and 80–200mm f2.8 zoom passed the test. Velvia.

35. *South Mitten, Monument Valley, Arizona.* To emphasize the sand pattern I used a wide-angle lens and a low camera position, plus a small aperture for maximum depth of focus. Hasselblad 500C, 50mm, Ektachrome 64.

36. *Canyonlands Overview, Southern Utah.* The sandstone face of Deadhorse Point makes a strong foreground anchor for the distant scene. A wide-angle lens heightens the sense of space. Wista VX, 125mm, Fujichrome 50D.

37. *Rock, Sand & Wind, Olympic N.P., Washington.* Late afternoon light defines the pattern and texture of the sand, while a tight composition strengthens its impact. Pentax 67, 165mm, Fujichrome 50D.

38. *Autumn Maple Leaves, Nikko, Japan.* A long lens isolates the leaves against a dark background, while a wide aperture limits the range of focus. Nikon F3, 80–200mm, Kodachrome 64.

38A. *Summer Pond, Oregon Cascades.* Using a small aperture for maximum depth of focus and eliminating the shoreline as a familiar anchor, I hoped to create a visual puzzle that required a long look to solve. V-Pan 617, 240mm, Velvia.

39. *Snake River, Wyoming.* The valley was in deep shadow when the mud on the river's edge suddenly caught the light from some high clouds and etched its path in silver. Hitting the brakes and setting up as fast as I could, I grabbed a few shots and it was gone. Nikon F3, 400mm, Kodachrome 64.

40. *Edge of Light, Antelope Canyon, Arizona.* The slot canyons of the Colorado Plateau are a photographic paradise, as the constantly changing light reveals one new scene after another. Nikon F3, 80–200mm, Kodachrome 64.

41. *Dunhuang Dunes, Western China.* Canon F1, 80–200mm, Kodachrome 64.

42. *Silversword Detail, Hawaii.* This shot was made by my father over forty years ago on Kodachrome I, and its color is still unchanged. Topcon D, 50mm.

43. *Reed Reflection, Montana.* The images I like best are usually the simplest. That doesn't mean always shooting details, but rather showing only what is necessary. Pentax 67, 105mm, Velvia.

44. *Sunrise Silhouette, Monument Valley, Utah.* It is important in silhouette shots to expose for the sky and not let the meter be influenced by the dark. Nikon F3, 80–200mm, Kodachrome 64.

45. *Sunset Silhouette, Southern Oregon.* To heighten the color's impact, I used a long lens to compress it. Olympus OM4, 200mm, Kodachrome 64.

46. *Moonlight Silhouette, French Alps.* A ten-minute exposure combined with the moving clouds to give the impression of an aurora. It also added a second moon that had to be cropped out of the picture. Olympus OM2, 200mm, Kodachrome 25.

47. *Sunset Silhouette, Oregon Cascades.* The new moon always sets with the sun, and it is especially photogenic when paired with Venus, as seen in this silhouette of the Three Sisters. Pentax 67, 165mm, Fujichrome 50D.

48. *Face Rock Wayside, Oregon Coast.* My lens choice, camera position, and exposure were chosen to move the viewer's eye to a single "crash point" at the sun. Pentax 67, 75mm, Velvia.

49. *Rock Window, Monument Valley, Utah.* Gathering clouds on a July afternoon put the window in shade while the valley remained in sun. Canon EOS1, 28–80mm, Velvia.

50. *Guadalupe Mountains, Texas.* The soft, but directional, last light of day gives great definition to the foreground rocks, and a wide-angle lens boosts their prominence. V-Pan 617, 125mm, Velvia.

51. Pebbles, Agate Beach, Oregon. The focus here was on the pattern of the rocks, so I used a flat frontal view with tight composition to stress only that. Pentax 67, 165mm, Fujichrome 50D.

52. Antelope Canyon, Northern Arizona. Slot canyons often have narrow entrances that widen out below, so squeezing in with my backpack on wasn't too smart—as my broken ground glass confirmed. Fortunately, I had a spare. Tachihara 4 x 5 Field, 125mm, Fujichrome 50D.

53. Iceberg Detail, Southern Chile. The exquisite ice sculptures of San Rafael Lagoon have provided some of the most spectacular subject matter of my life. The overall scenes are impressive (see page 113), but the details are equally strong. Olympus OM2, 100mm, Kodachrome 64.

54. Obsidian Detail, Central Oregon. Newberry Crater National Monument in central Oregon provides a solid rock counterpart to the icebergs of Chile. Pentax 67, 105mm, Fujichrome 50D.

55. Sandstone, Zion National Park, Utah. The varied angles of Zion's sandstone formations make it possible to find optimum lighting conditions at all times of day. V-Pan 617, 240mm, Velvia.

56. Sandstone Wall, Southeast Oregon. The southeast corner of Oregon is one of the least traveled regions of the United States, and the rock forms of Owahee Canyon are very much like those seen in the plateau lands of southern Utah. Pentax 67, 400mm, Velvia.

57. Bark Detail, Ponderosa Pine. A medium-long lens flattens perspective to accent the jigsaw-like bark pattern. Pentax 67, 165mm, Velvia.

58. Rock Formation, Maine Coast. Wista VX 4 x 5 metal field, 90mm, Velvia.

59. Driftwood & Pebbles, Washington Coast. The shores of the Olympic Peninsula are unmatched for textural detail, as high seas and rough weather litter its beaches with timeworn stones and sun-bleached driftwood. Pentax 67, 165mm, Fuji 50.

60. Sunflowers, North Dakota. A long lens compresses the scene and intensifies its color. The heat and humidity of early August don't need to be intensified! V-Pan 617, 240mm, Velvia.

61. Cape Cod Lily Pond. A long exposure in pre-dawn light accents the soft blue feeling of the scene. When the first rays of sunlight hit the pond, the feeling was gone. V-Pan 617, 125mm, Velvia.

62. Autumn Detail, Northern Japan. A long lens isolates the leaves against the dark background and compresses the elements of color. Canon F1, 80–200mm, Kodachrome 64.

63. Tiger Lily, Northern California. An extreme telephoto and a large aperture combine to make the background a soft blur and increase the impression of sharpness in the lily. Pentax 67, 560mm, Velvia.

64. Bluebonnets & Mesquite, Texas Hill Country. It had rained hard the night before, freshening the skies and lowering the pollen count to only about 200 percent—the perfumed air was remarkable! A wide-angle lens and low camera position accent the foreground flowers and emphasize the sweep of the field. V-Pan 617, 90mm, Velvia.

65. Common Sorel, Redwood National Park. A perpendicular camera angle and small aperture provide maximum sharpness across the frame. Pentax 67, 165mm, Fujichrome 50D.

66. Dendritic Branch Pattern, Central Oregon. After a week of freezing fog, the sunlight provided a true visual feast. Pentax 67, 165mm, Fujichrome 50D.

67. Dendritic Mud Pattern, Colorado Plateau. I am always attracted to the identical patterns displayed in disparate natural environments. This mirror of a tree branch is at Sheep Springs in Monument Valley. Canon EOS1, 80–200mm, Velvia.

68. Rock Pattern, Zanskar Himalaya, Kashmir. The rock structure displayed in this shot is only about six feet tall, and it repeats in larger forms all the way to the summit. Nikon F3, 55mm Macro, Kodachrome 64.

69. Summit Structure, Hindu Kush Range, Pakistan. The summit form of this twenty-thousand-foot peak is similar to the six-foot pattern seen in plate 68. Nikon F3, 80–200mm, Kodachrome 64.

70. Cascade Sunrise, Central Oregon. The southerly angle of winter sunrise light accents the fire-and-ice character of central Oregon's high desert environment. V-Pan 617, 125mm, Velvia.

71. Sunset Surf, Big Sur, California. A telephoto lens and a cliff-top camera position give an unusual view of the leading edge of the surf as it runs up the beach and is lit by the rays of the setting sun. Hasselblad 500C, 250mm, Ektachrome 64.

72. Aiguilles, Chamonix, France. The summit of the Aiguille du Midi provides one of the world's best alpine views. Pentax 645, 75mm, Fuji Astia.

73. Horns of the Payne, Southern Chile. The story of the photography is on page 94. Leicaflex SL2, 180mm, Kodachrome 25.

74. Matterhorn & Clouds, Zermatt, Switzerland. There are few mountains as beautiful or as shy as the Matterhorn. The downside of its nature is that you may spend days in Zermatt and never see it. The upside is you might see it when it takes off its veil, which is the most dramatic view it can offer. Canon F1, 80–200mm, Kodachrome 25.

75. *Sunset over Mt. Chephren, Alberta, Canada.* It was a stormy day in the Rockies with little hope of clearing. But just before sunset the clouds began billowing downward, and a high wind started moving them off the mountains. A shaft of colored sunlight then broke through the darkness, igniting a snow plume on top of Mt. Chephren and creating the most dramatic sunset I've ever seen. Mamiya 7, 65mm, Velvia.

76. *Sunrise over Mt. Jefferson, Oregon Cascades.* A sunrise flight around Mt. Jefferson provided a similar experience, when a snow plume from the mountain's summit was set on fire by the first light of day. Shooting into the sun caused a fiery lens flare that enhanced the final image. Olympus OM4, 100mm, Fujichrome 50D.

77. *Old Growth Redwoods, California.* The best condition for shooting in the redwoods or any forest is when there is fog or a cloud cover to filter the light. Linhof Technorama, Fujichrome 50D.

78. *Birch Forest, Upper Michigan.* The foreground trees are needed to create a sense of depth in this scene. V-Pan 617, 125mm, Velvia.

79. *Sunrise & Fog, Three Sisters Wilderness.* Ground fog creates pictures with a sense of mystery because the information given is limited to shapes. Pentax 67, 165mm, Fujichrome 50D.

80. *Autumn Forest, Catskill Mountains, New York.* Road cuts can provide visual access to forest scenes that would otherwise be impossible to record. A telephone wire runs just above the frame line in this picture. Linhof Technorama, Fujichrome 50D.

81. *First Snow, Kananaskas, Alberta, Canada.* The striking branch pattern of these lodgepole pines was greatly enhanced by an unexpected autumn snow. V-Pan 617, 180mm, Velvia.

82. *Rhododendron & Redwoods, Northern California.* A wide-angle lens and a low camera position close to the flowers show good foreground detail and relate it to the overall scene. Tilting the camera up also makes the trees appear to "fall" toward the center, emphasizing their great height. Pentax 67, 45mm, Velvia.

83. *Monument Valley from Hunts Mesa, Arizona.* This is an unusual view of the valley, which is only accessible by an arduous four-wheel-drive journey. Linhof Technorama, Ektachrome 64.

84. *Sunset Aerial, Monument Valley.* The long shadows of the buttes accentuate their dominance over the valley. Canon EOS1, 80–200mm, Velvia.

85. *Desert Bloom, Southeast Oregon.* The high desert comes alive with color in early July. Linhof Technorama, Fujichrome 50D.

86. *Evening Primrose, Sonoran Desert.* Using an extreme-wide-angle lens and a small aperture from a very close-up position puts all the emphasis on the foreground flowers and shows the background for location purposes only. Mamiya 7, 43mm, Velvia.

87. *Painted Hills, Central Oregon.* The spring bloom lasts only a few short weeks at this unit of the John Day Fossil Beds National Monument. Linhof Technorama, Fujichrome 50D.

88. *Sunset, Grand Canyon National Park.* The last light of day gives great definition to the Grand Canyon from Mather Point on the South Rim. Tachihara 4 x 5 Field, 125mm, Fujichrome 50D.

89. *Rialto Beach, Olympic National Park.* Sunset light reflects from a driftwood log and gives color to the mist caused by an offshore wind. Tachihara 4 x 5 Field, 125mm, Fujichrome 50D.

90. *Seagull & Surf, Oregon Coast.* Looking down on the surf from a cliff above Heceta State Park reveals the power of the water and the warmth of the sunset light reflecting from its surface. Pentax 67, 400mm, Fujichrome 50D.

91. *Cloudbreak, Tavarua, Fiji.* The size and shape of the waves on this Fijian reef are legendary among surfers. The face height of this wave was over twenty feet. Canon EOS1, 35–350mm, Fuji Astia.

92. *Crashing Wave, Cape Kiwanda, Oregon.* Few subjects can match the film-consuming power of waves. Those at Cape Kiwanda on the central Oregon coast are especially notorious in January and February. Pentax 67, 400mm, Velvia.

93. *Face Rock Wayside, Oregon Coast.* At sunset when the sea stacks are silhouetted, the face in Face Rock is clearly seen. Wista VX, 180mm, Velvia.

94. *Palouse Wheatfield, Eastern Washington.* The rolling wheatlands of the Palouse are best viewed from Steptoe Butte. This shot was made partway up the butte with a low, close-in camera angle to accentuate the vastness of the wheatfields. Linhof Technorama, Fujichrome 50D.

95. *Wild Grasses, Japan.* Shooting toward the rising sun with a telephoto lens from a low angle, I was able to capture the beautiful rim lighting on these grasses. Nikon F3, 500mm, Kodachrome 25.

96. *Bluebells, Zermatt, Switzerland.* A long lens, large aperture, and close focus softened the background and accented the sharpness of the main flowers. Canon F1, 80–200mm, Kodachrome 25.

97. *Ice Jewelry, Oregon.* A catadioptric or "mirror" lens turns out-of-focus specular highlights into circles. Nikon F3, 500mm, Kodachrome 64.

Oh, the depth of the riches both of the
wisdom and knowledge of God!
How unsearchable are His judgments
and His ways past finding out!
"For who has known the mind of the LORD?
Or who has become His counselor?
Or who has first given to Him
And it shall be repaid to him?"
For of Him and through Him and to
Him are all things,
to whom be glory forever.
Amen.

ROMANS 11:33-36